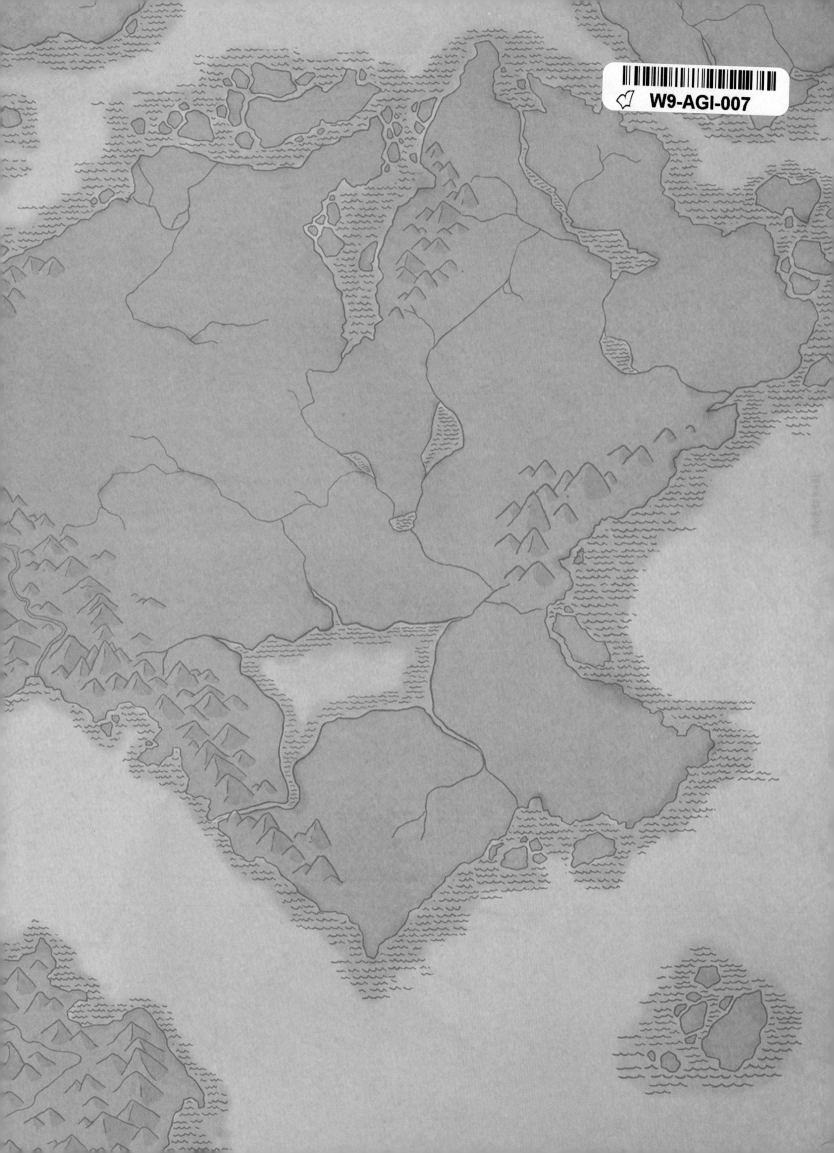

THE ART OF
THE DRAGON PRINCE

WRITTEN BY

DEVON GIEHL

IAIN HENDRY

NEIL MUKHOPADHYAY

JUSTIN RICHMOND

INTRODUCTION BY

AARON EHASZ AND

JUSTIN RICHMOND

DARK HORSE BOOKS

PRESIDENT AND PUBLISHER
Mike Richardson

EDITOR
Rachel Roberts

ASSISTANT EDITOR
Jenny Blenk

DESIGNER
Sarah Terry

DIGITAL ART TECHNICIAN
Ann Gray

Special thanks to Justin Santistevan at Wonderstorm
and Tina Alessi and Lia Ribacchi at Dark Horse Books.

Neil Hankerson Executive Vice President • **Tom Weddle** Chief Financial Officer
• **Randy Stradley** Vice President of Publishing • **Nick McWhorter** Chief Business
Development Officer • **Dale LaFountain** Chief Information Officer • **Matt Parkinson**
Vice President of Marketing • **Vanessa Todd-Holmes** Vice President of Production
and Scheduling • **Mark Bernardi** Vice President of Book Trade and Digital Sales
• **Ken Lizzi** General Counsel • **Dave Marshall** Editor in Chief • **Davey Estrada**
Editorial Director • **Chris Warner** Senior Books Editor • **Cary Grazzini** Director
of Specialty Projects • **Lia Ribacchi** Art Director • **Matt Dryer** Director of Digital
Art and Prepress • **Michael Gombos** Senior Director of Licensed Publications •
Kari Yadro Director of Custom Programs • **Kari Torson** Director of International
Licensing • **Sean Brice** Director of Trade Sales

Published by Dark Horse Books
A division of Dark Horse Comics LLC
10956 SE Main Street | Milwaukie, OR 97222

DarkHorse.com | Wonderstorm.net

First Edition: August 2020
eBOOK ISBN: 978-1-50671-780-7
ISBN: 978-1-50671-778-4

10 9 8 7 6 5 4 3 2 1
Printed in China

THE

DRAGON
PRINCE™

CREATED BY

AARON EHASZ AND
JUSTIN RICHMOND

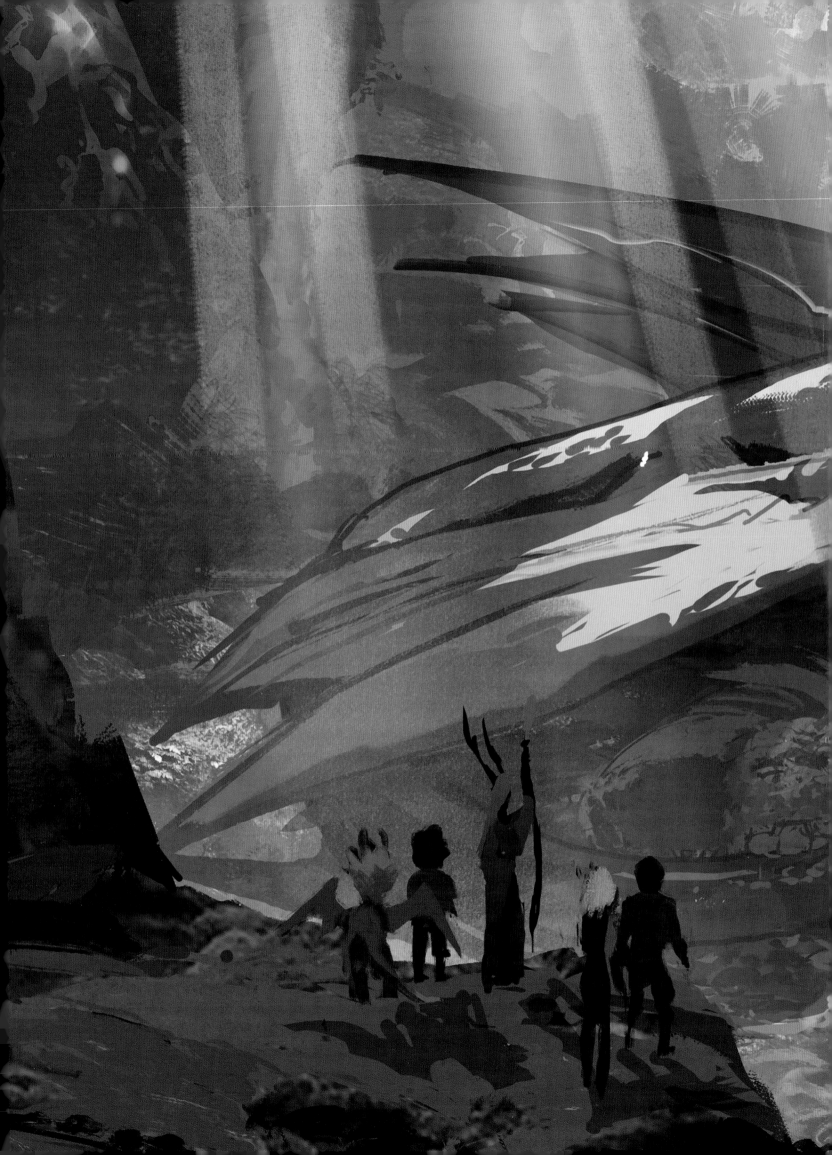

INTRODUCTION

⊥⊢

BY AARON EHASZ AND JUSTIN RICHMOND

It was late summer of 2015 and Wonderstorm had just moved into its first office, a 200-square-foot room that we were overly excited to discover came with a rusty table and some beat-up chairs. We tacked some black poster board up to the wall—a place to collect all our ideas. Aaron smiled, opened a fresh pack of colored index cards, pulled one out—a purple card, to be exact—and wrote the words "Dark Magic" in black marker. Then with a flourish, he pinned it to the board . . . The beginning of what would become *The Dragon Prince*!

Now, five years later, it's hard to believe how far the saga has come. Three seasons of a TV show (so far), a video game deep in development, and so much more we haven't even talked about yet. None of that would have happened if it had remained a few people in that room. We have been lucky enough to have a huge number of amazing people join us on this journey—people who took a chance on a tiny team with big ambitions and turned that single index card into so much more.

At Wonderstorm, we believe in visionary teams. Each person has a role and distinct responsibilities, but all are invited and expected to be a part of the creative vision together. From our writing team to our artists, designers, and engineers, everyone has grown the

vision of *The Dragon Prince* into something far bigger than ourselves.

Wonderstorm has had the great fortune to find tremendous partners. The first is the team at Netflix, who saw our pitch and said, "Let's do it," and then afforded us the creative freedom to build this saga. Our next essential partners have been the team at MWM, who looked at our startup, saw the potential, and took the leap with us. Their support has helped turn our dreams for Wonderstorm into realities.

Our journey to build this saga really came to life when we found our partners at Bardel, *The Dragon Prince*'s animation studio. A chance meeting in our tiny office turned into one of the best creative experiences imaginable. The entire crew at Bardel puts so much heart and soul into *The Dragon Prince* that you can feel it in every frame. The book you are holding is full of their work, and even this is just a glimpse at everything they've done to bring the world of *The Dragon Prince* to life. I can't tell you how many times we were reviewing designs or animation and found ourselves getting emotional—stunned and inspired by the artists' work.

We also want to thank you, the fans, because without you all, none of this would matter. You drive us to keep making *The Dragon Prince* better than it was the day before, to keep pushing the world and characters forward. The community that has grown around *The Dragon Prince* is full of creative and inspiring voices. Perhaps that's a story for another book! We have the best fans in the world, and we are so excited to give you a small taste of what it was like developing the show.

Also, a huge thank-you to Dark Horse, without whom all this amazing art would still just be files on a computer instead of being shared with an audience that deserves to see how we got here.

So enjoy! We hope you like this backstage pass to the world of Xadia, and we hope you have as much fun reading this as we did making it.

Aaron Justin

EARLY DEVELOPMENT

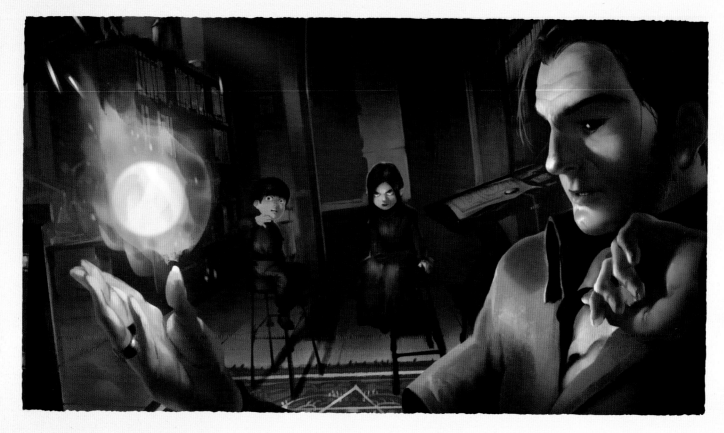

THE SPARK

THE VERY FIRST story sketch that became *The Dragon Prince* is five short pages. In it, a father lectures his children on the magical arts. He tells them the bitter tale of humanity's history: born without magic, left to suffer and struggle while elves and dragons turned their backs on their plight.

But humans discovered another path. They learned how to harness the innate magic inside of creatures themselves.

As his children look on, the father reaches for a bell jar containing a spider and lets the creature crawl onto his hand and up his arm. The abdomen of the spider glows like

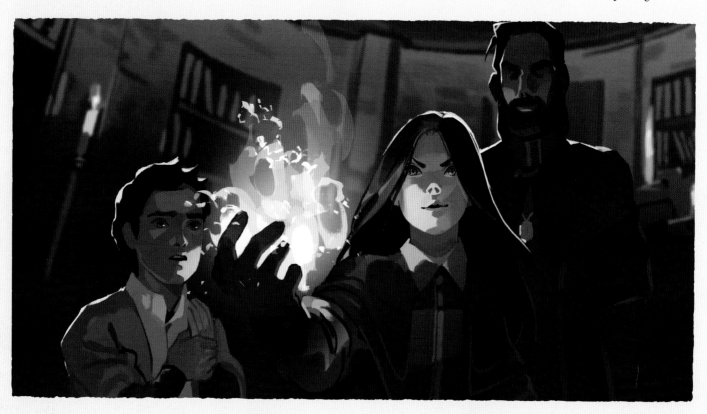

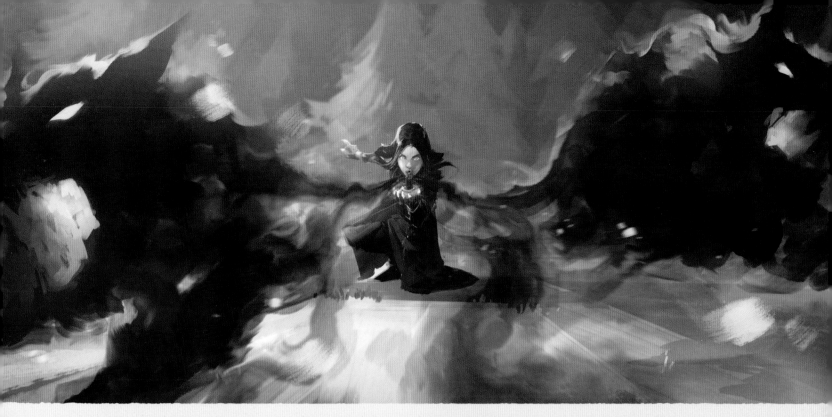

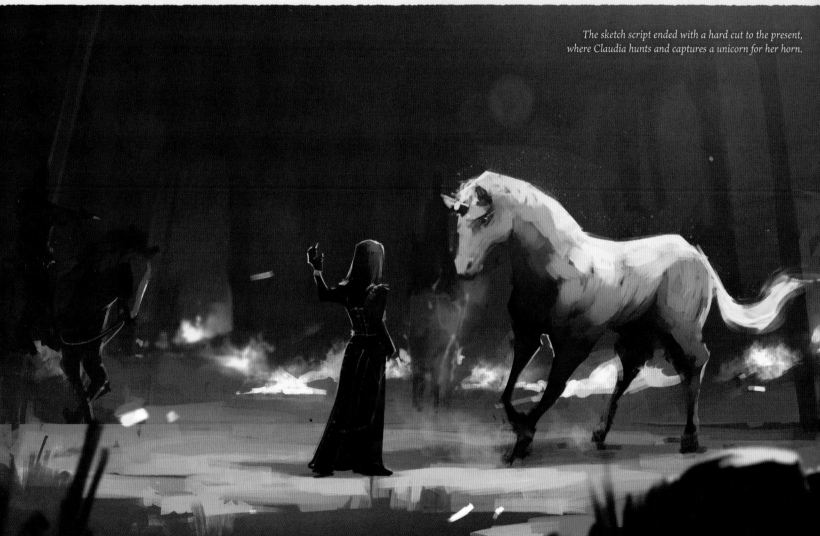

a flame. This is an emberback spider, he explains; so small a thing—but so full of magical power.

The father crushes the spider in his hand and a fireball leaps to life in his palm. His son, who would later be named Soren, recoils. But his daughter Claudia's eyes widen, transfixed. This is dark magic, the father explains. He is not yet named.

Dark magic was the spark that grew into the world of *The Dragon Prince*, a place where magic is extraordinarily difficult—if not impossible—for humans, except for a grisly shortcut. That shortcut and the power struggle it creates set the stage for the two sides of a continent-spanning conflict, and the three main characters caught on opposite sides of it.

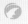

heroes

RAYLA, CALLUM, AND EZRAN are the heroic trio who look past their complicated and violent history and work instead for peace. But before our main characters even had names, we explored their dynamic through a concept we thought of as tri-fold strength: head, hand, and heart; mind, body, and spirit.

Exploring the trio's individual strengths also illuminated individual weaknesses: an elven assassin who is capable of extreme feats of strength and skill, but struggles with softer emotions and expression; an artist with a perfect memory and witty intellect, but zero martial prowess to speak of; finally, a prince small of body and young of mind, but with a depth of empathy that allows him to communicate beyond his own species.

Alone, their shortcomings might be their undoing, but together they make a powerful team.

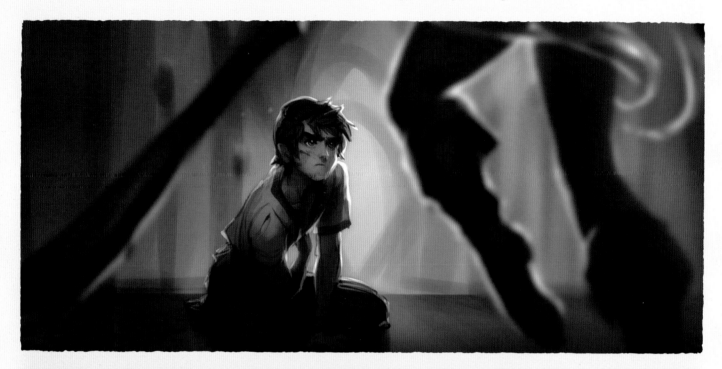

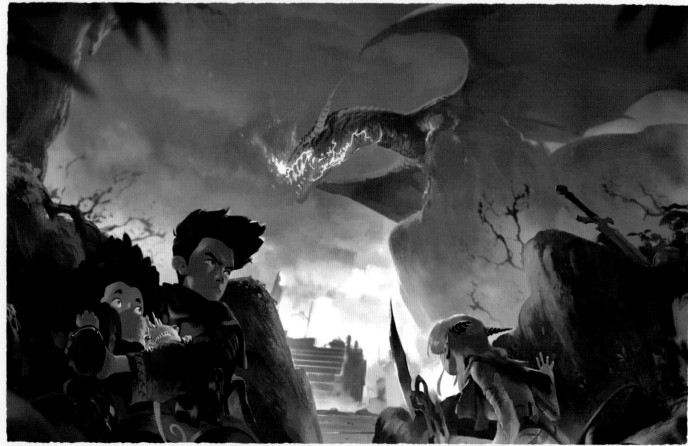

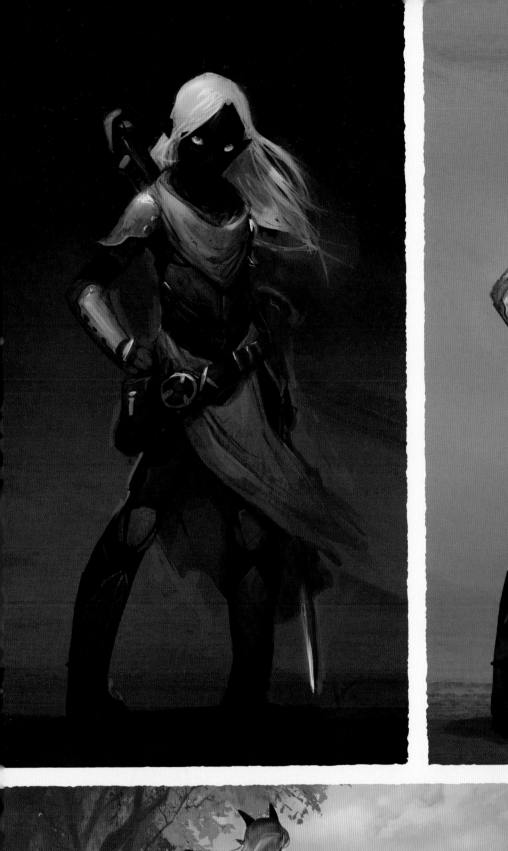
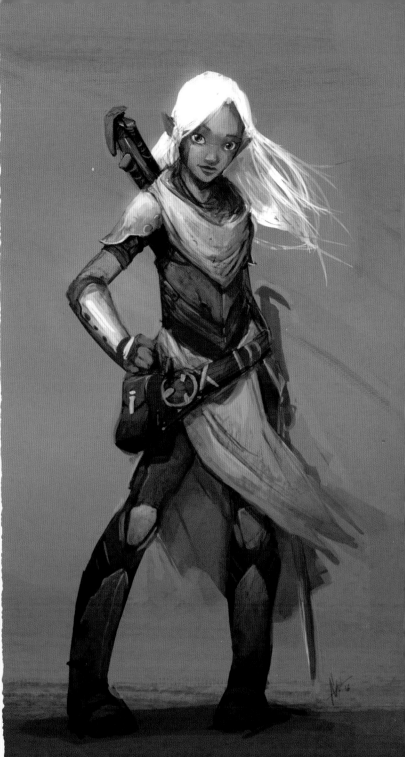
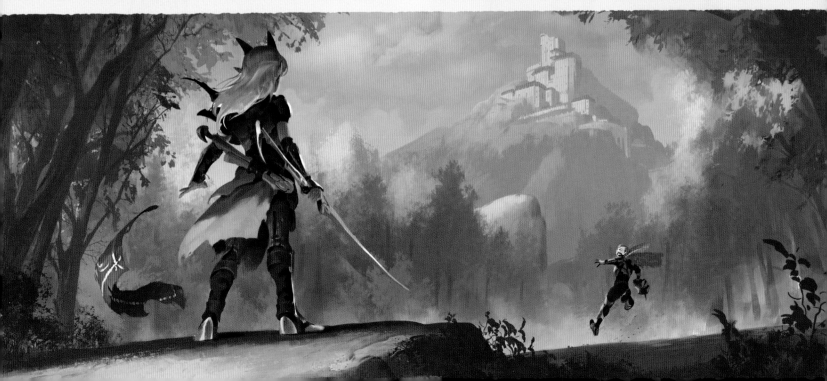

VILLAINS

THE FATHER TEACHING his children dark magic in the sketch script would eventually be named Viren. As the series' central villain, he received some of the most careful attention during early development. Viren needed to be much more than just the "evil royal advisor." Early descriptions frame him as truly and wholly loyal to his best friend, the king, and willing to sacrifice anything to further the power of humanity.

Sacrifice became a core theme for Viren. His "true form," in which he is frighteningly corpse-like and corrupted by dark magic, is a representation of both his twisted nature and his self-destructive dedication to the elevation of humanity.

In their very earliest conception, Soren and Claudia were one character, a son who learned dark magic from his father. This son was later split into two characters—one child in Viren's shadow, and the other his prodigy.

But once they were "split," Soren and Claudia quickly became more than creepy siblings. They sprang to life in concept art almost fully formed, changing very little from their very first paintings (despite a brief detour in which Soren had black hair and a more intense demeanor).

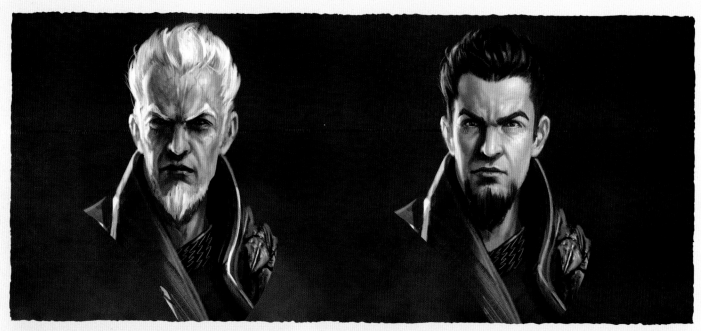

THE CRASHED DRAGON

SOMETIME IN EARLY 2016, the writing team sat around a table at a Santa Monica coffee shop and mulled over a thorny question for a children's show: if our trio comes from two sides of a war, what does that war look like? How do we show it?

"Dragons attacking border towns," someone said. "Raining fire from the sky. Like *Grave of the Fireflies*!"

After a lot of pained oh nos and frantic hand-waving about just how devastating we wanted our tone to be, we circled back to something compelling: What would happen if three kids caught up in a war witnessed a fighter plane attacking a base, but then the plane was shot out of the sky? What would they do if the pilot survived, and it was up to the kids to either help him escape or leave him to be captured—or worse?

It was the type of story we wanted *The Dragon Prince* to tackle, relatable to real-world complexity with no clear right

or wrong, but approachable enough to engage a younger audience. It became our first real episode pitch: a dragon attacks a town but is shot down by a dark mage. Knowing their complicated experiences on both sides of the war, will our heroes fight to save the dragon, or leave it to its fate?

The seed of this story would eventually become the Book Two episode "Fire and Fury," but in its earliest form it was a fifteen-page test script loosely titled *The Crashed Dragon*.

The characters in *The Crashed Dragon* weren't quite the people they eventually became for the show. Callum was much more cautious with magic than he is (something that never would have worked with Jack De Sena's high-energy acting). Rayla was a bit cocky, lacking the self-doubt and hesitation she would eventually struggle with. Ezran, called "Findlay" at the time, barely spoke at all.

But they did have the qualities that formed the core of *The Dragon Prince* thematically: humor, heart, and an earnest belief in change. Though they knew the dragon's vicious attack was a small piece of a complex war, someone had to take the first step toward peace. Someone had to show her mercy.

When Callum, Rayla, and Ezran see the power of mercy, of forgiveness, of vulnerability, they realize that maybe, just maybe, they have the power to change everything.

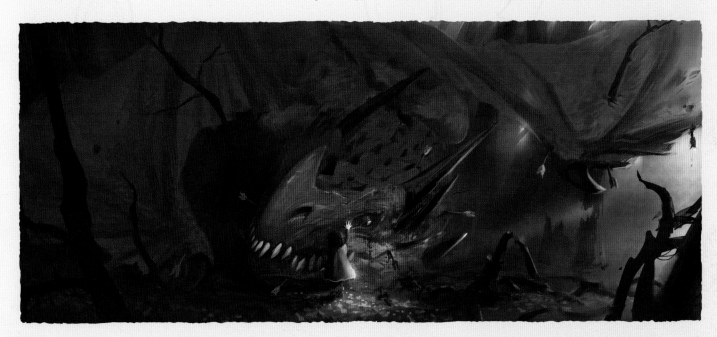

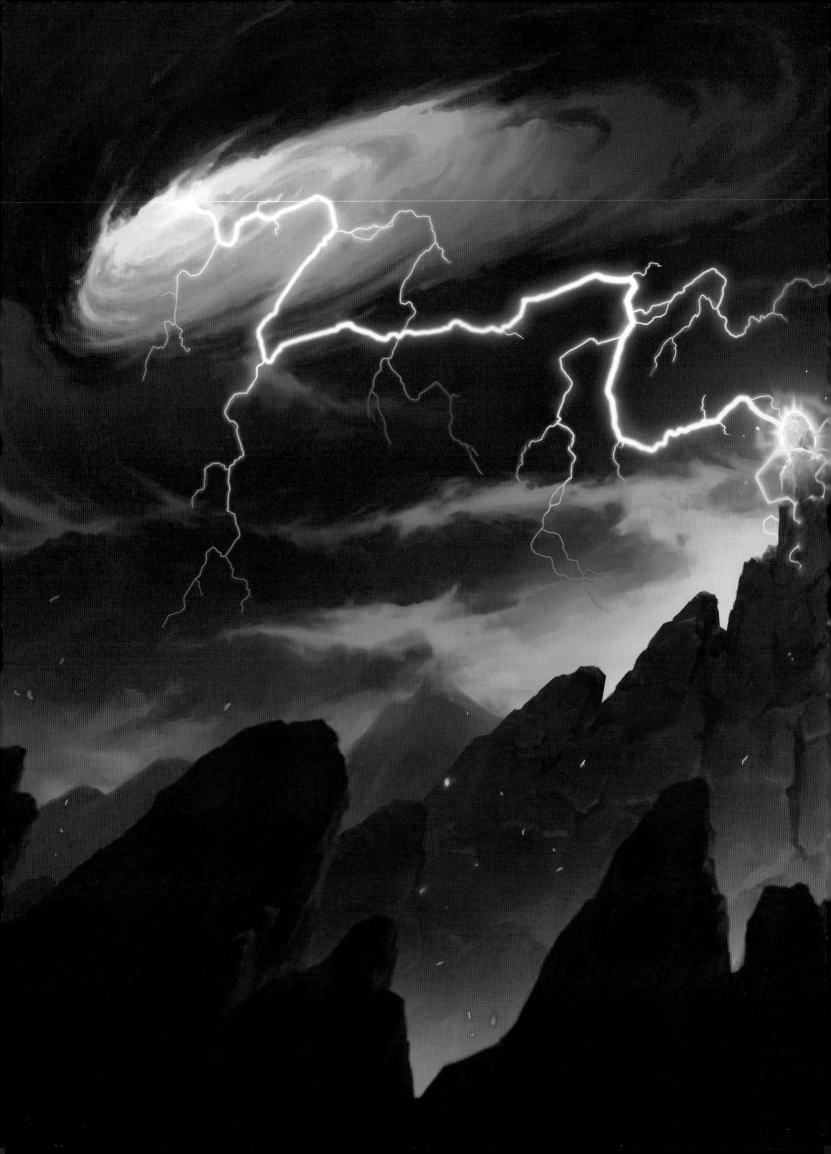

BOOK ONE

MOON

THE LAND OF XADIA has been divided by bloodshed between humans and magical creatures for centuries. The story of *The Dragon Prince* begins when a trio of unlikely allies uncovers a secret hidden in the human territories: the stolen egg of the Dragon King and Queen! Together they embark on a race to return the egg to the Dragon Queen before the world tears itself apart.

CALLUM

CALLUM IS THE stepson of King Harrow, but he's never felt like a real prince. He prefers art to swordplay, and he falls off nearly every horse he rides, but he keeps his head up knowing he's good at what matters: watching out for his little brother, Ezran. Nevertheless, Callum dreams of a different path: studying magic. But everyone knows humans can't be mages . . .

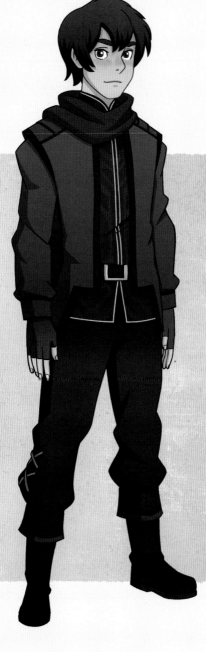

Callum's scarf combines design motifs from his mother's armor and the uneven towers of Katolis.

Even ceremonial armor can't help Callum fit in as a prince. Some designs made him look a little too cool–this armor had to be clunky and awkward.

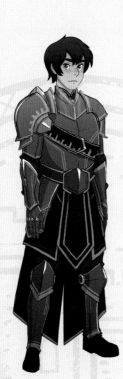

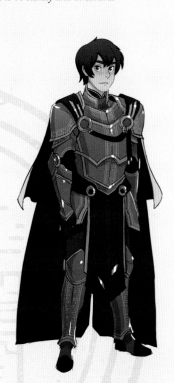

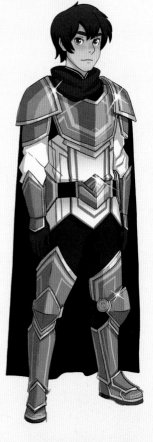

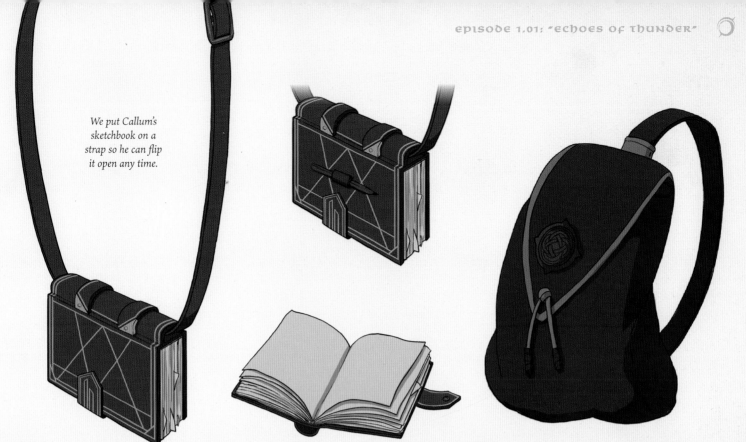

We put Callum's sketchbook on a strap so he can flip it open any time.

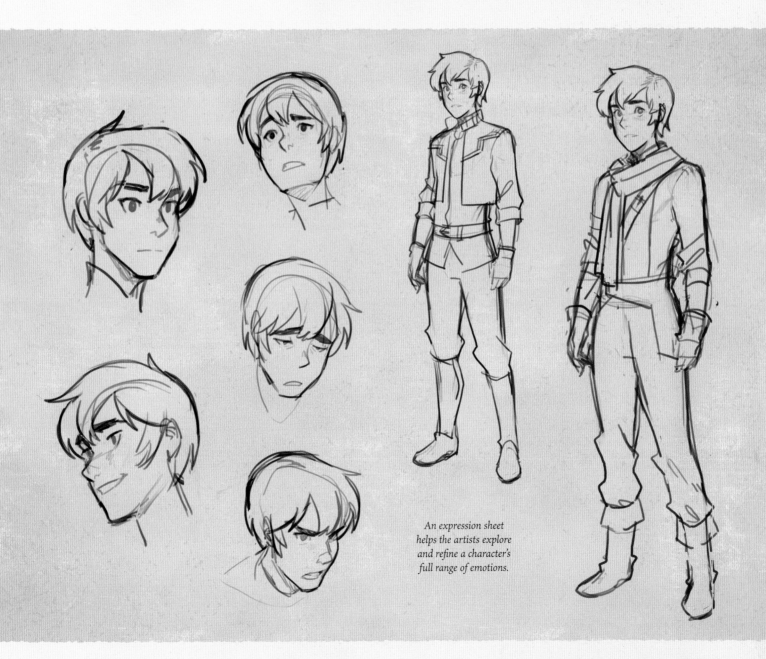

An expression sheet helps the artists explore and refine a character's full range of emotions.

EZRAN

THE WEIGHT OF ruling a kingdom on the brink of war will one day rest on Prince Ezran's tiny shoulders, but his endless, big-hearted optimism makes him ready to take on everything from dragons and rebellions to overprotective bakers (with the help of his glow toad Bait, of course).

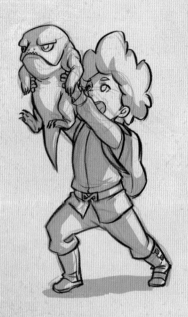

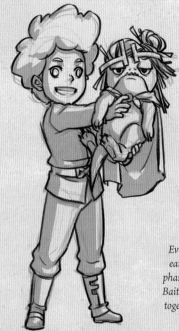
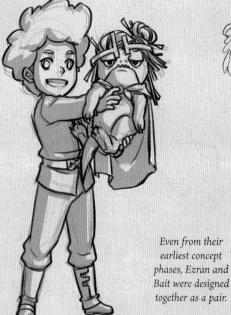

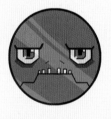

Even from their earliest concept phases, Ezran and Bait were designed together as a pair.

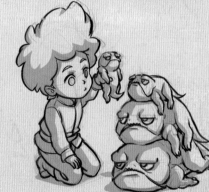

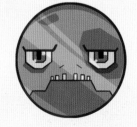

Close inspection of Ezran's bag reveals patches and pins of his favorite things. He's working on finding a jelly tart patch.

BAIT

YOU'D THINK A creature called a "glow toad" might have a more sunny disposition, but Bait is all grump all the time. Why? Because glow toads are notoriously delicious! If everything wanted to gobble you up, you'd be grumpy too.

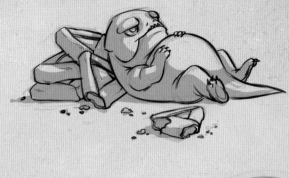

Bait's expression sheet explored just how many kinds of grumpy our glow toad could achieve.

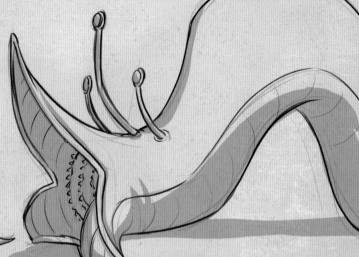

Angry and grumpy

Sad and grumpy

Embarrassed and grumpy

Sleepy and grumpy

Stressed and grumpy

Jealous and grumpy

Regular grumpy

In early development, Bait was described as a "living, mostly grumpy mood ring."

Happy and grumpy

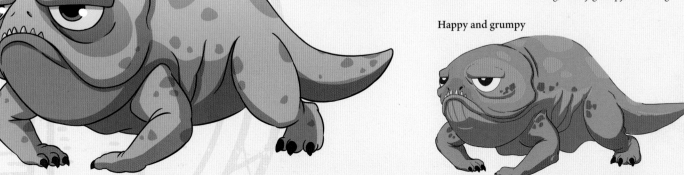

RAYLA

RAYLA COULD BE the fastest, strongest, most talented Moonshadow elf assassin of her generation, but there's just one minor problem: she's never actually taken a life. She sets out to prove herself, but Rayla's empathy for "the enemy" leads her to discover her true purpose, one that might just save the world from all-out war.

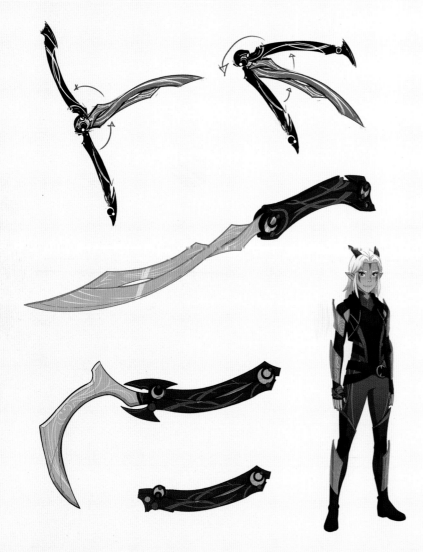

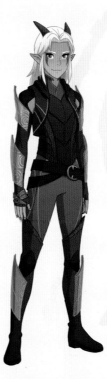

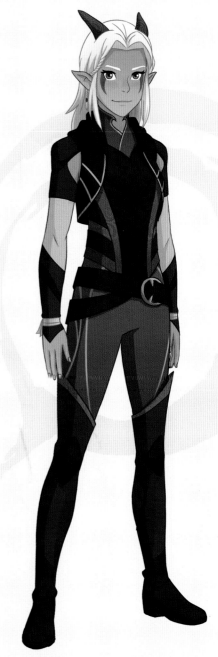

Rayla's transforming butterfly blades allow her to be even more resourceful, adaptable, and deadly.

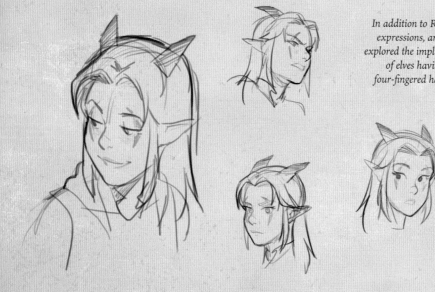

In addition to Rayla's expressions, artists explored the implications of elves having four-fingered hands.

SHORTER

VERY SIMILAR IN SIZE

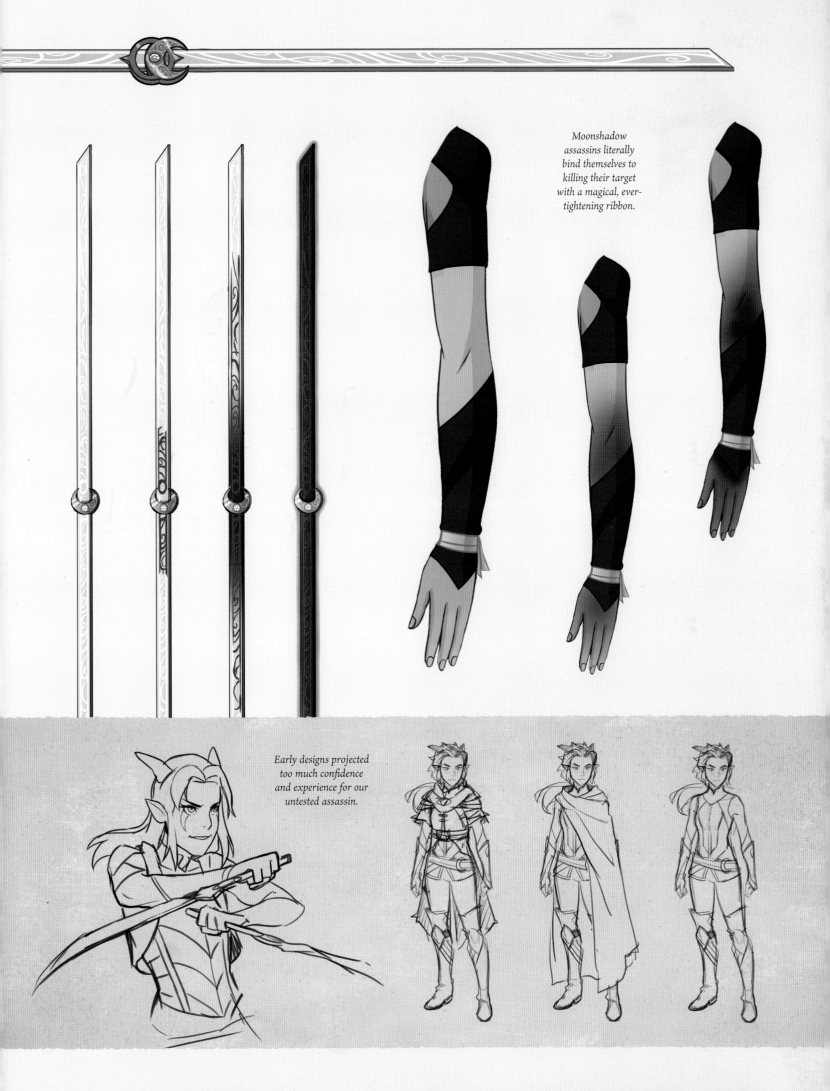

Moonshadow assassins literally bind themselves to killing their target with a magical, ever-tightening ribbon.

Early designs projected too much confidence and experience for our untested assassin.

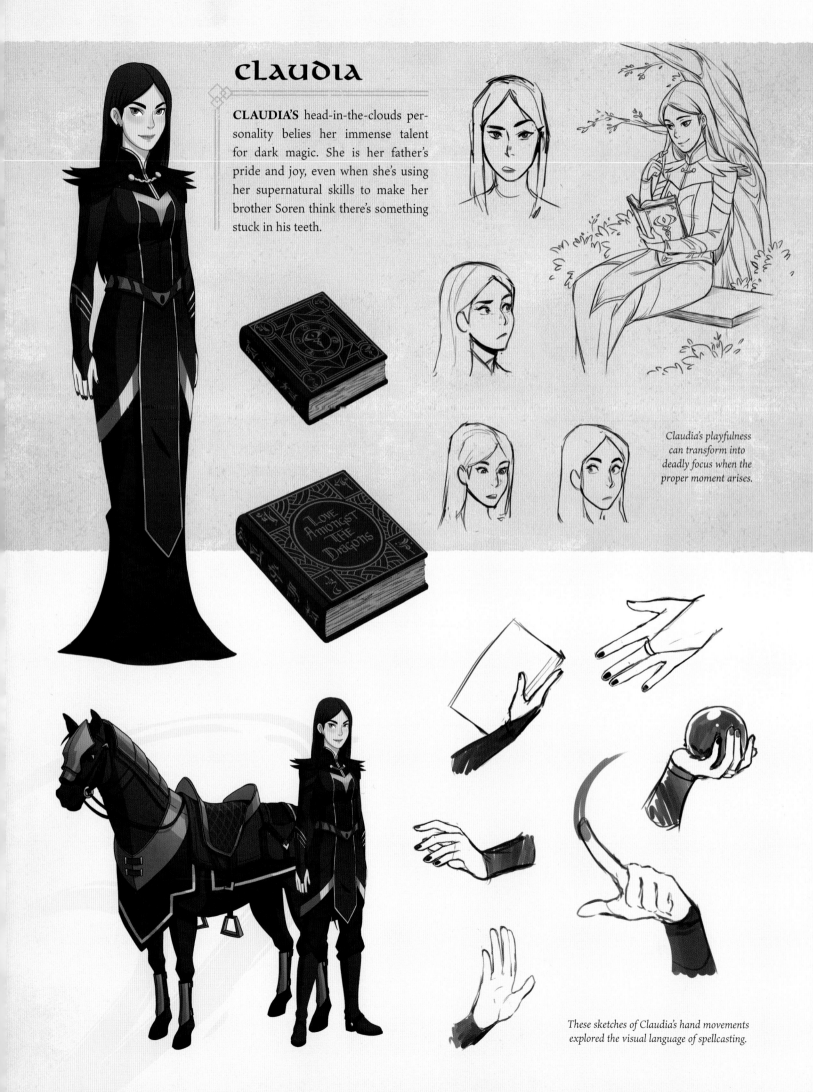

CLAUDIA

CLAUDIA'S head-in-the-clouds personality belies her immense talent for dark magic. She is her father's pride and joy, even when she's using her supernatural skills to make her brother Soren think there's something stuck in his teeth.

Claudia's playfulness can transform into deadly focus when the proper moment arises.

These sketches of Claudia's hand movements explored the visual language of spellcasting.

SOREN

SOREN'S SKILL IN swordsmanship is equaled only by his ego. He's the youngest warrior ever named to the Crownguard, the king's elite defenders. But deep, deep beneath the muscles and bluster, Soren hides a big heart and a desire to do the right thing.

With Soren's expressions, artists sought a balance of "sneering bully" and "loveable doof."

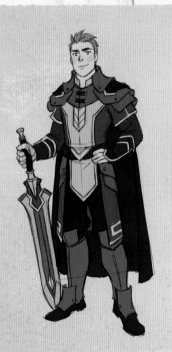

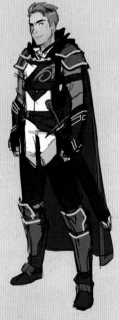

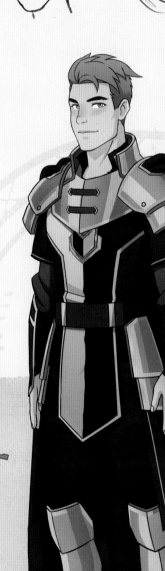

VIREN

AS KING HARROW'S closest advisor and lifelong friend, Viren serves as High Mage of Katolis. Viren's skill as a dark mage allows for creative solutions to difficult problems, but the hidden costs of his magic have begun to erode Harrow's trust in him.

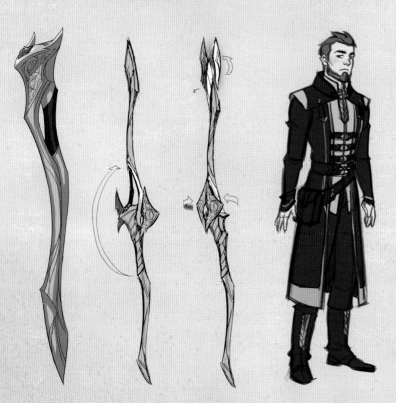
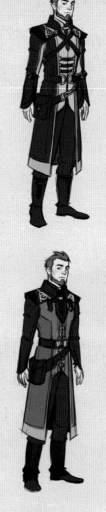
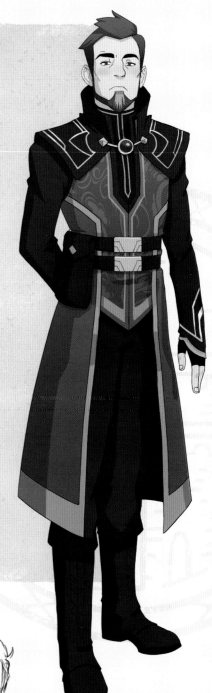

Viren's expressions demonstrate exactly how out of patience he is with . . . well, everyone (but mostly Soren).

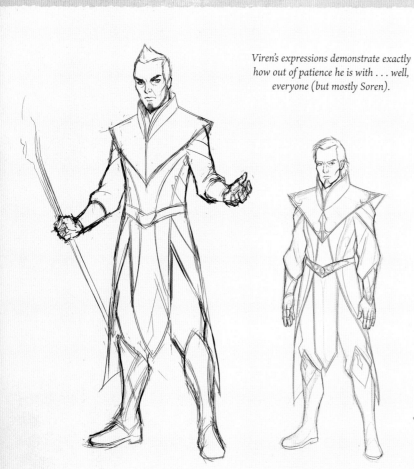
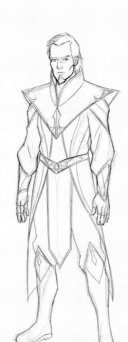
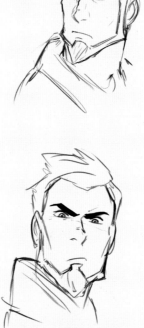
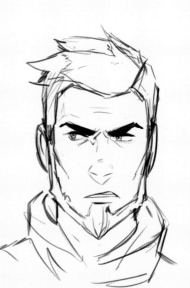

HARROW

WHEN HE TOOK the crown, Harrow swore to be a "servant king" and rule with care and compassion for all the people of Katolis. However, his reign has not been easy, and a history of sacrifice and bloodshed weighs heavily on his heart.

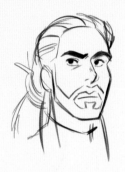

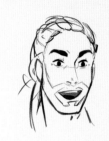

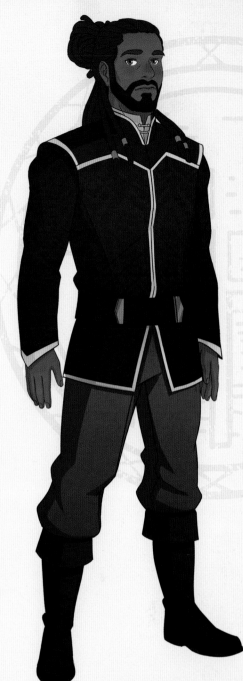

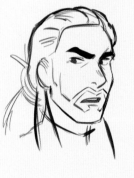

We see Harrow's emotional range in these early episodes: pensive, burdened, angry, telling bad jokes.

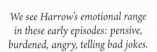

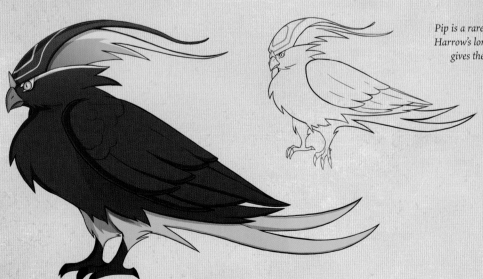

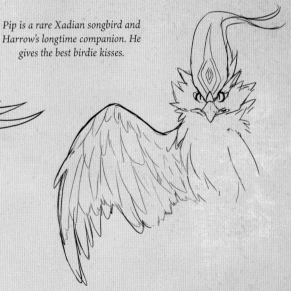

Pip is a rare Xadian songbird and Harrow's longtime companion. He gives the best birdie kisses.

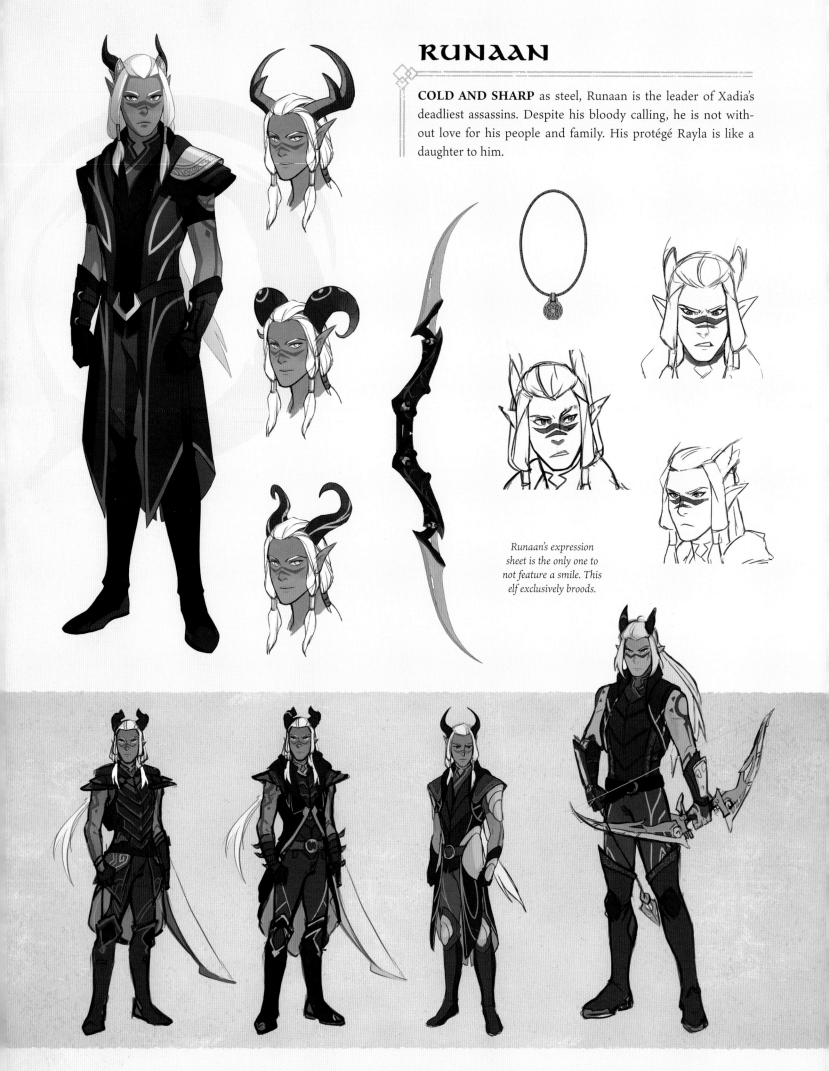

RUNAAN

COLD AND SHARP as steel, Runaan is the leader of Xadia's deadliest assassins. Despite his bloody calling, he is not without love for his people and family. His protégé Rayla is like a daughter to him.

Runaan's expression sheet is the only one to not feature a smile. This elf exclusively broods.

BARIUS THE BAKER

MUCH LIKE HIS signature jelly tarts, Barius the baker is crusty on the outside, but warm, soft, and gooey on the inside.

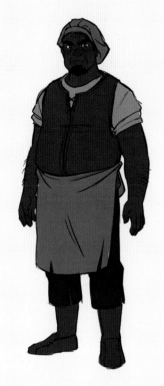
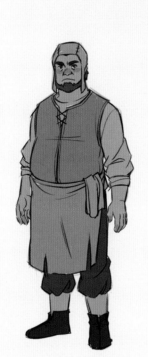

The longtime favorite snack of Katolis's royal family is based on the real-life hamantaschen pastry.

CITIZENS

THE DIVERSITY IN Katolis needed to go deeper than just the main cast. The citizens represent the kingdom's many skin tones, body types, and ages. Later episodes called for background couples, many of which are same-gender or interracial.

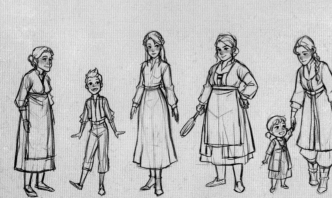

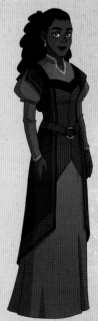

SPOTLIGHT

CREATURES OF XADIA

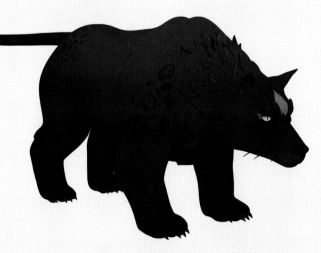

efore the conflict between humans and magic-connected creatures tore Xadia in two, all living animals existed together in harmony. An impassable river of lava now separates the land, but as our characters journey across much of the continent, they come into contact with animals of all kinds.

On the human side, we see many of the same landscapes that are common in Earth's Northern Hemisphere: verdant broadleaf forests, snowy mountain peaks, and river plains. Familiar squirrels, birds, and insects make their home in such places just as they do in real life. Closer to the Border we start to see some of the more fantastic inhabitants of Xadia.

We wanted Xadian creatures to feel in tone with grounded fantasy—unique and magical, but still believable. We often combined existing mythic archetypes with real-world creatures, taking care to make sure they always had a new twist, like a vibrant color pattern or a tasteful number of unexpected new appendages.

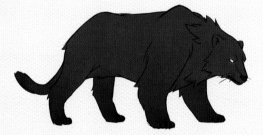

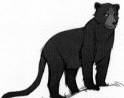

Banthers have the hulking body of a bear and the feline features of a panther. It just so happens that bears and panthers haunted the childhood dreams of some of the series creators, but in The Dragon Prince, these peaceful beasts won't attack unless provoked.

Traditional fantasy griffons are often depicted with the head and wings of an eagle and the body of a lion. We thought using an owl instead of an eagle would make for a wiser and more thoughtful being–certainly one that might have more patience for these adorable owl griffon cubs. Or is it chicks?

"The Battle of the Dragon and the Marshmallow Monster" is the first ever showcase of Callum's drawing style and talent.

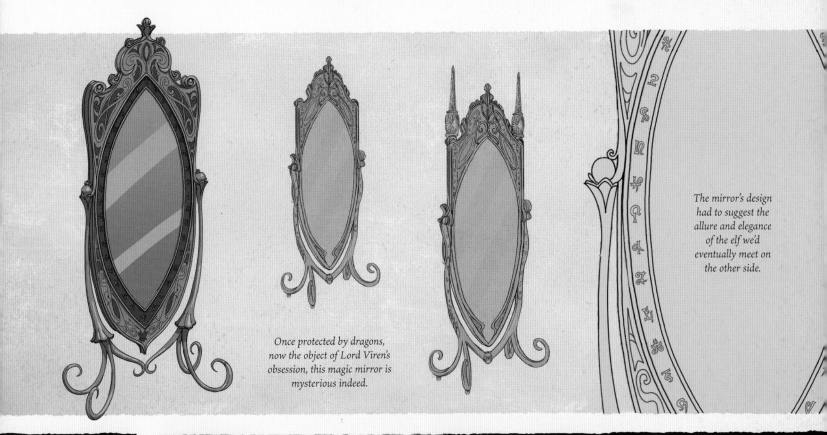

Once protected by dragons, now the object of Lord Viren's obsession, this magic mirror is mysterious indeed.

The mirror's design had to suggest the allure and elegance of the elf we'd eventually meet on the other side.

PRIMAL STONE

A PRIMAL STONE is a rare magical arti-fact that gives a mage access to primal magic anywhere, at any time. Callum's primal stone allows him to cast Sky magic even as a human.

The two-headed soulfang serpent, a rare creature and the key part of Viren's plan to save Harrow.

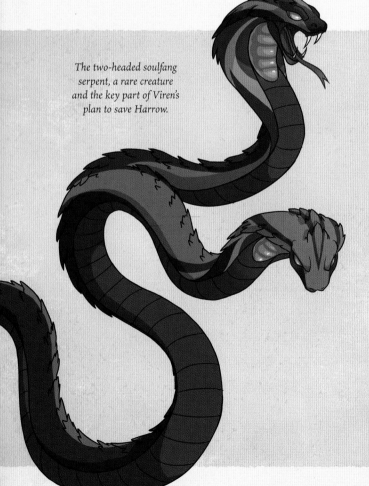

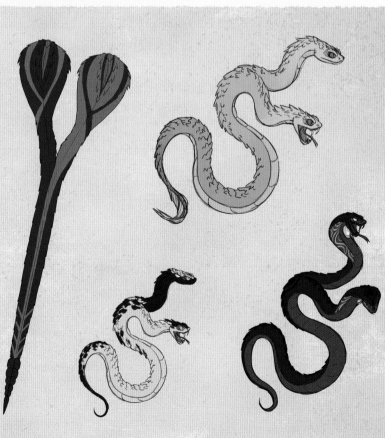

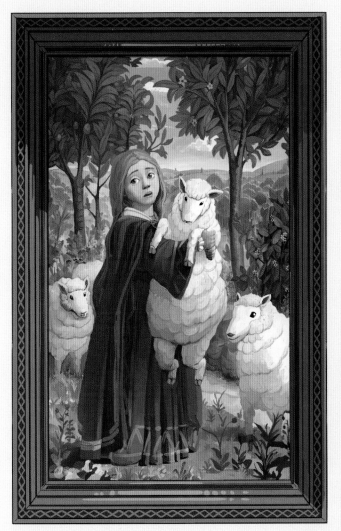

The "sheep girl painting" was initially a silly placeholder in the storyboards, but became permanent during production.

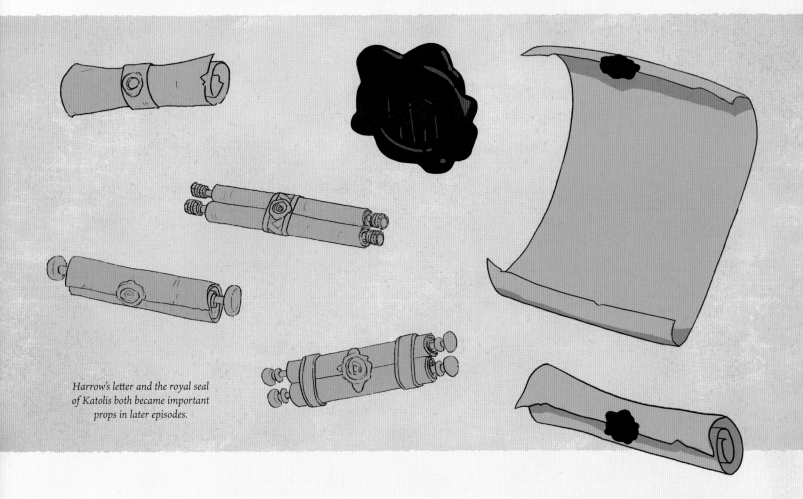

Harrow's letter and the royal seal of Katolis both became important props in later episodes.

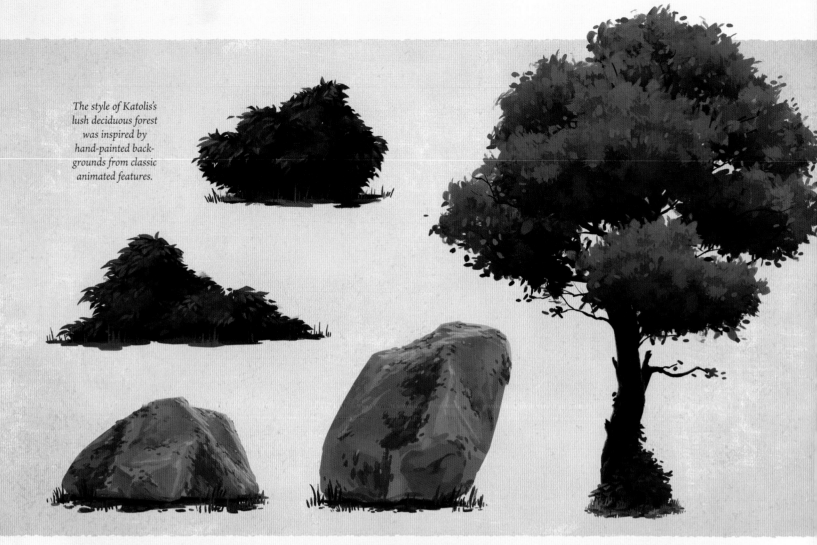

The style of Katolis's lush deciduous forest was inspired by hand-painted backgrounds from classic animated features.

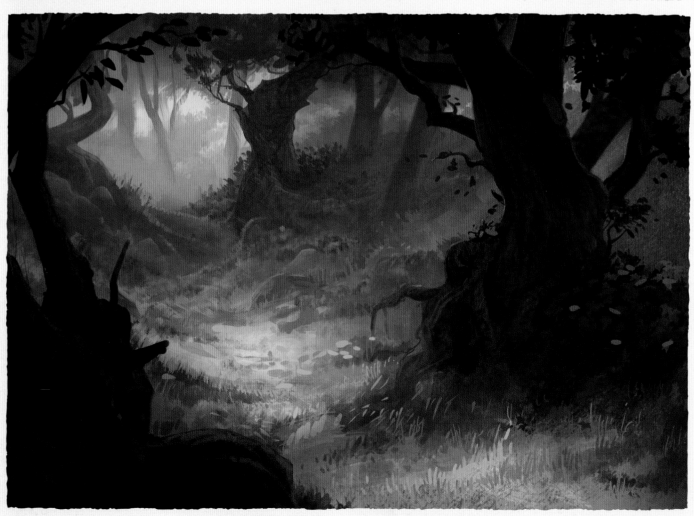

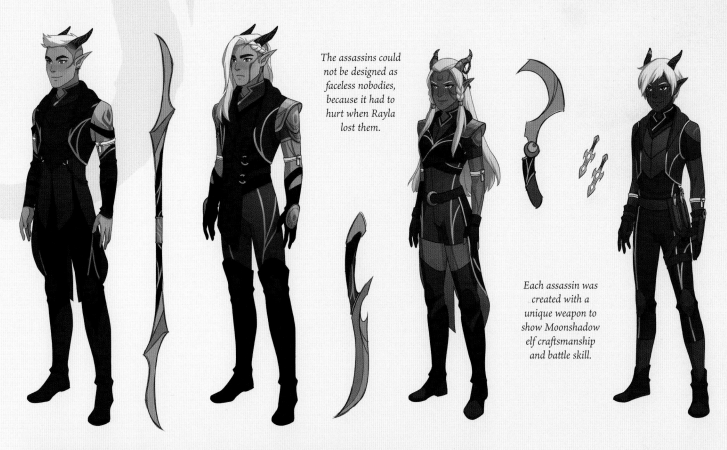

The assassins could not be designed as faceless nobodies, because it had to hurt when Rayla lost them.

Each assassin was created with a unique weapon to show Moonshadow elf craftsmanship and battle skill.

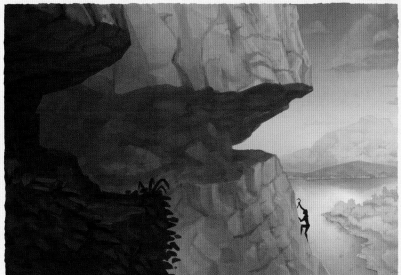

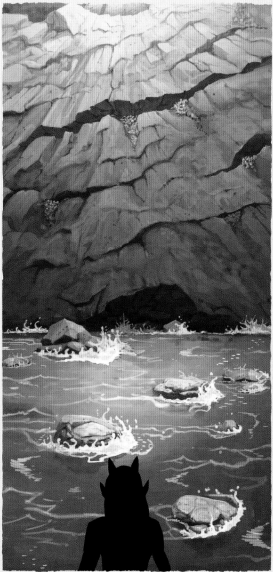

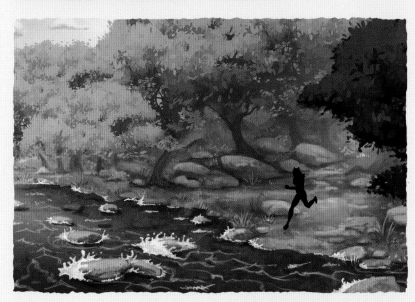

Rayla's journey through the forest, across the river, and up the sheer cliffs of Katolis pushed the show's cinematic scale to greater heights.

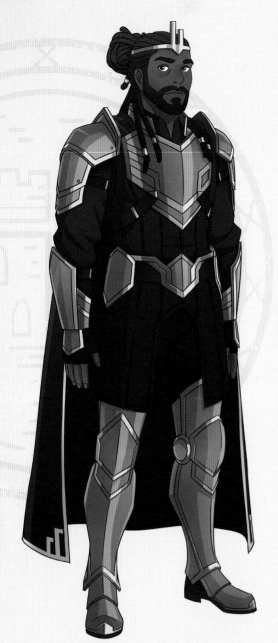

ARMORED HARROW

THOUGH HARROW IS a thoughtful ruler and a warm father, he becomes an imposing warrior king when he dons his battle armor.

Early armor designs tried to find a balance between regality and function. The crown's design, too, was later simplified.

MOONSHADOW FORM

MOONSHADOW ELF ASSASSINS have the power to become nearly invisible under the light of a full moon. Under the moonlight, a trained assassin can infiltrate any defenses and eliminate their target with perfect stealth. If not for Rayla's "mistake," which gave Katolis time to prepare for the assassins' attack, King Harrow might have died before anyone realized he was in any danger.

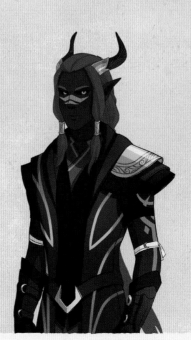

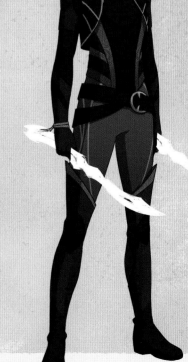

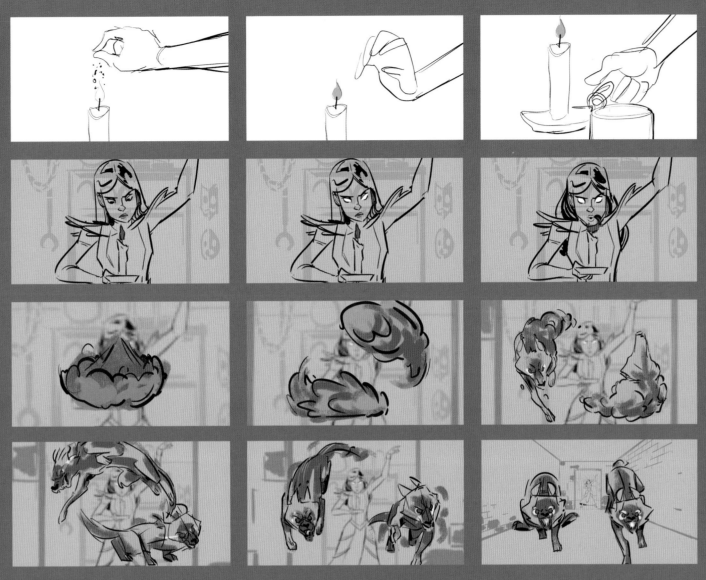

In the first showcase of dark magic's terrifying potential, Claudia summons magic wolves with a phoenix blood candle and wolves' ashes.

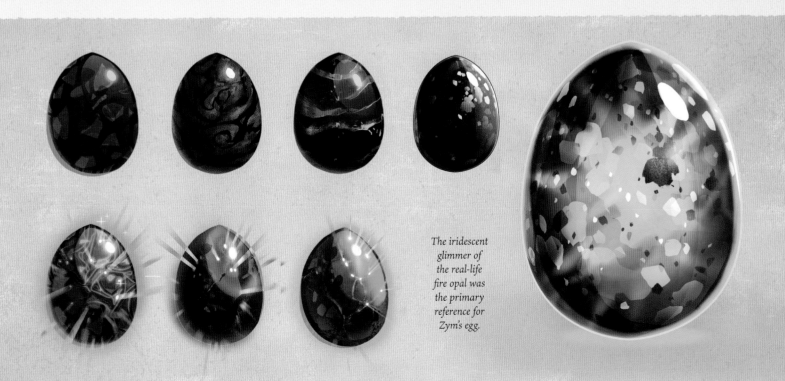

The iridescent glimmer of the real-life fire opal was the primary reference for Zym's egg.

Viren's dungeon is filled with a spooky harvest from his journeys through Xadia. There are plenty of dark magic details scattered throughout.

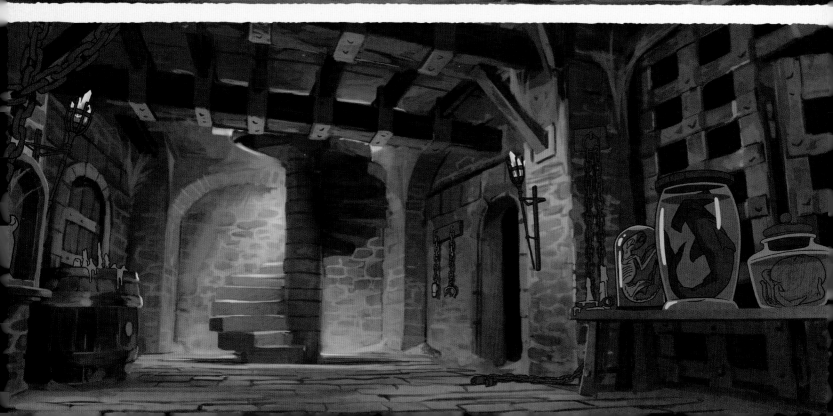

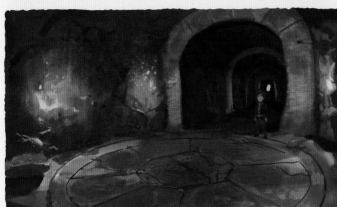

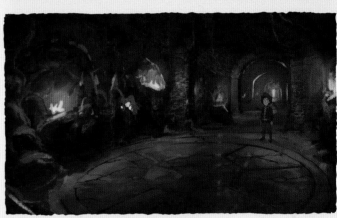

Though Katolis Castle is made of stone, the use of warm tones reflects the royal family's personality.

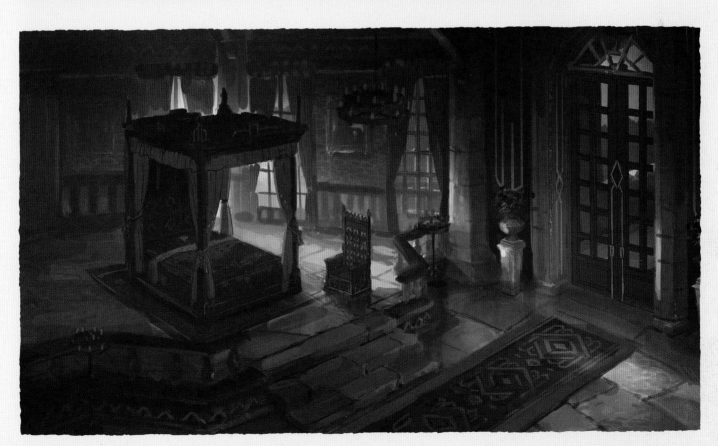

For the audience, Harrow and Viren's relationship begins near its end. This painting needed to show that things between them had once been warmer.

Even these standard-issue crossbows bear the motifs seen elsewhere in Katolis.

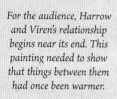

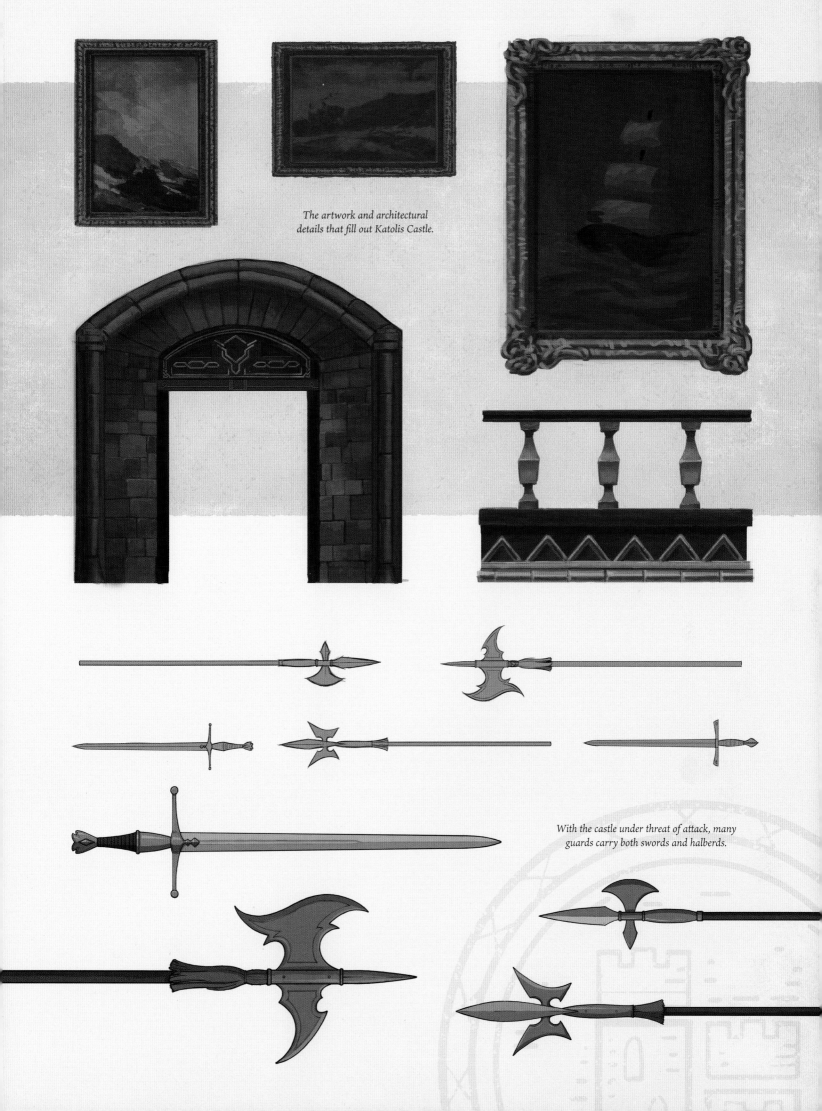

The artwork and architectural details that fill out Katolis Castle.

With the castle under threat of attack, many guards carry both swords and halberds.

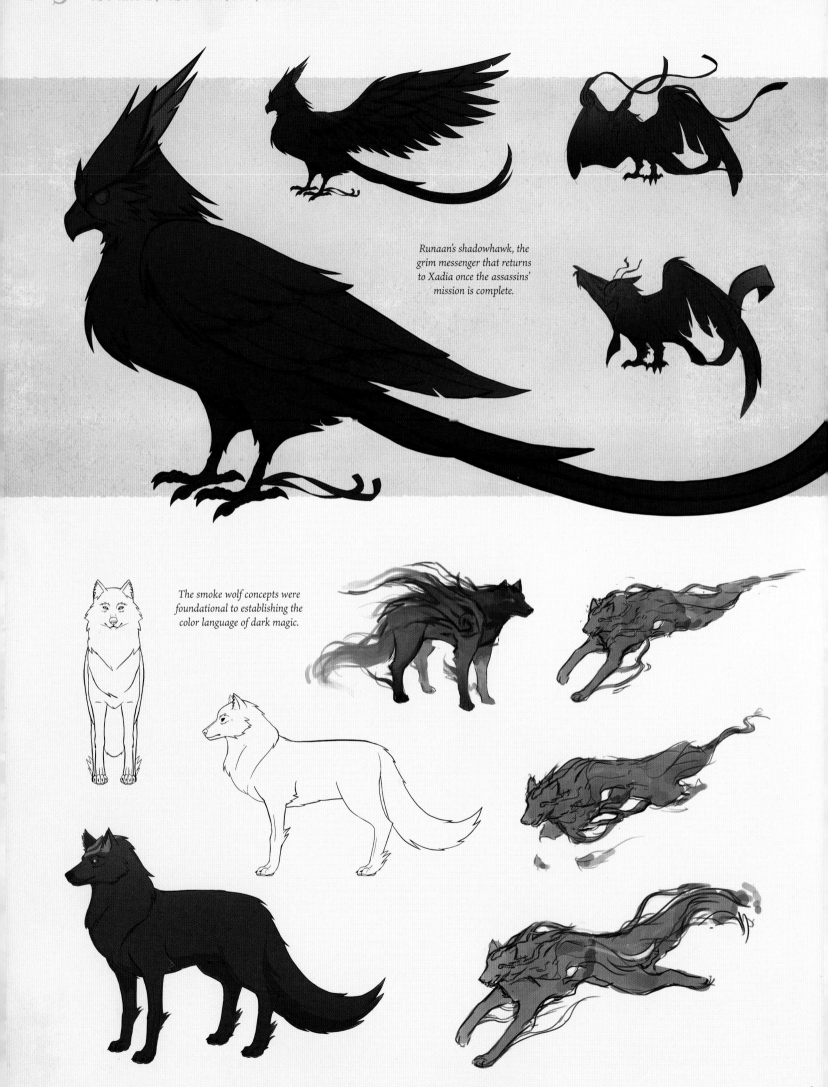

Runaan's shadowhawk, the grim messenger that returns to Xadia once the assassins' mission is complete.

The smoke wolf concepts were foundational to establishing the color language of dark magic.

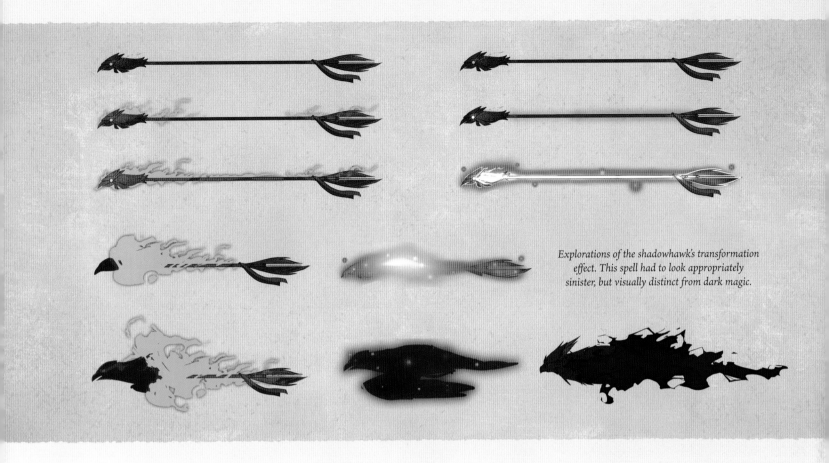

Explorations of the shadowhawk's transformation effect. This spell had to look appropriately sinister, but visually distinct from dark magic.

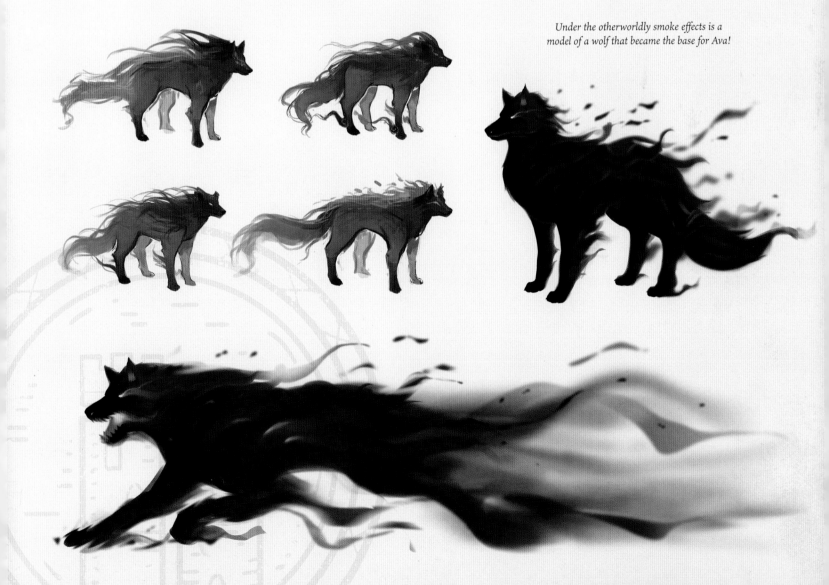

Under the otherworldly smoke effects is a model of a wolf that became the base for Ava!

AMAYA

ONE OF THE highest-ranking generals in the army of Katolis, Amaya is both an immovable object and an unstoppable force. Her battalion could never put their trust in any other leader, for her iron will and ferocity in battle are unmatched. Amaya has harbored a burning hatred for Xadia ever since her sister, Queen Sarai, was killed by the Dragon King.

We explored a wide range of "tough military aunt" hair styles and colors.

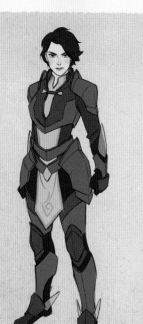

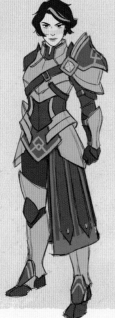

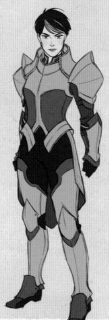

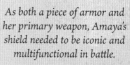

As both a piece of armor and her primary weapon, Amaya's shield needed to be iconic and multifunctional in battle.

SPOTLIGHT

AMAYA'S SIGN LANGUAGE

General Amaya is a tough, inspiring leader and a protective, loving aunt. She's also deaf, and bringing the way she communicates with the world into an animated series proved to be a unique challenge.

We began with research, diving into resources provided by Deaf and Hard of Hearing organizations and community groups, and consulting with several experts. In order to help the directors present the speaker/interpreter relationship, we looked into depictions of deaf characters in live-action shows. We had to be sure to establish the dynamic between Amaya and Gren without ever sacrificing the focus on Amaya herself.

Next, we worked with professional interpreters to translate Amaya's lines into American Sign Language, including the creation of signs for character names and in-world concepts like Moonshadow elves. With this translation, we'd film the interpreter signing each line from multiple angles. The animatic editors would overlay the video footage onto the storyboards for timing, while the animators would reference the footage for accuracy. As work progressed, we would show early versions of scenes to ASL speakers to provide feedback and help fine-tune.

When the series was released, Amaya quickly became a fan-favorite character, but there was definitely room to improve. We heard that the animation style could make some of Amaya's motions hard to read, and that her dark gloves often made signs difficult to make out against the background or her armor. We continued to refine the process for subsequent seasons, smoothing out the animation and switching her gloves out for a paler tan color. And through it all, we never, ever skipped breakfast.

GREN

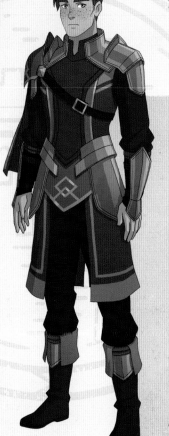

GREN WAS INITIALLY envisioned to be comic relief to the more serious Amaya, but when he became her interpreter, his role expanded along with the tousleability of his strawberry-blond hair.

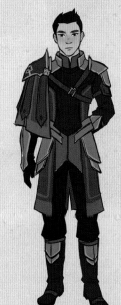

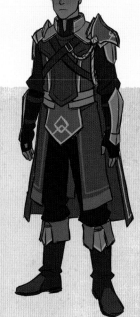

This design (left) later became the basis for Marcos.

CORVUS

CORVUS IS AMAYA'S go-to soldier when a mission requires stealth and subtlety. His skills as a tracker and spy are unparalleled in Katolis.

Corvus's placeholder name in early scripts was "Dennis Trackerman."

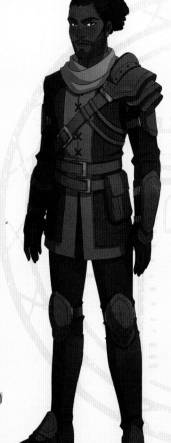

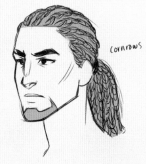

cornrows

OPELI

OPELI IS STERN, principled, and knows the laws of Katolis inside and out. Opeli was not intended to be a recurring character, but she proved to be a delightful thorn in Viren's side.

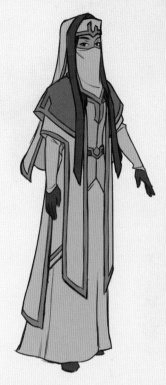

Opeli's costume doubled as an outfit for her ceremonial torchbearers.

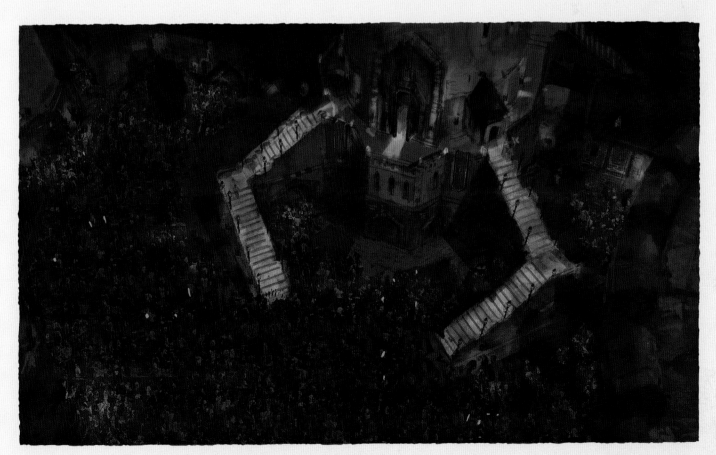

While a normal coronation might be brightly lit and celebratory, Viren's midnight coronation had to feel ominous and uneasy, more like a coup than a crowning.

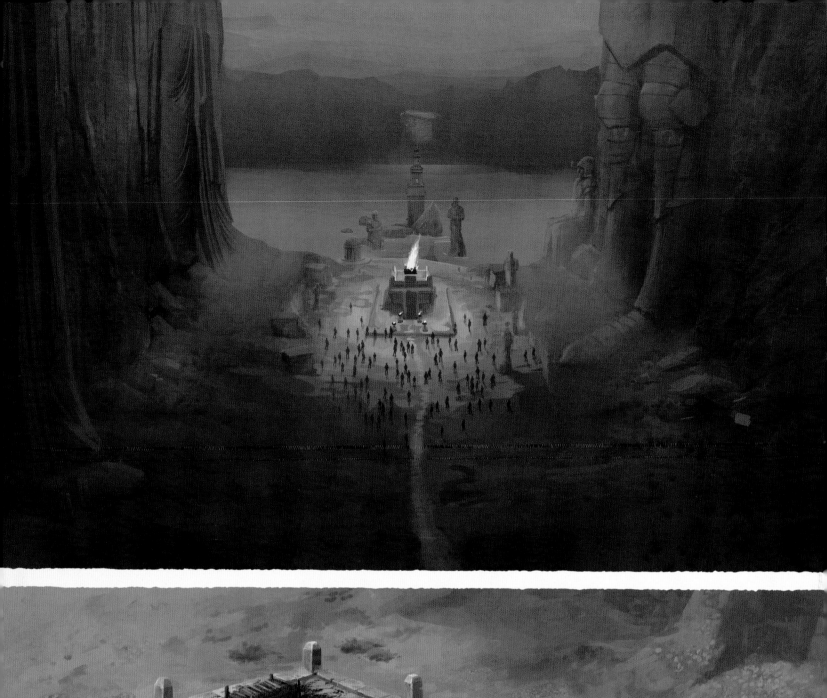

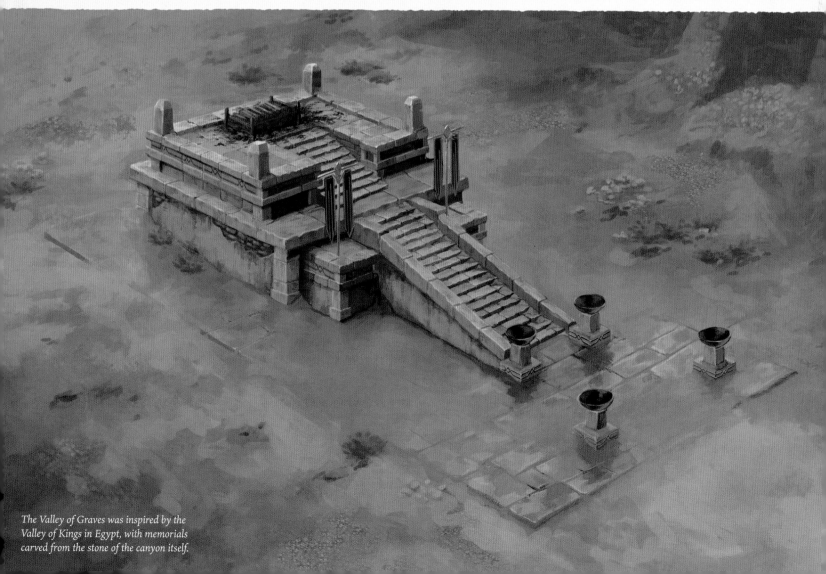

The Valley of Graves was inspired by the Valley of Kings in Egypt, with memorials carved from the stone of the canyon itself.

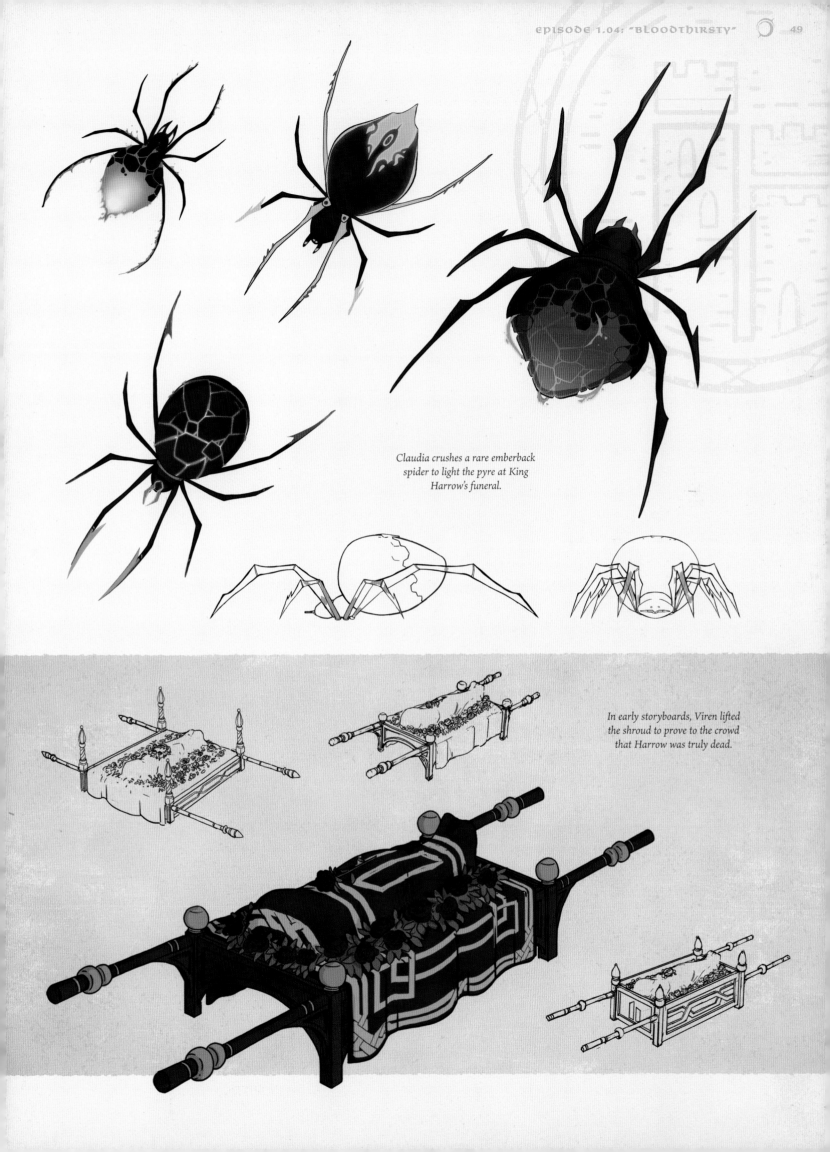

Claudia crushes a rare emberback
spider to light the pyre at King
Harrow's funeral.

In early storyboards, Viren lifted
the shroud to prove to the crowd
that Harrow was truly dead.

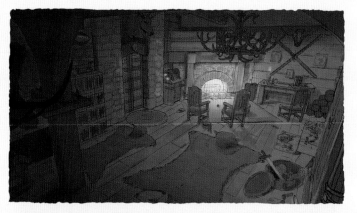

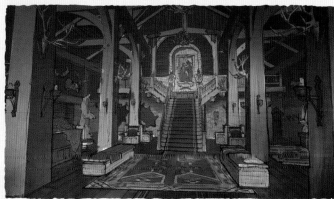

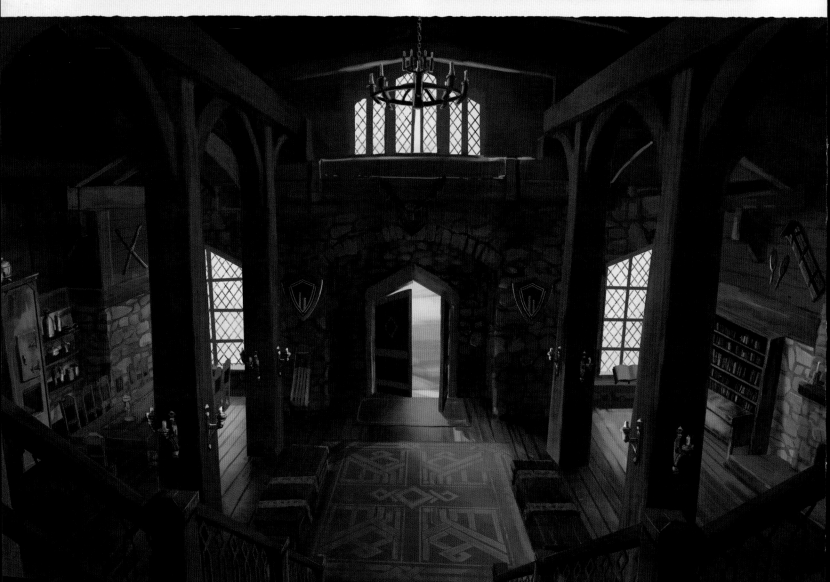

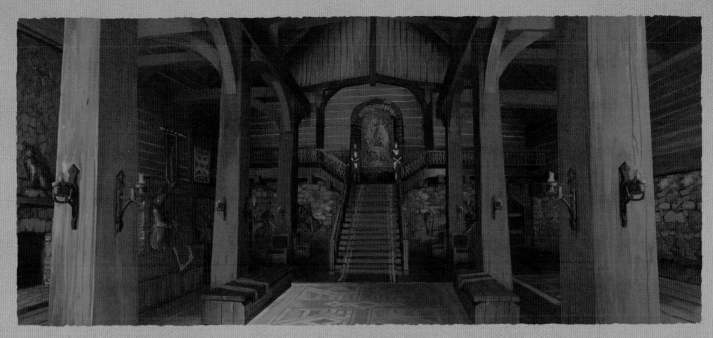

Amaya shield-smashes through the central beam in this room. Apparently it isn't a load-bearing beam, because the lodge doesn't immediately collapse.

The Banther Lodge demonstrates the blend of 3D models and 2D paintings seen throughout the series.

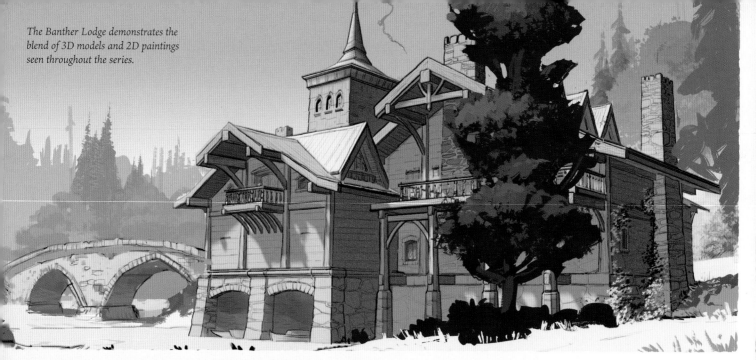

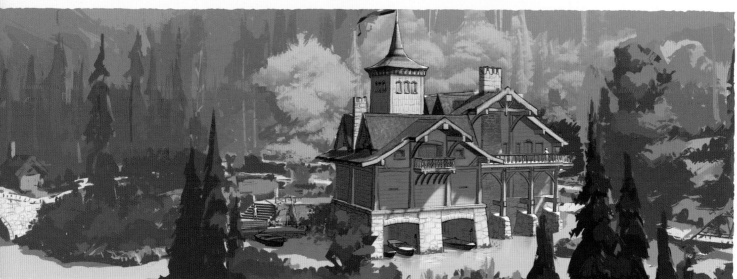

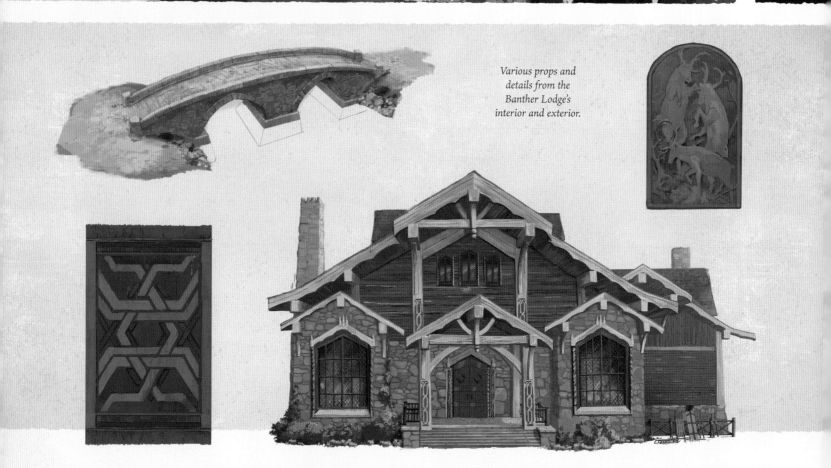

Various props and details from the Banther Lodge's interior and exterior.

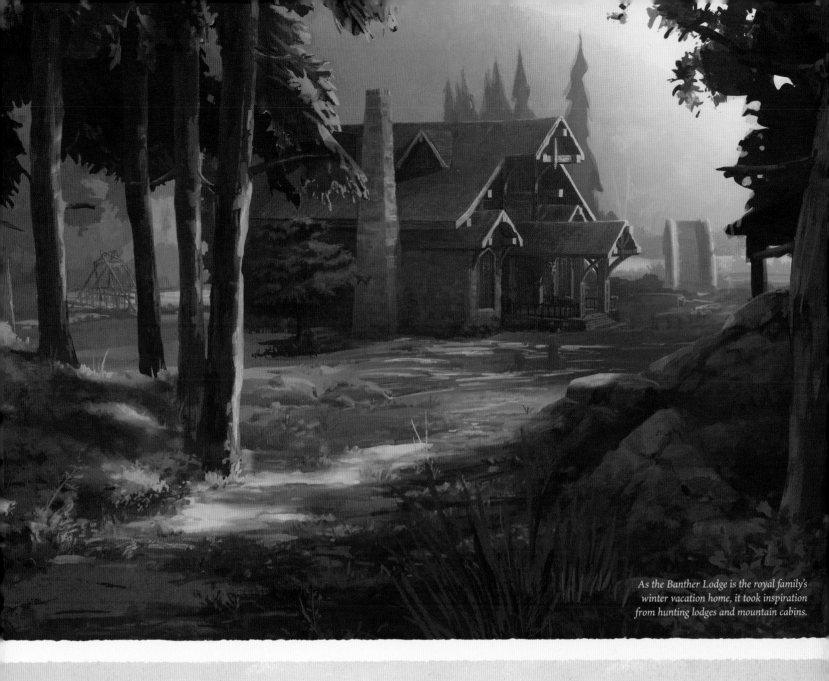

As the Banther Lodge is the royal family's winter vacation home, it took inspiration from hunting lodges and mountain cabins.

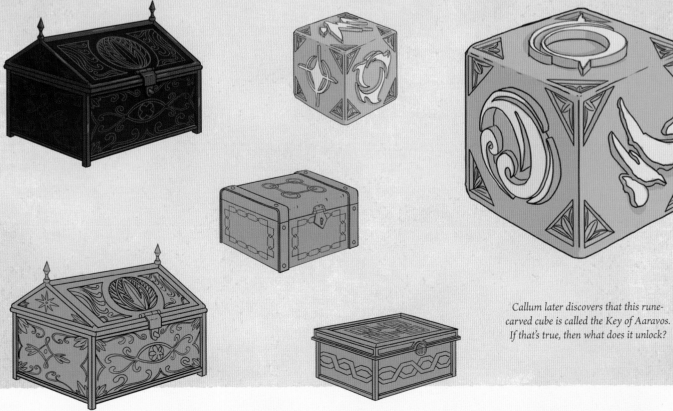

Callum later discovers that this rune-carved cube is called the Key of Aaravos. If that's true, then what does it unlock?

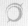

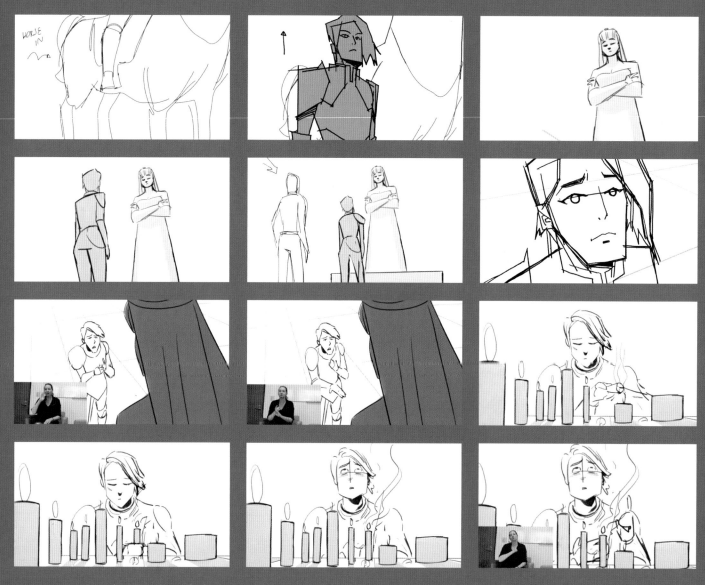

An ASL-only scene with no subtitles or voiceover was a risk, but when we first saw the storyboards set to music, the team knew it would work.

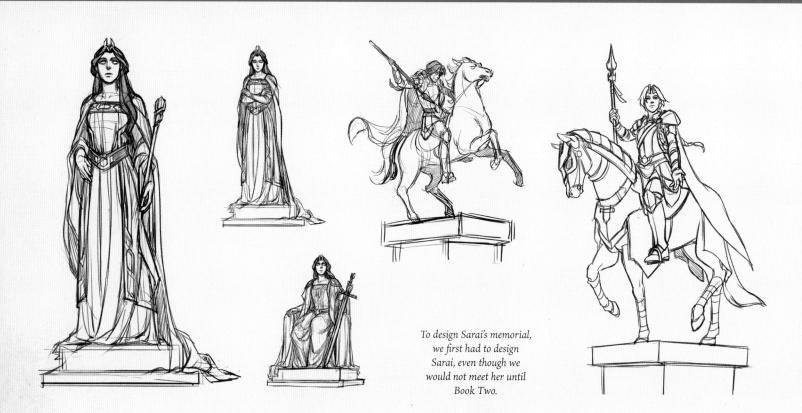

To design Sarai's memorial, we first had to design Sarai, even though we would not meet her until Book Two.

The final pose for the statue mirrors a moment we'd see in a flashback, when Sarai reaches down to save Viren's life.

It was easy to go
a little overboard
with the "uneven
towers" motif.

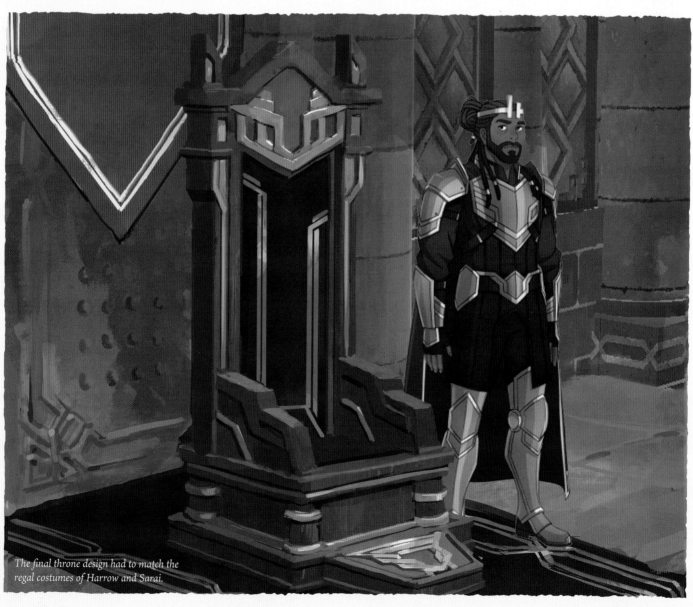

*The final throne design had to match the
regal costumes of Harrow and Sarai.*

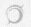

Glowing Xadian butterflies provide fuel for dark magic so that Viren can sustain his form.

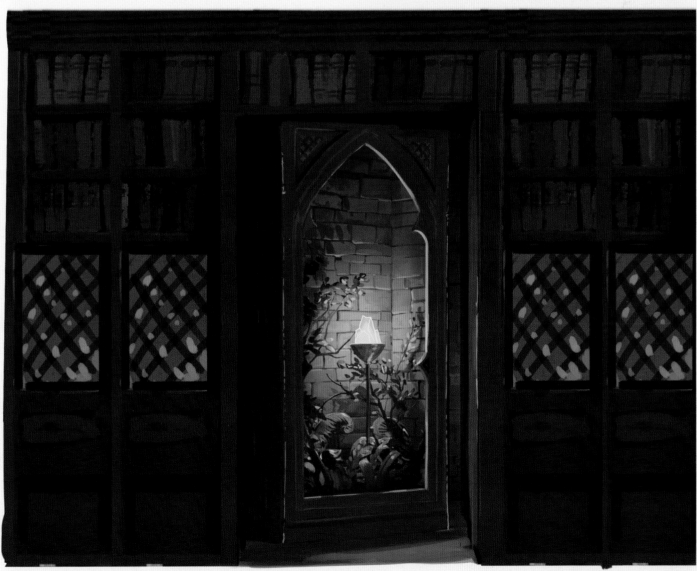

The butterflies feed not on food, but on the energy emanating from the crystal in their hidden terrarium.

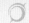

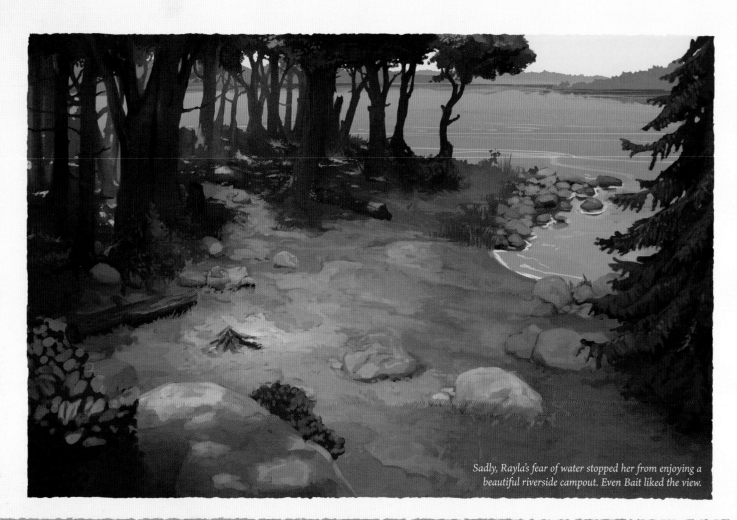

Sadly, Rayla's fear of water stopped her from enjoying a beautiful riverside campout. Even Bait liked the view.

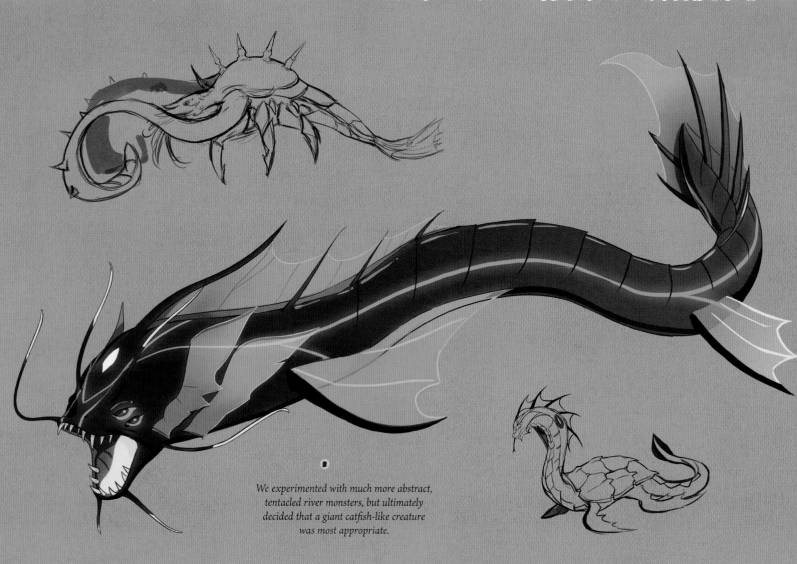

We experimented with much more abstract, tentacled river monsters, but ultimately decided that a giant catfish-like creature was most appropriate.

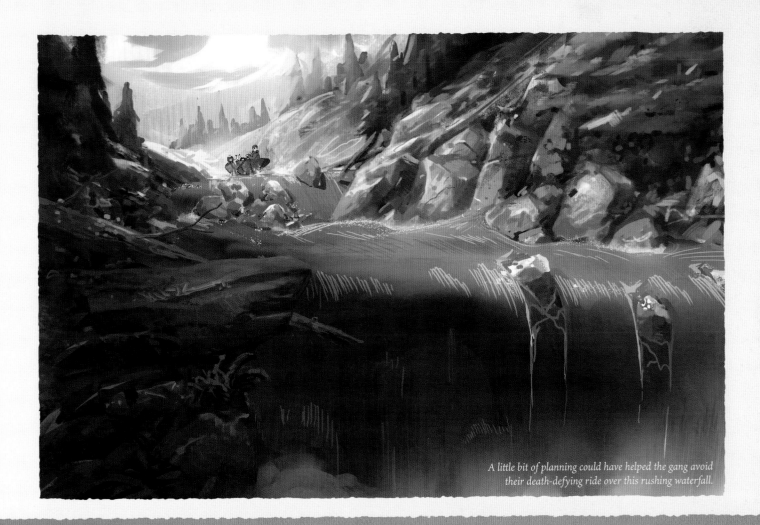

A little bit of planning could have helped the gang avoid their death-defying ride over this rushing waterfall.

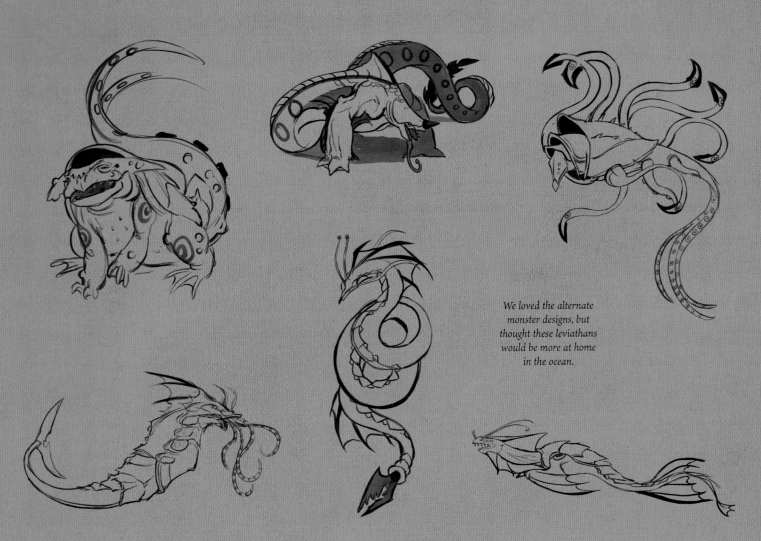

We loved the alternate monster designs, but thought these leviathans would be more at home in the ocean.

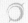

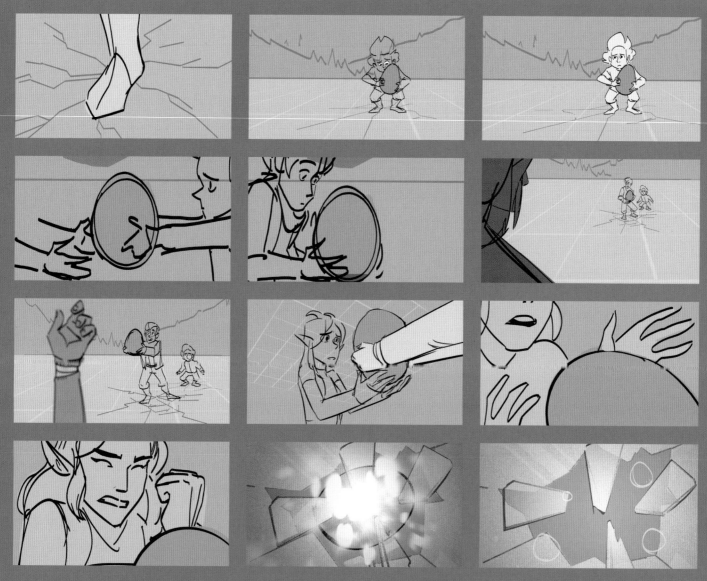

Board artists were directed to keep Ezran and the egg underwater, their fate uncertain, for an "unreasonable and uncomfortable" amount of time.

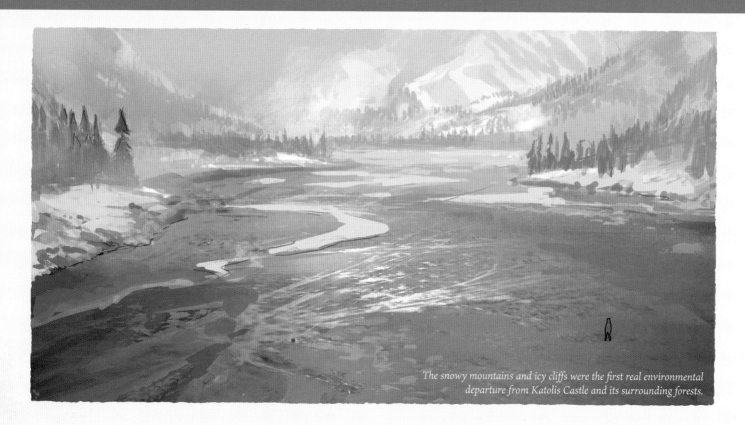

The snowy mountains and icy cliffs were the first real environmental departure from Katolis Castle and its surrounding forests.

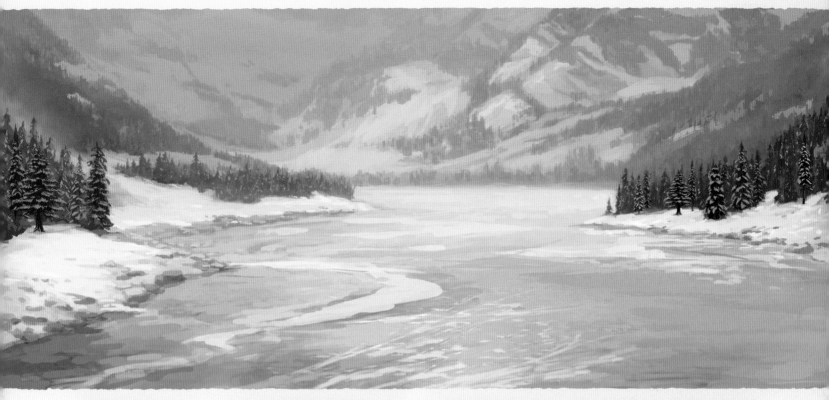

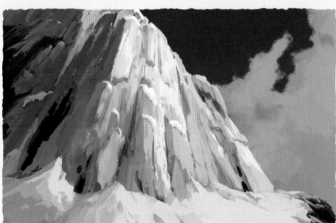 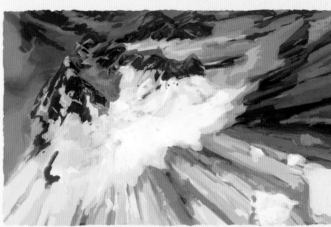

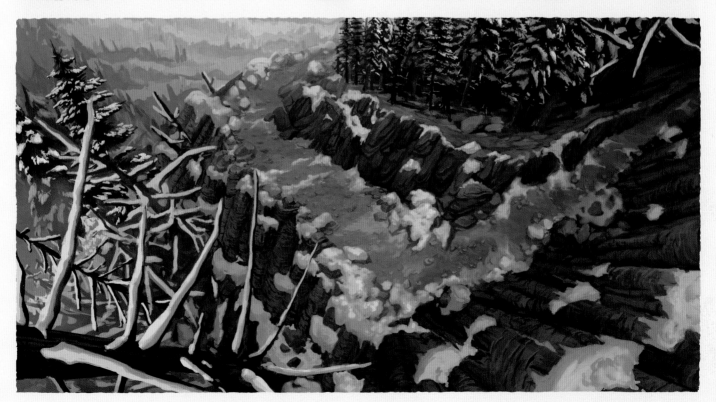

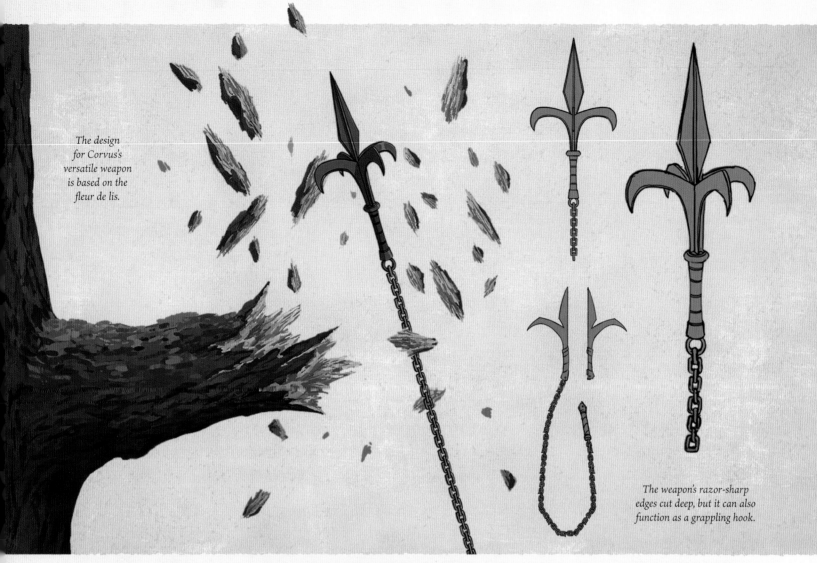

The design for Corvus's versatile weapon is based on the fleur de lis.

The weapon's razor-sharp edges cut deep, but it can also function as a grappling hook.

Rivers run clear and deep through the heart of Katolis. Their depths hold creatures much bigger than fish and frogs . . .

spotlight
PRIMAL SOURCE: MOON

"Most people believe that reality is truth and appearances are deceiving, but we can only truly know the appearance itself. You can never touch the so-called reality that lies just beyond the reach of your own perception." —Lujanne

From new to full, the Moon itself follows an endless cycle of light to darkness, and darkness to light: two fundamentally opposed forces, existing in parallel harmony. The primal source of the Moon deals in reflections, phases, and dualities: truth and lies. Life and death. Reality and illusion. Moon mages understand that all shadows are born of light, and to reach for light is to cast a shadow.

Moon magic, too, is cyclical in nature: strongest under the full moon, and weakest during the new. Some great Moon mages are illusionists, using their powers to befuddle and confuse their enemies' senses. Simple illusion spells can fool the eyes and ears, but more powerful illusions can mimic even taste or touch. It's no surprise that those connected to the Moon do not trust easily. Moonshadow elves in particular place deep value in oaths and blood promises, knowing that trust and perception are easily manipulated.

In places where the energy of the Moon is highly concentrated, the veil between life and death can thin, allowing the living and the dead alike to glimpse the other side. Mages can conjure flickers of the past, restless spirits can be put to rest, and the living can bid final farewells to the lost.

ELLIS

GROWING UP IN the mountains of Katolis gave Ellis an explorer's heart. She's curious and brave, more so than her fellow villagers, who would never dare to climb the slopes of the Cursed Caldera. But Ellis will do anything for her wolf friend Ava.

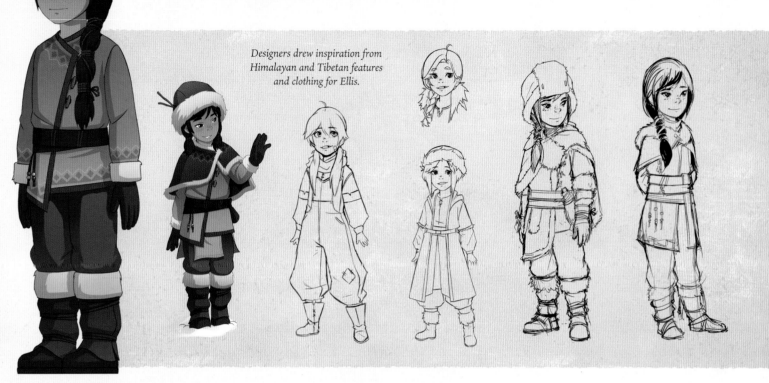

Designers drew inspiration from Himalayan and Tibetan features and clothing for Ellis.

AVA

AVA LOST HER leg in a hunter's trap as a puppy, but Ellis set her free and saved her life. Some doubted she'd survive with only three legs, but Ava grew up as happy and strong as any other wolf.

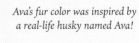

Ava's fur color was inspired by a real-life husky named Ava!

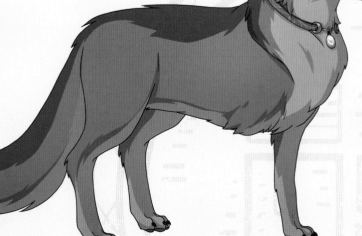

HUMAN RAYLA

MEET HUMAN RAYLA, a simple human girl who spends her time doing human things, like eating bread, counting money, and complaining about lower back pain.

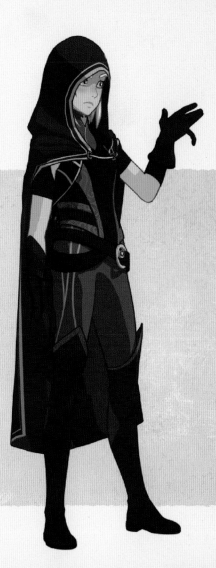

The droopy pinky finger on Human Rayla's gloves was a fun addition by the storyboards team.

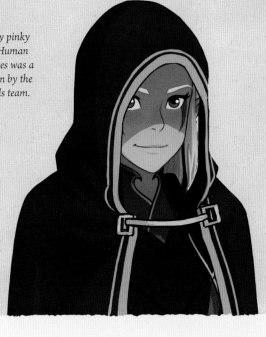

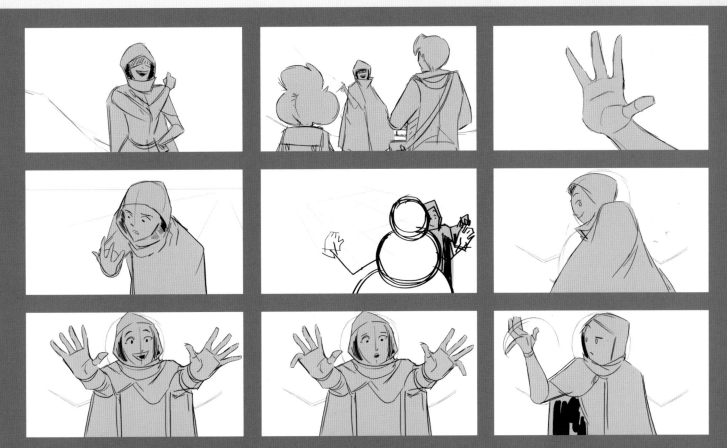

Rayla had been waiting for a chance to show off her incredible skills of deception and disguise.

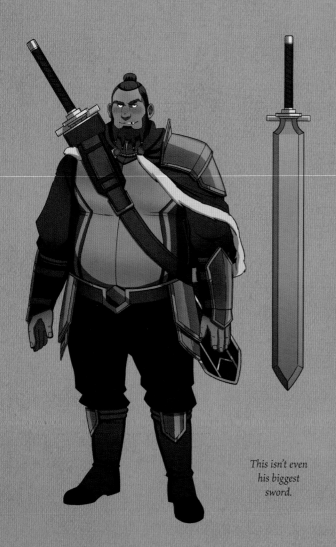

BURLY CHALLENGER

LOOK AT THIS hulking warrior! How could anyone hope to defeat him with nothing but a simple dagger!?

This isn't even his biggest sword.

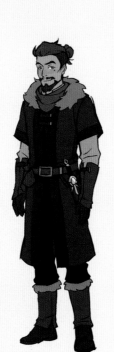
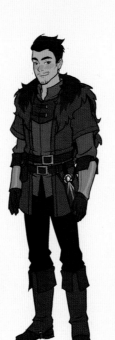
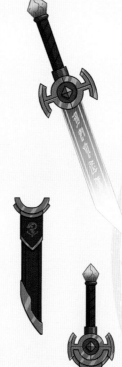
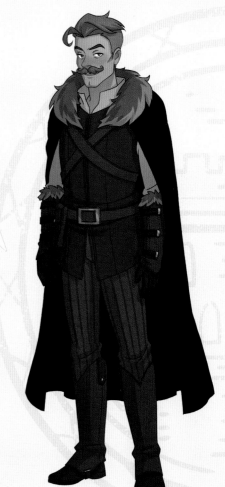

THE MERCENARY

THE WAXED MOUSTACHE, hair curl, and pinstripe pants inspired the storyboard artists to elevate this character from average swindler to acrobatic performance artist. Where did he get that Sunforge blade anyway?

ANIMAL DOCTOR

THE KIND BUT severely overworked animal doctor has definitely poured more money into his practice than it's made him. Ava sometimes stops by for treats.

It's best for animals to stay indoors to stop them from venturing up the Cursed Caldera.

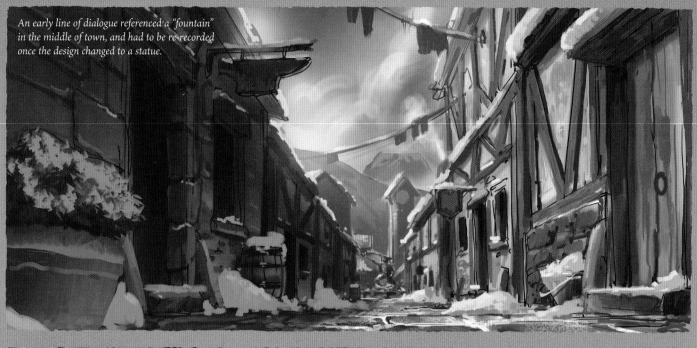

An early line of dialogue referenced a "fountain" in the middle of town, and had to be re-recorded once the design changed to a statue.

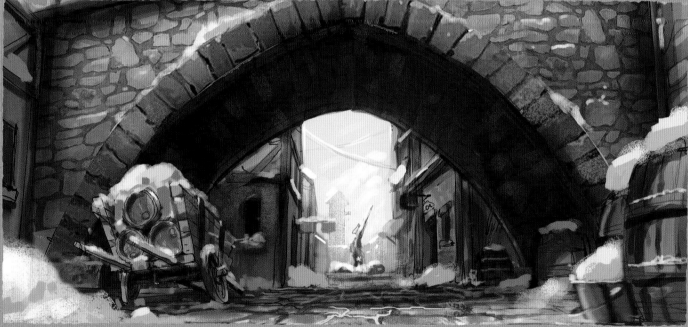

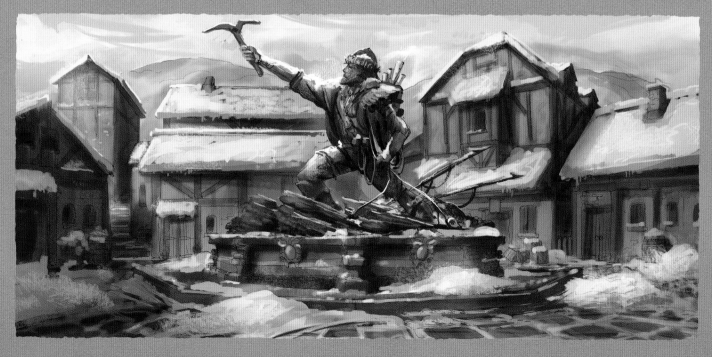

Every fantasy village needs a set of signs advertising the adventurers' basic needs, right?

Ellis's village has a "remote mountain town" vibe. It was an exciting change from the highly formal designs of Katolis Castle.

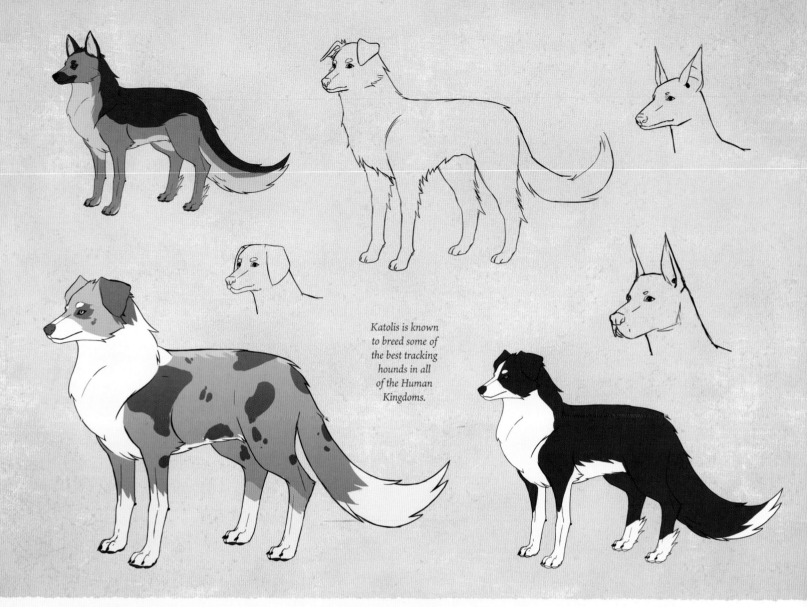

Katolis is known to breed some of the best tracking hounds in all of the Human Kingdoms.

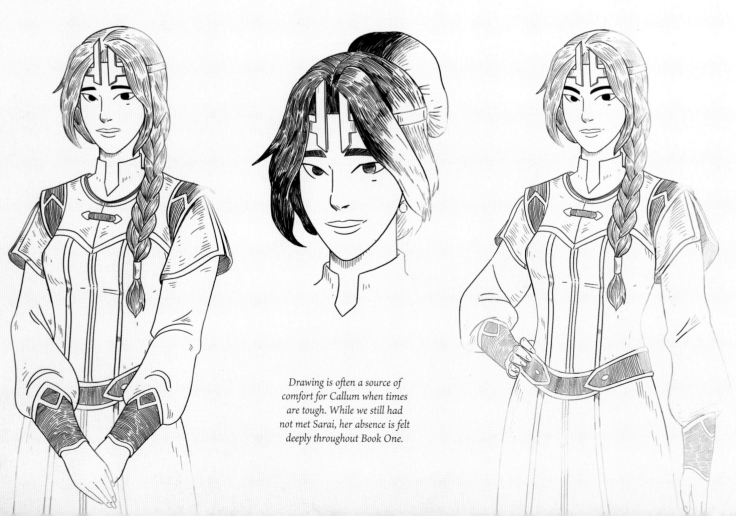

Drawing is often a source of comfort for Callum when times are tough. While we still had not met Sarai, her absence is felt deeply throughout Book One.

Only the keenest scholars of human and elf cultures can distinguish between a snowman and a snowelf.

Bogey berries are the surefire natural cure for a cold, but few will put up with having two berries stuffed up their nostrils.

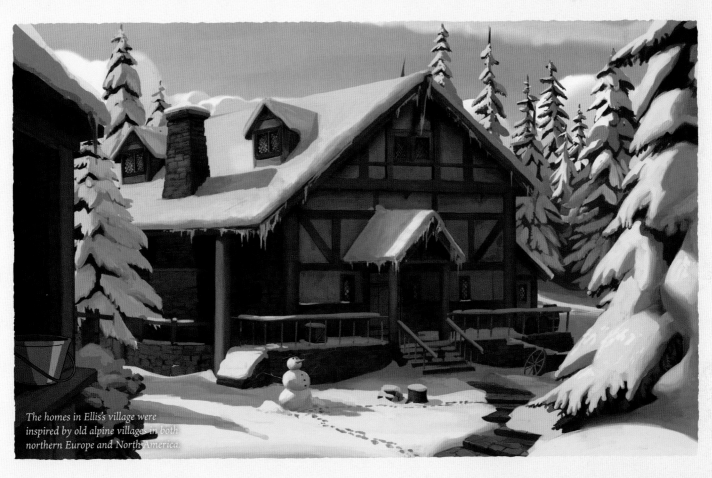

The homes in Ellis's village were inspired by old alpine villages in both northern Europe and North America.

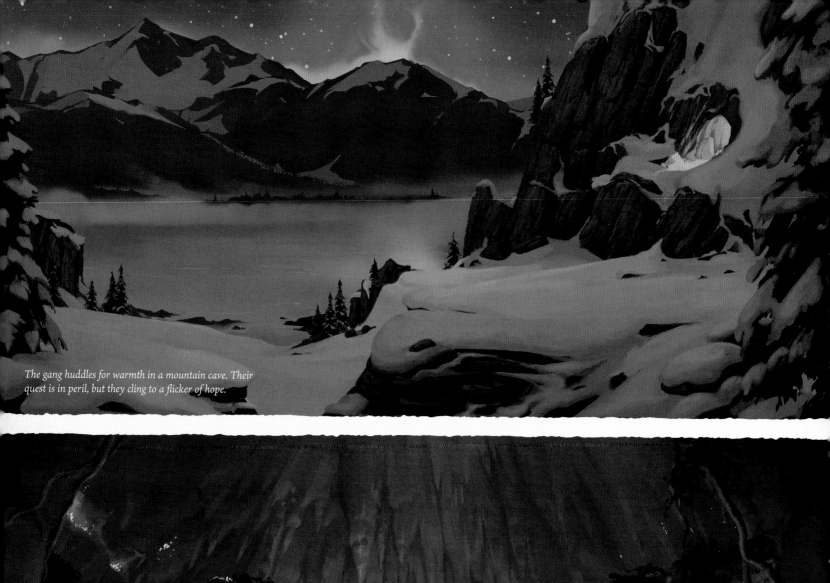

The gang huddles for warmth in a mountain cave. Their quest is in peril, but they cling to a flicker of hope.

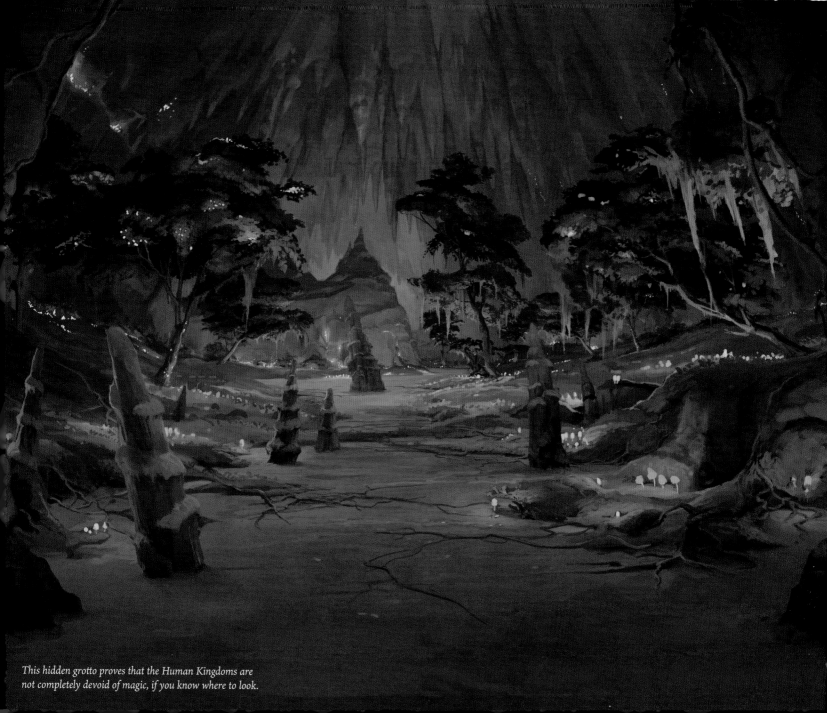

This hidden grotto proves that the Human Kingdoms are not completely devoid of magic, if you know where to look.

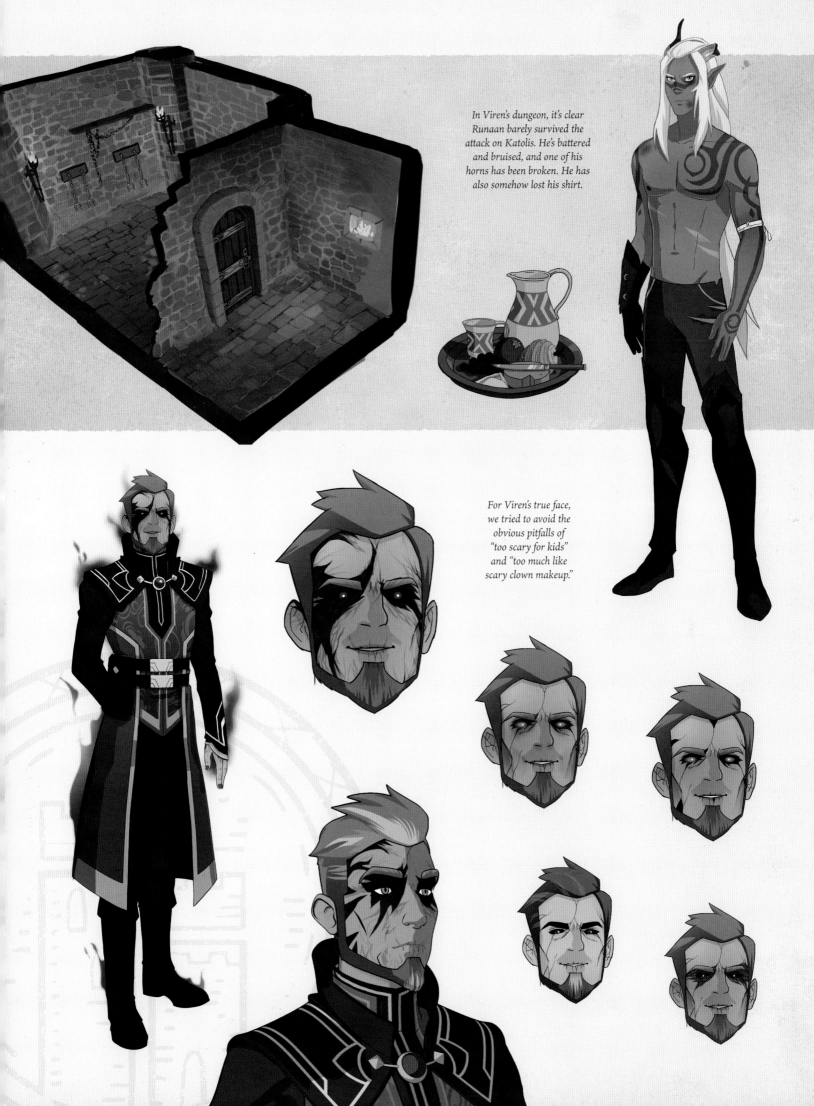

In Viren's dungeon, it's clear Runaan barely survived the attack on Katolis. He's battered and bruised, and one of his horns has been broken. He has also somehow lost his shirt.

For Viren's true face, we tried to avoid the obvious pitfalls of "too scary for kids" and "too much like scary clown makeup."

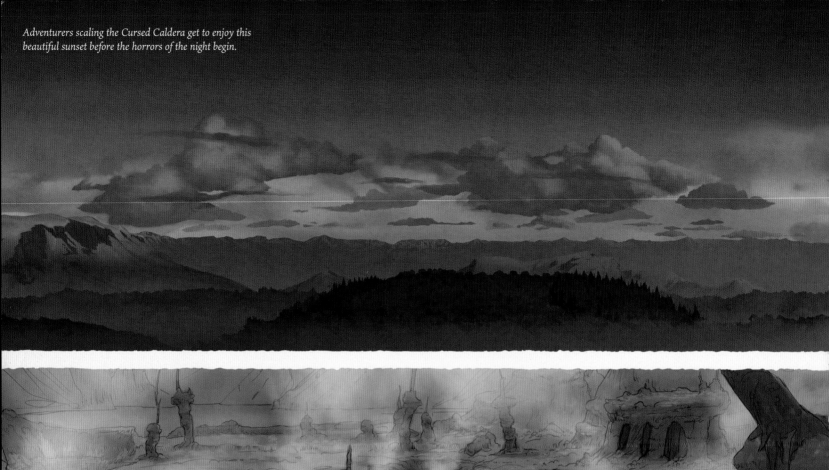

Adventurers scaling the Cursed Caldera get to enjoy this beautiful sunset before the horrors of the night begin.

What's scarier than a giant leech? A giant leech with eyestalks.

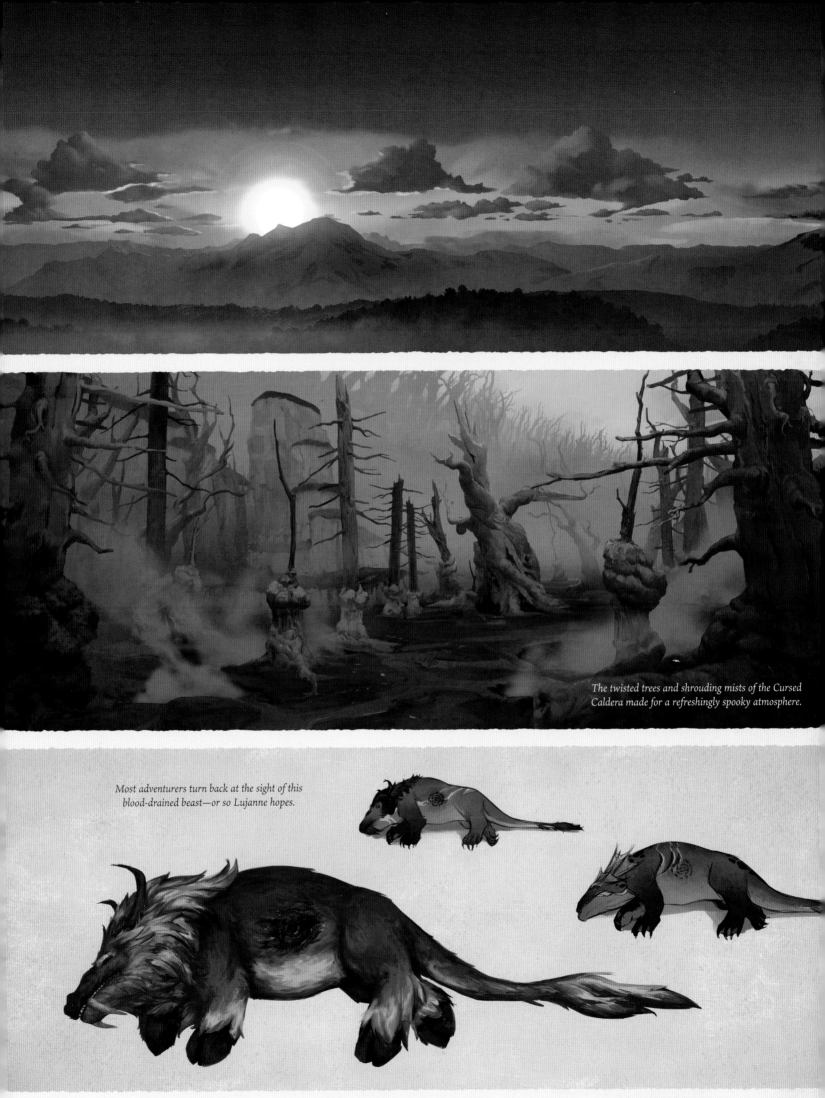

The twisted trees and shrouding mists of the Cursed Caldera made for a refreshingly spooky atmosphere.

Most adventurers turn back at the sight of this blood-drained beast—or so Lujanne hopes.

phoe-phoe

PHOE-PHOE (short for Phoenix-Phoenix) is Lujanne's close companion and faithful steed. A spin on traditional fiery phoenixes, Phoe-Phoe draws her power from the Moon.

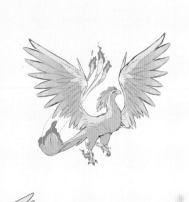

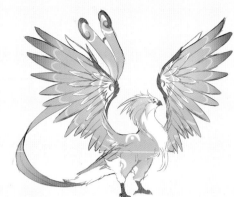

Phoe-Phoe's extravagant design allows Lujanne to make a dramatic entrance in every scene.

The idea of a "Moon phoenix" born from a "ghost feather" led to this beautiful design.

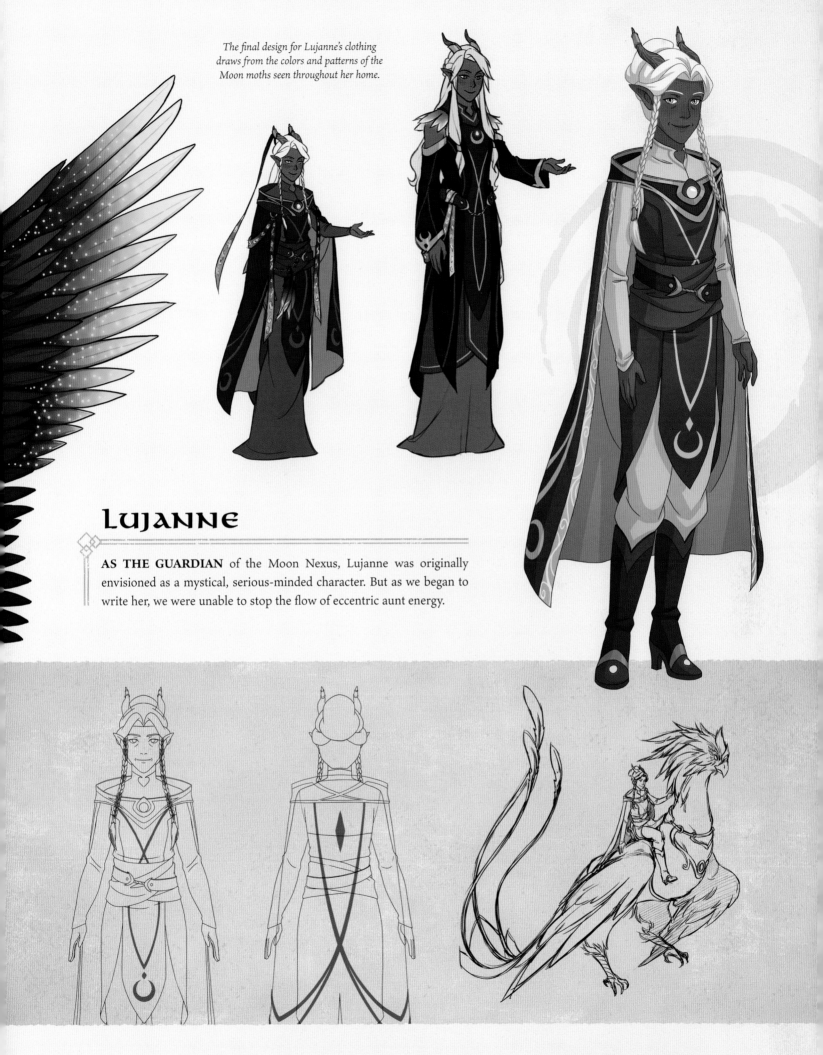

The final design for Lujanne's clothing draws from the colors and patterns of the Moon moths seen throughout her home.

LUJANNE

AS THE GUARDIAN of the Moon Nexus, Lujanne was originally envisioned as a mystical, serious-minded character. But as we began to write her, we were unable to stop the flow of eccentric aunt energy.

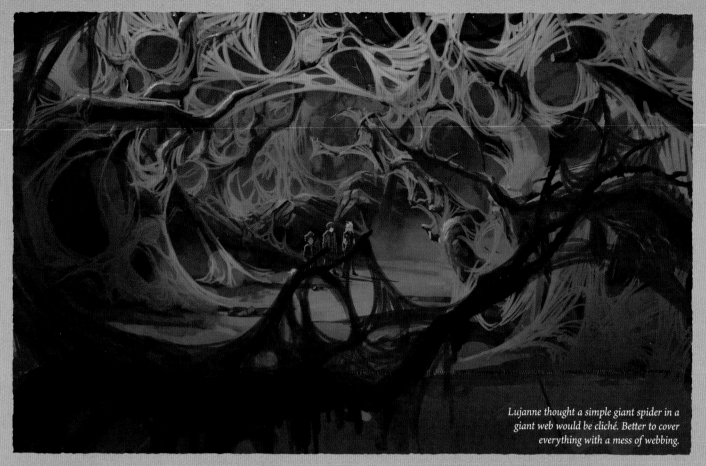

*Lujanne thought a simple giant spider in a
giant web would be cliché. Better to cover
everything with a mess of webbing.*

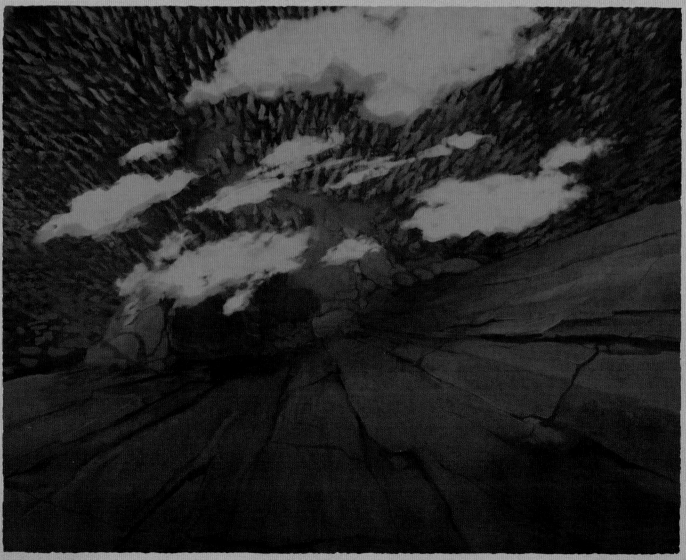

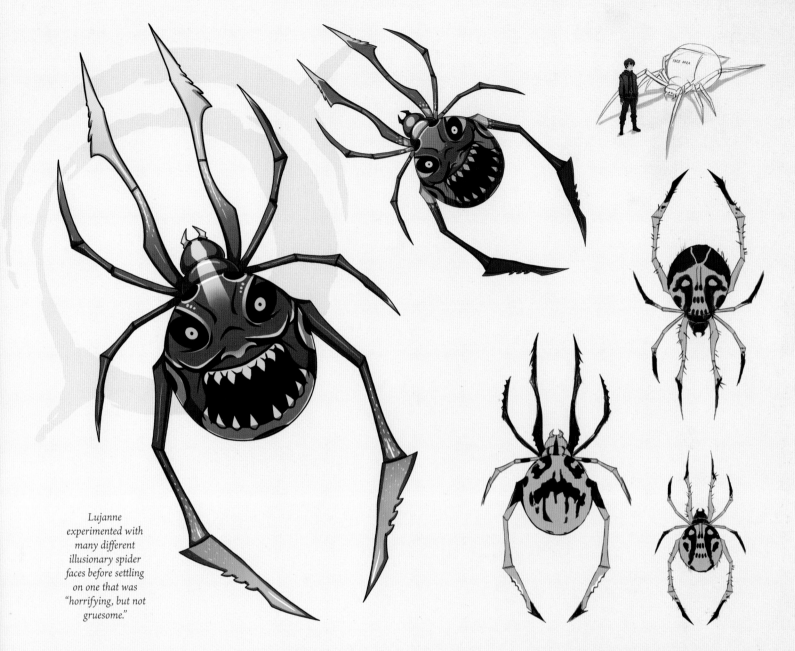

Lujanne experimented with many different illusionary spider faces before settling on one that was "horrifying, but not gruesome."

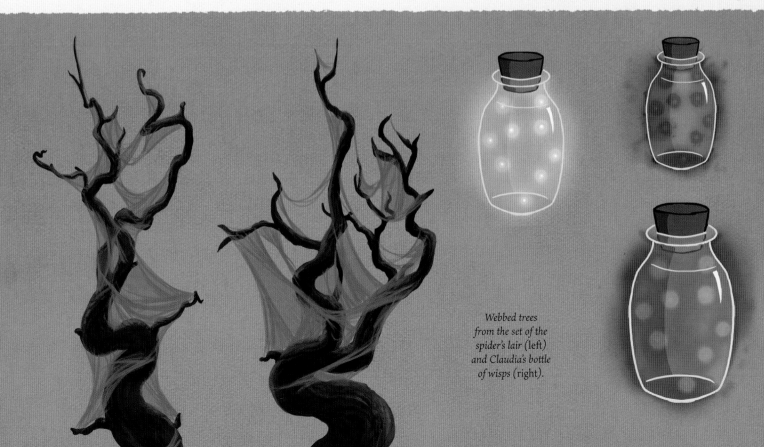

Webbed trees from the set of the spider's lair (left) and Claudia's bottle of wisps (right).

ZYM

THE DRAGON PRINCE LIVES! Azymondias—or Zym for short—is the center of the conflict that has brought the world to the edge of war, and will one day grow up to be an impossibly powerful Sky dragon. But for now, he's just the cutest little guy.

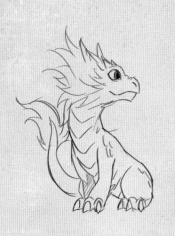

Zym's poses and movements were inspired by real-life baby animals. He's curious, tentative, and bold in equal measures.

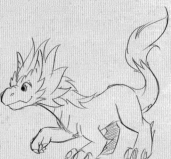

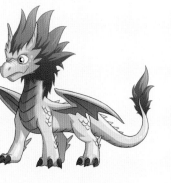

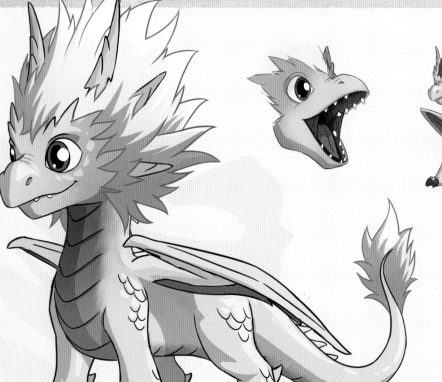

We explored more vibrant colors for Zym's mane, but ultimately went with a baby version of his dad's palette.

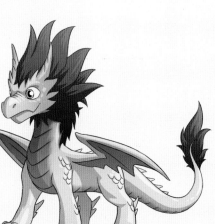

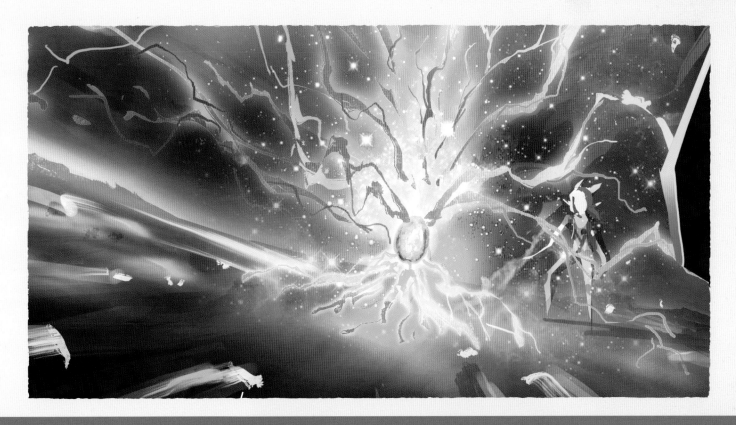

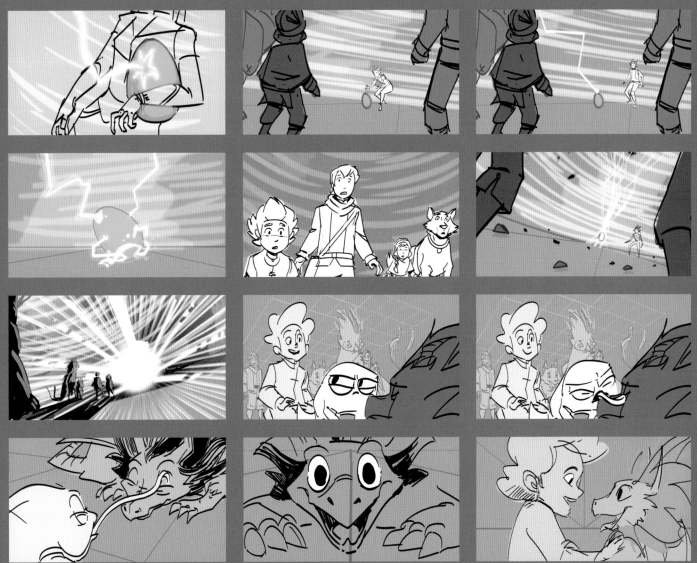

As the season finale, the storm that allows Azymondias to hatch from his egg is a spectacle of swirling color and emotion.

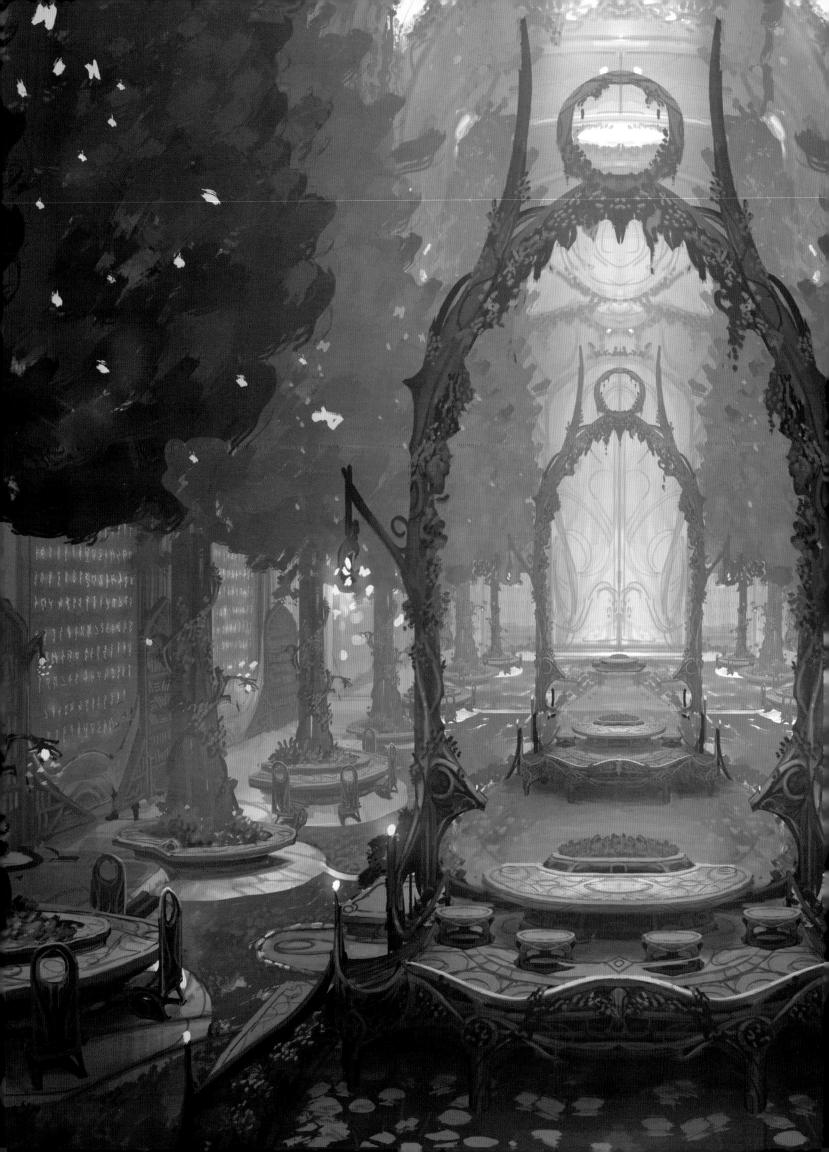

BOOK TWO
sky

AFTER THE DRAGON Prince hatches, Callum, Rayla, and Ezran's journey toward Xadia grows more treacherous by the day. The war is escalating; humans and Sunfire elves clash at the Breach and dragons circle the skies over Katolis's border towns. Without a primal stone, Callum is no longer a mage. Is he helpless to protect Zym without magic, or can he unlock a different path?

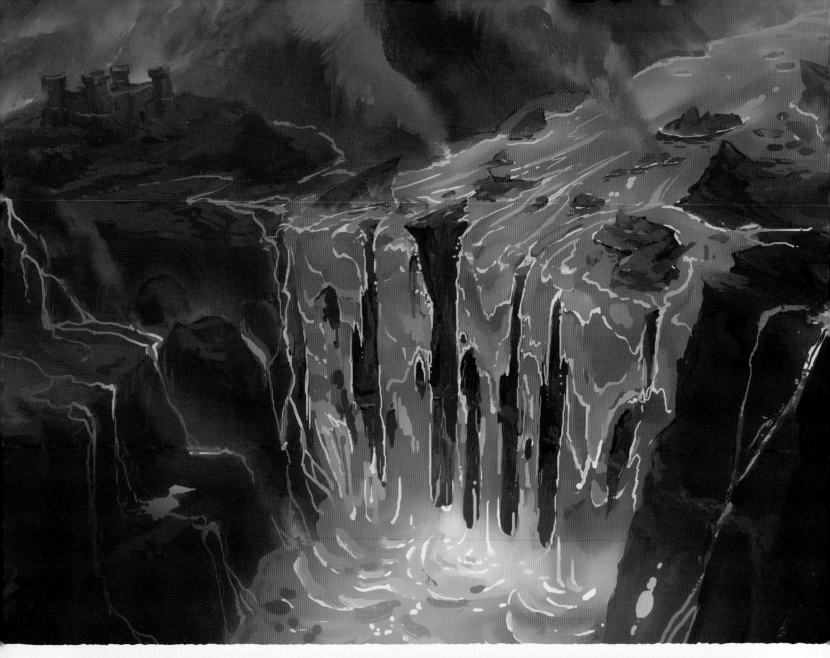

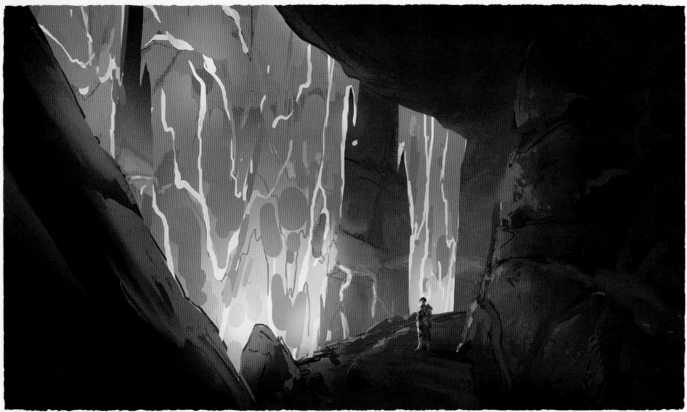

The first moments of Book Two unfold at the Border, the massive river of lava that separates the two sides of the world.

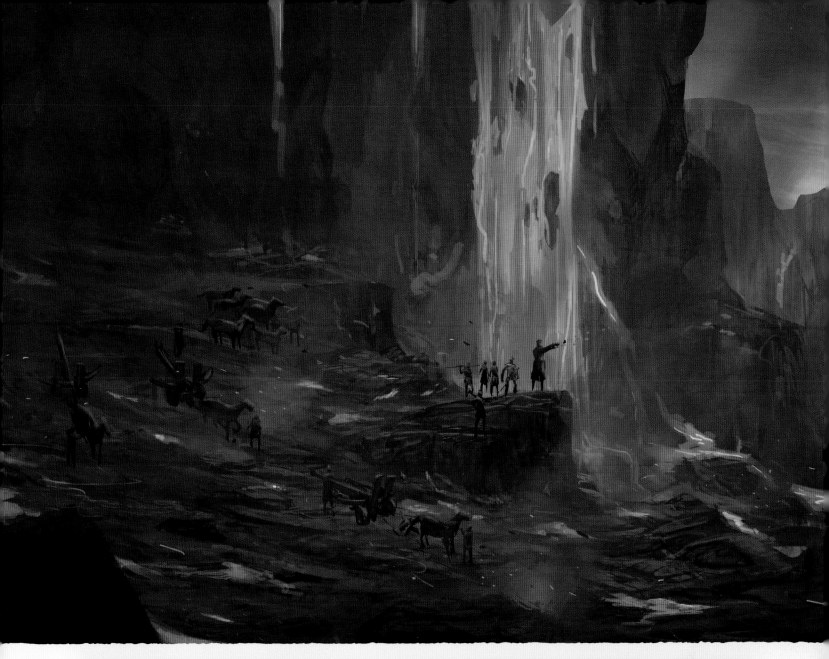

Hidden behind a flow of lava, humans found a path across the Border. On the Xadian side, they carved a secret base into the volcanic rock.

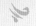

JANAI

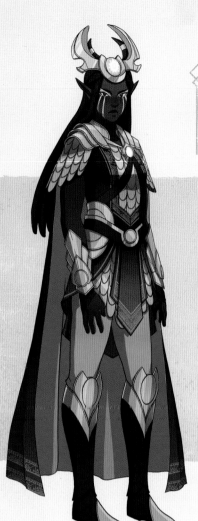

JANAI IS THE Golden Knight of Lux Aurea, an elite warrior who leads the Sunfire elves at the border of Xadia. When Amaya first encounters her, she only sees Janai as a fierce enemy who fulfills her duty with a burning fury.

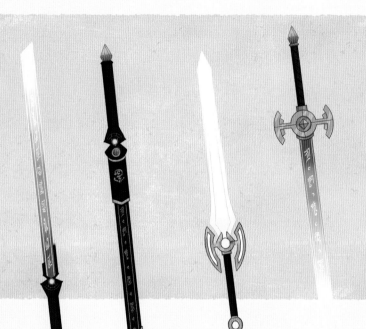

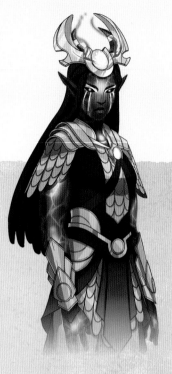

Janai can channel her rage into a molten-hot state we called "Heat-Being Mode."

SUNFIRE ELVES

THE SUNFIRE ELVES are one of the most militant factions in Xadia. Like the Sun itself, they see themselves as a guiding light for others to follow—for better and for worse.

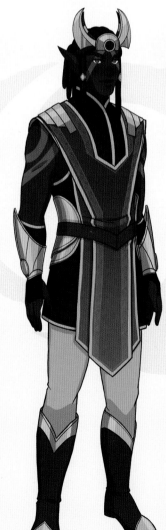

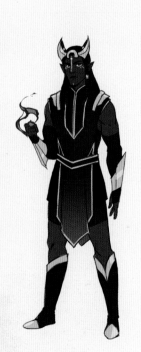

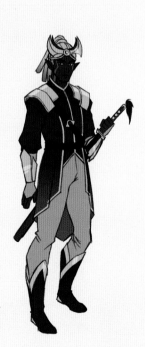

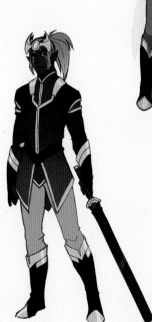

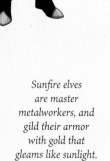

Sunfire elves are master metalworkers, and gild their armor with gold that gleams like sunlight.

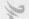

COUNCIL OF KATOLIS

A WISE RULER does not make all of their choices alone. The Council of Katolis lends the kingdom's royalty their expertise and guidance when necessary.

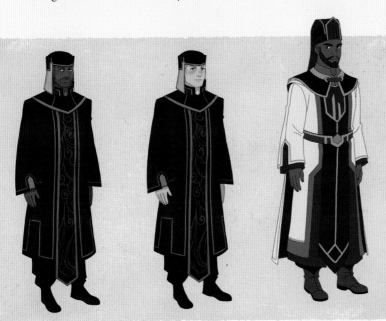

Councilman Saleer grows frustrated with King Ezran and throws his support behind Viren.

CROW MASTER

THE MYSTERIOUS CROW Lord left a big pair of shoes for Katolis's number two crow expert, the bumbling Crow Master, to fill. Hopefully someday his boss will notice what a good job he's doing . . .

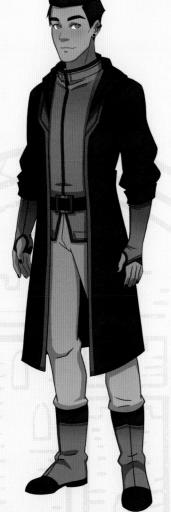

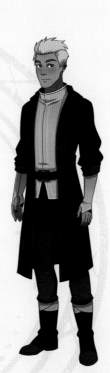

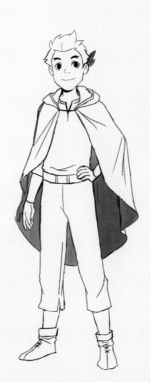

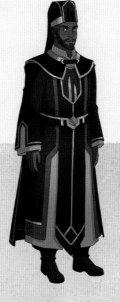

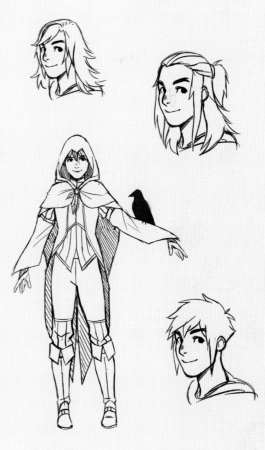

The Crow Master can be timid and hesitant, but there isn't a more nurturing and thoughtful crow parent in the kingdom.

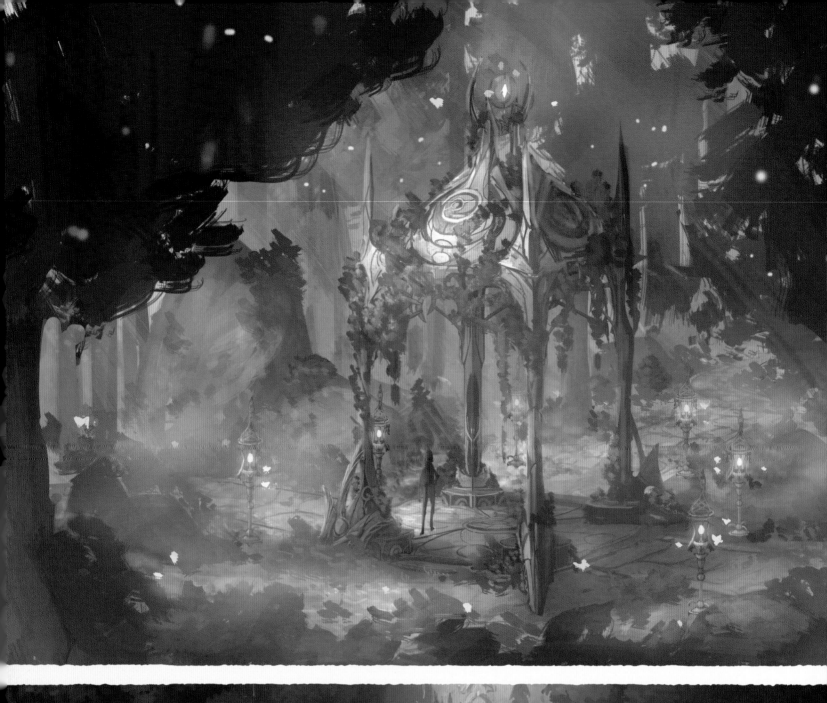

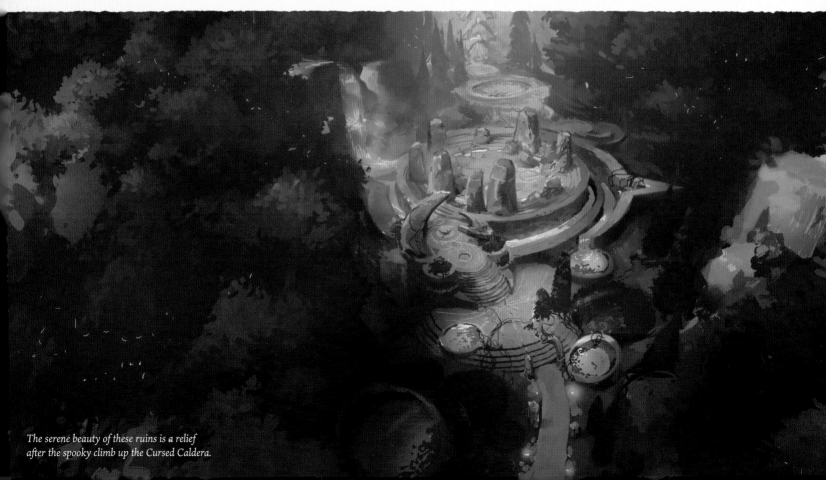

*The serene beauty of these ruins is a relief
after the spooky climb up the Cursed Caldera.*

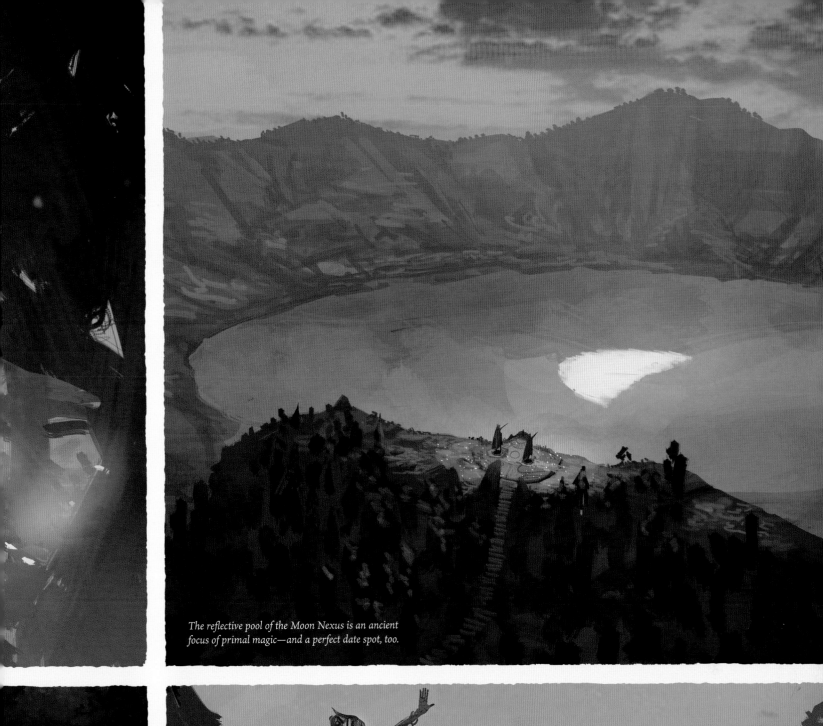

The reflective pool of the Moon Nexus is an ancient focus of primal magic—and a perfect date spot, too.

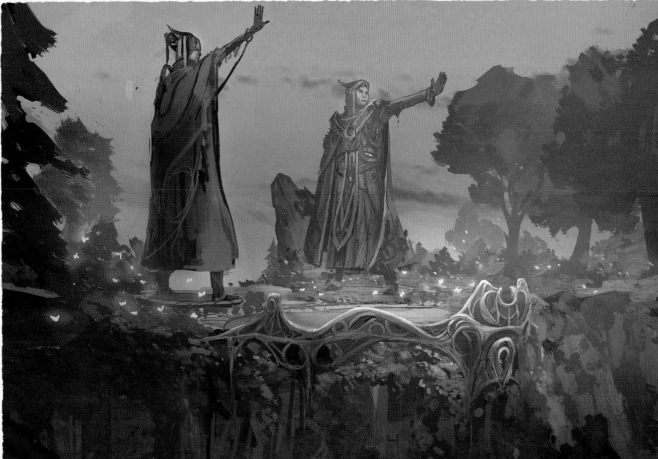

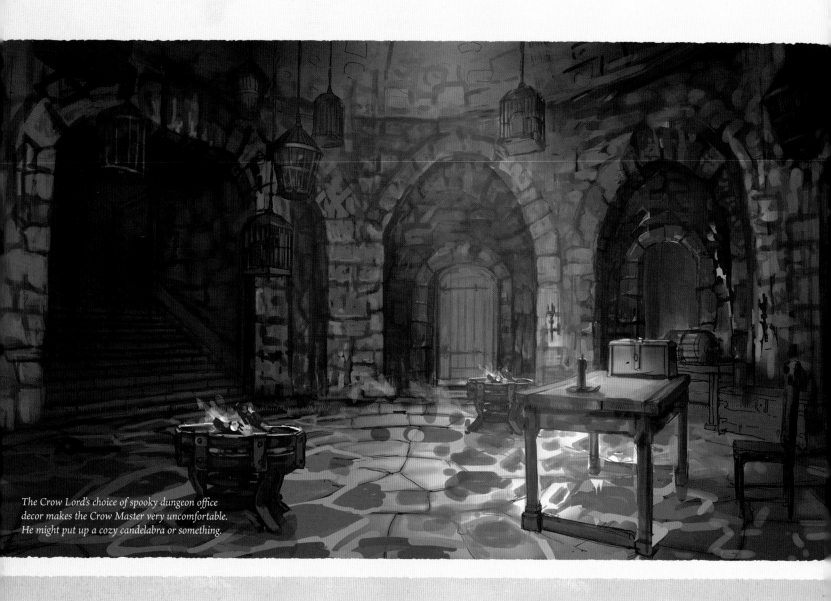

The Crow Lord's choice of spooky dungeon office decor makes the Crow Master very uncomfortable. He might put up a cozy candelabra or something.

The royal seal can only be used by the ruler of Katolis. It marks messages of utmost importance.

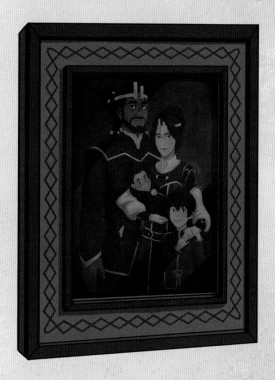

Harrow spent some of his final moments looking at this family portrait. Now it haunts Viren, too.

SPOTLIGHT

PRIMAL SOURCE: SKY

"Find the wind, boy! Be like a wing!" —Villads

Sky magic draws from the energy and movement of the vast Sky above us. From the outer heavens to dank cavernous depths, the air is everywhere and nowhere all at once, around us and within us. Sky mages thrive on the ever-changing energy their primal source offers them, from the churning chaos of a storm to the clarity and freedom of a cloudless sky.

The Sky primal can manifest in the ability to summon wind, lightning, or shrouding fog, but its power is not limited to the weather. A talented Sky mage can magically enhance their movement, allowing bursts of speed and leaps of great length. The most powerful among them can even transform their own arms into wings, giving them the gift of flight. Even with limited physical strength, a Sky mage can learn to perform feats of incredible agility, making them excellent acrobats, dancers, and sometimes thieves.

Although Skywing elves have a deep connection to the Sky primal, the form of their connection can be as unpredictable. Only about one out of ten Skywing elves is born with wings, and whether these special individuals choose to use their powers for virtue or vice is as uncertain as a falling leaf's path through the autumn air.

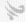

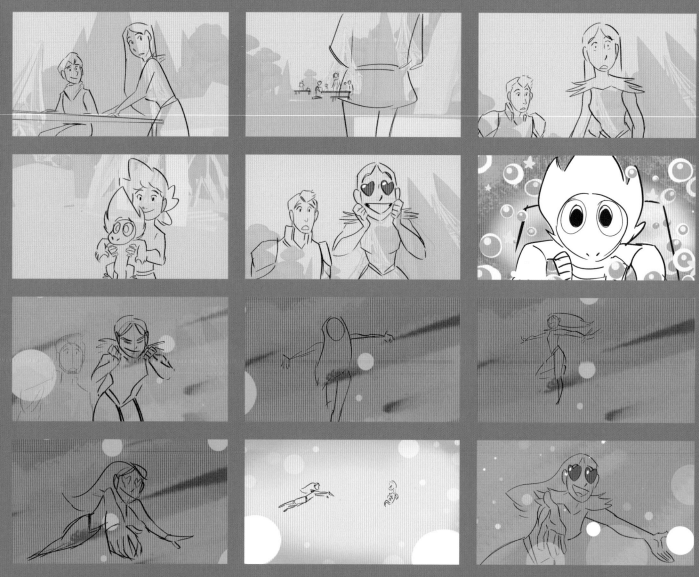

Claudia's big goofy heart eyes and exaggerated float towards Zym were a departure from the show's usual style . . . but so, so worth it.

What are all these runes? Powerful magic spells? Tales of elven heroes? Funny limericks?

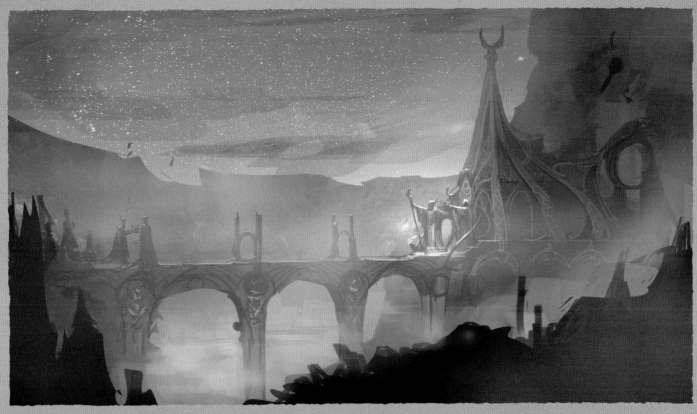

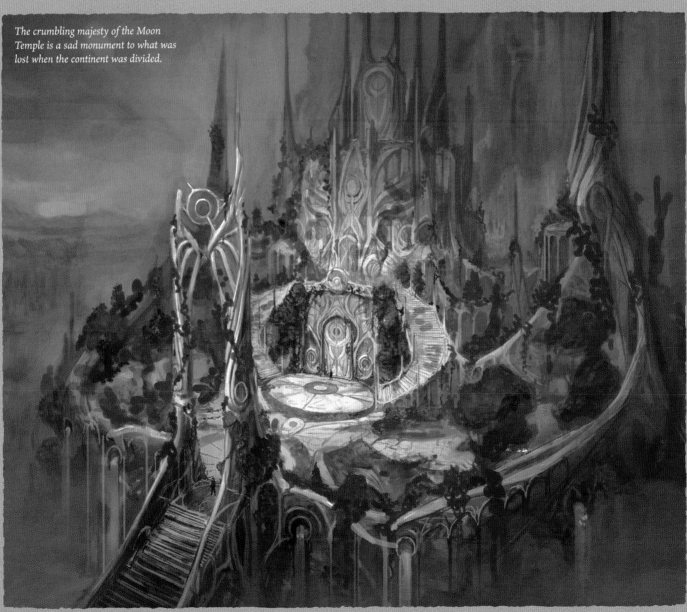

The crumbling majesty of the Moon
Temple is a sad monument to what was
lost when the continent was divided.

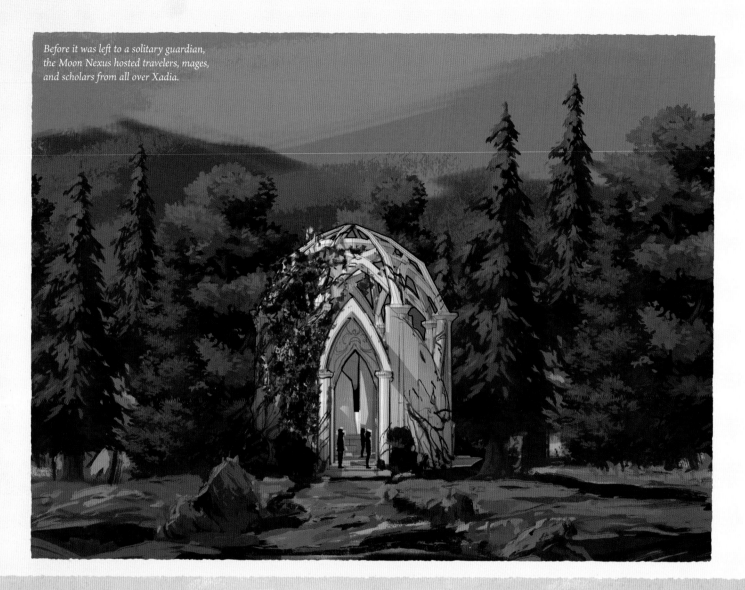

Before it was left to a solitary guardian, the Moon Nexus hosted travelers, mages, and scholars from all over Xadia.

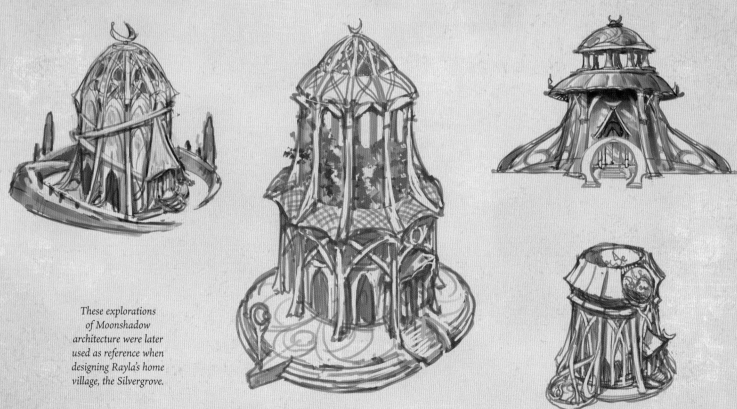

These explorations of Moonshadow architecture were later used as reference when designing Rayla's home village, the Silvergrove.

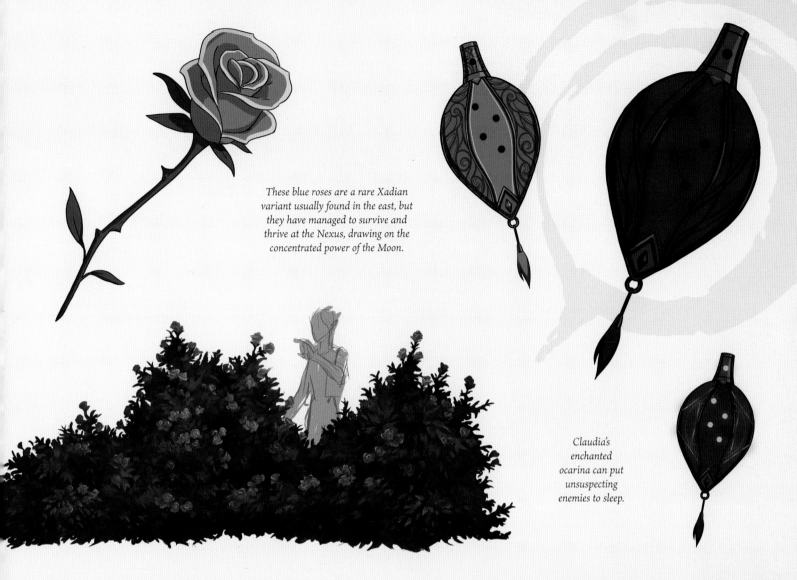

These blue roses are a rare Xadian variant usually found in the east, but they have managed to survive and thrive at the Nexus, drawing on the concentrated power of the Moon.

Claudia's enchanted ocarina can put unsuspecting enemies to sleep.

These "Moon dorms" gave past visitors to the Nexus a place to stay.

Even the most mundane of Moonshadow elf household items is ornately crafted.

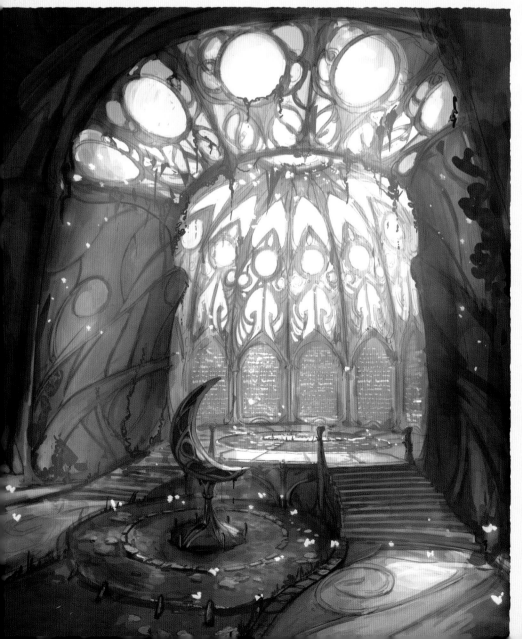

Moon symbolism and motifs are heavily featured in every detail of Moonshadow elf decor.

This Hot Brown Morning Potion flask is perfect for the dark mage on the go.

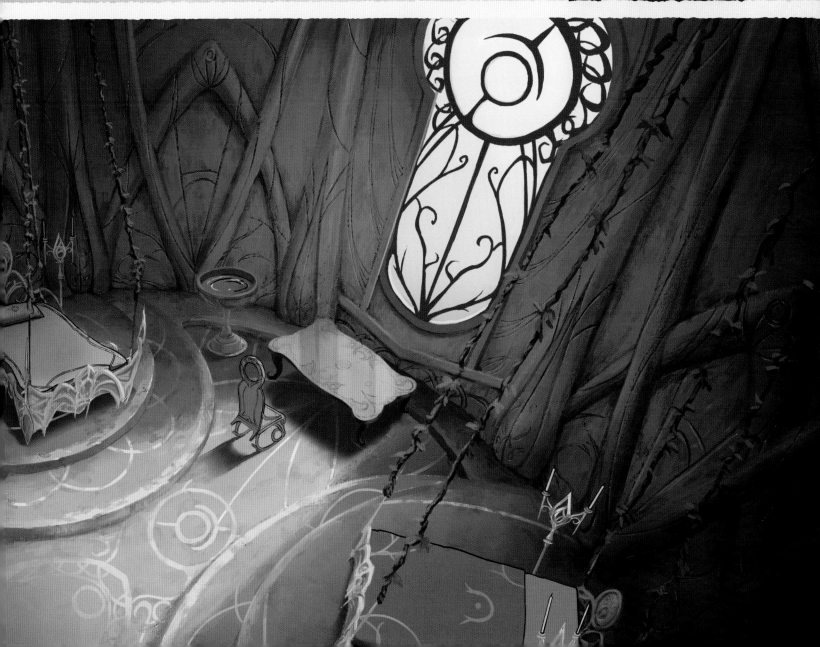

AARAVOS

AARAVOS IS AS mysterious as he is alluring, and his charisma compels even Viren to entertain his sinister influence. A Startouch elf of great power, his past has been purged from history, and Aaravos himself is trapped somewhere in a magical prison—but why? Is Aaravos a tragic victim of Xadia's arrogance, or a manipulator who pulled too hard at the strings of his puppets?

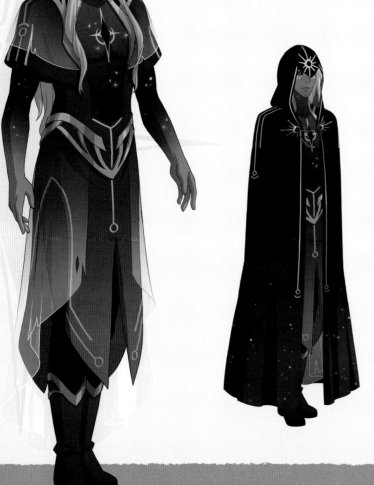

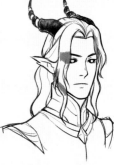

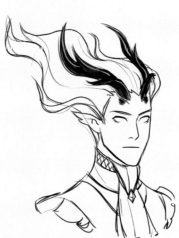

As a "fallen" Startouch elf, Aaravos can only access a fraction of his former power.

We began explorations of Startouch elves using words like "beautiful," "ethereal," and "otherworldly."

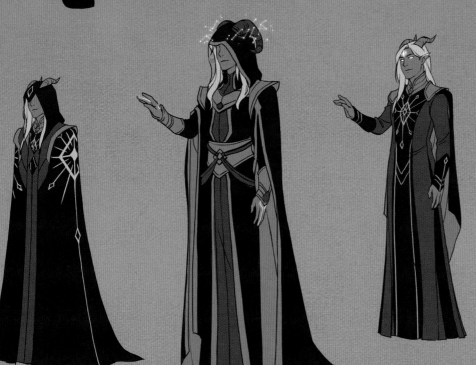

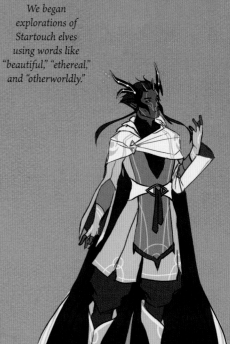

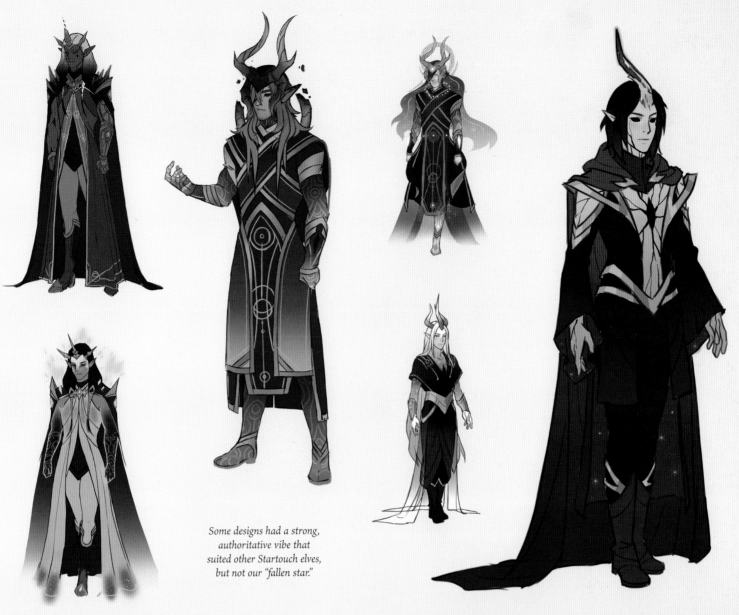

Some designs had a strong, authoritative vibe that suited other Startouch elves, but not our "fallen star."

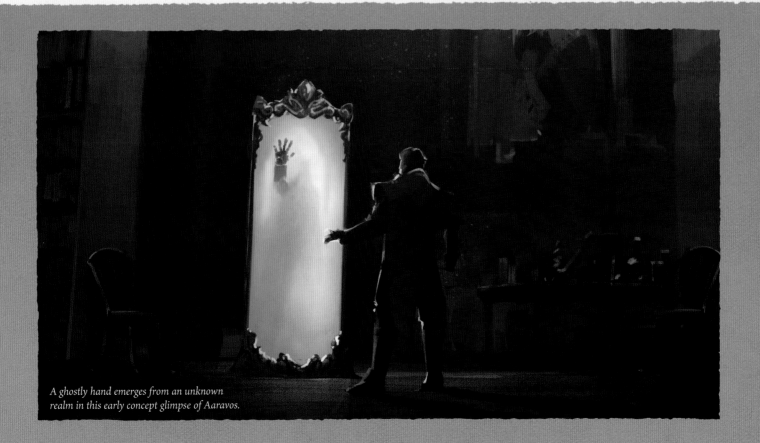

A ghostly hand emerges from an unknown realm in this early concept glimpse of Aaravos.

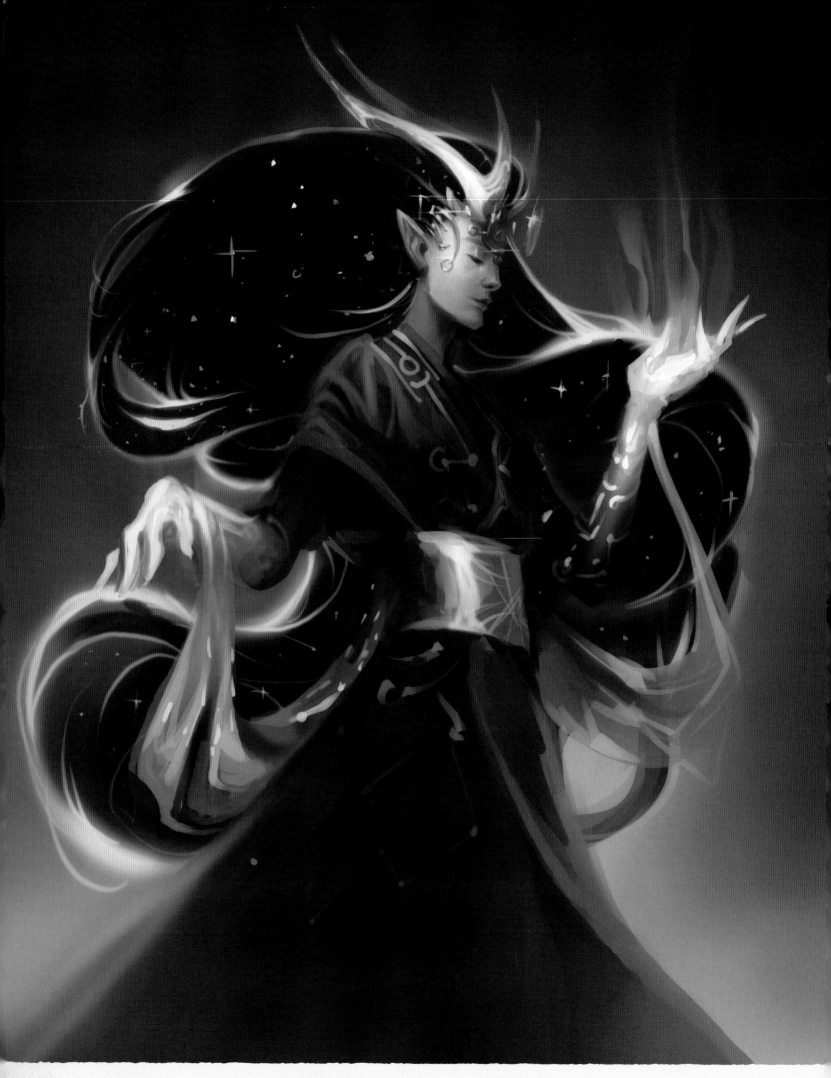

This first concept of a celestial elf defined how we thought of Aaravos and other mysterious Startouch elves.

How does it feel to replace your arm with a writhing tentacle, Claudia?

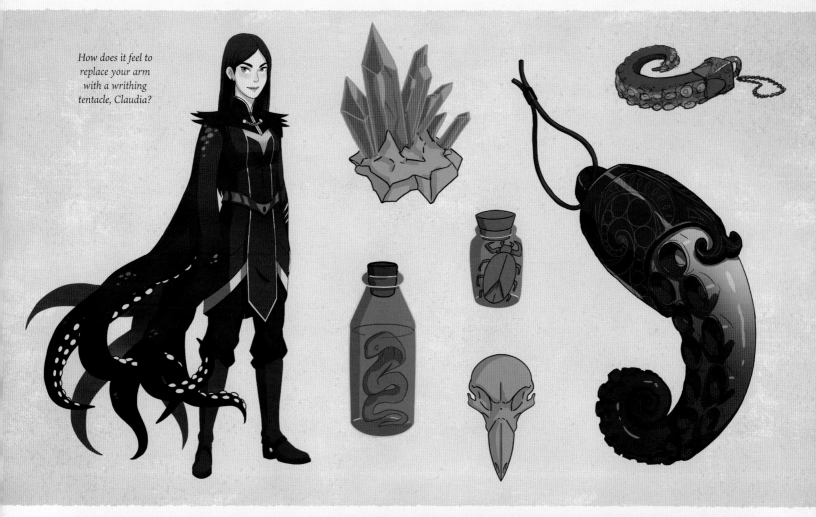

This spell was Claudia's biggest display of power yet. The tentacle's creepiness underscored her betrayal of the princes.

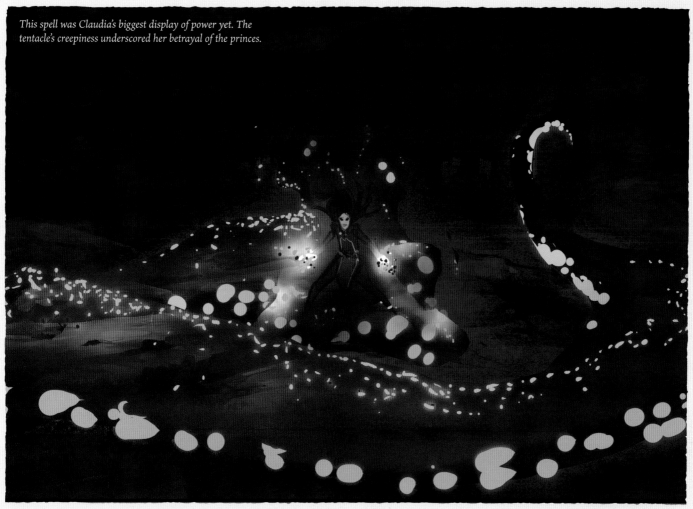

CAPTAIN VILLADS

WHETHER OR NOT Villads's tales of his past life as a pirate are true, his warm-hearted advice touched Rayla, Callum, and Ezran. His ragged clothing is more reflective of his weird sense of humor than his blindness.

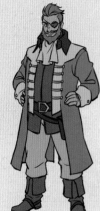

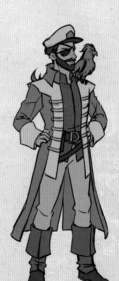

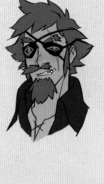

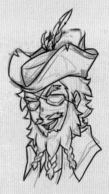

These concepts helped us calibrate the maximum amount of bird poop a character design could sustain.

BERTO

BERTO WAS BASED on an actual parrot. The real version is even meaner.

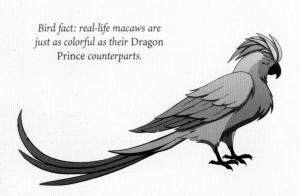

Bird fact: real-life macaws are just as colorful as their Dragon Prince counterparts.

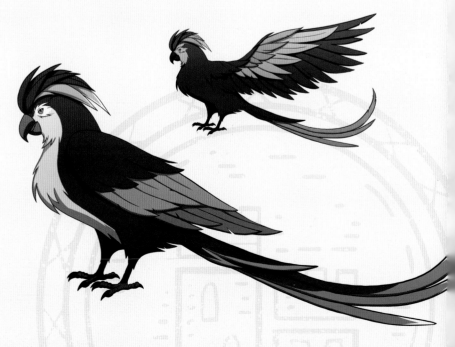

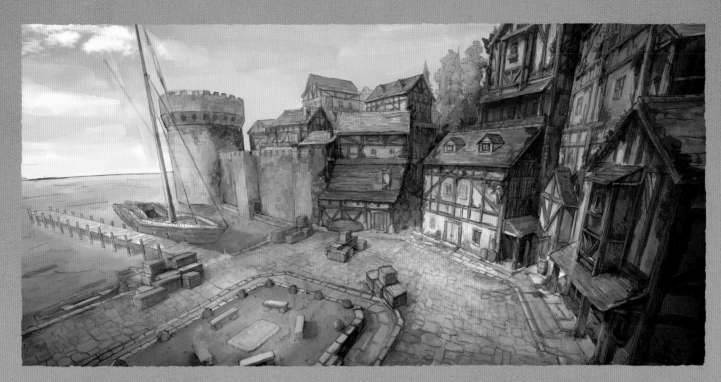

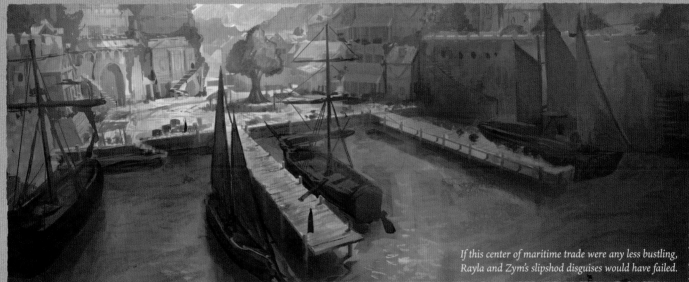

If this center of maritime trade were any less bustling,
Rayla and Zym's slipshod disguises would have failed.

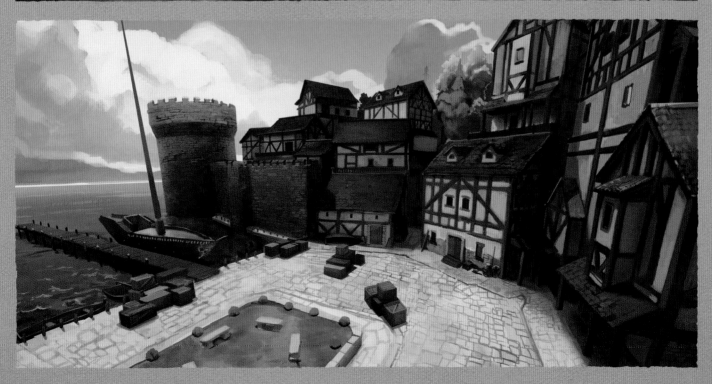

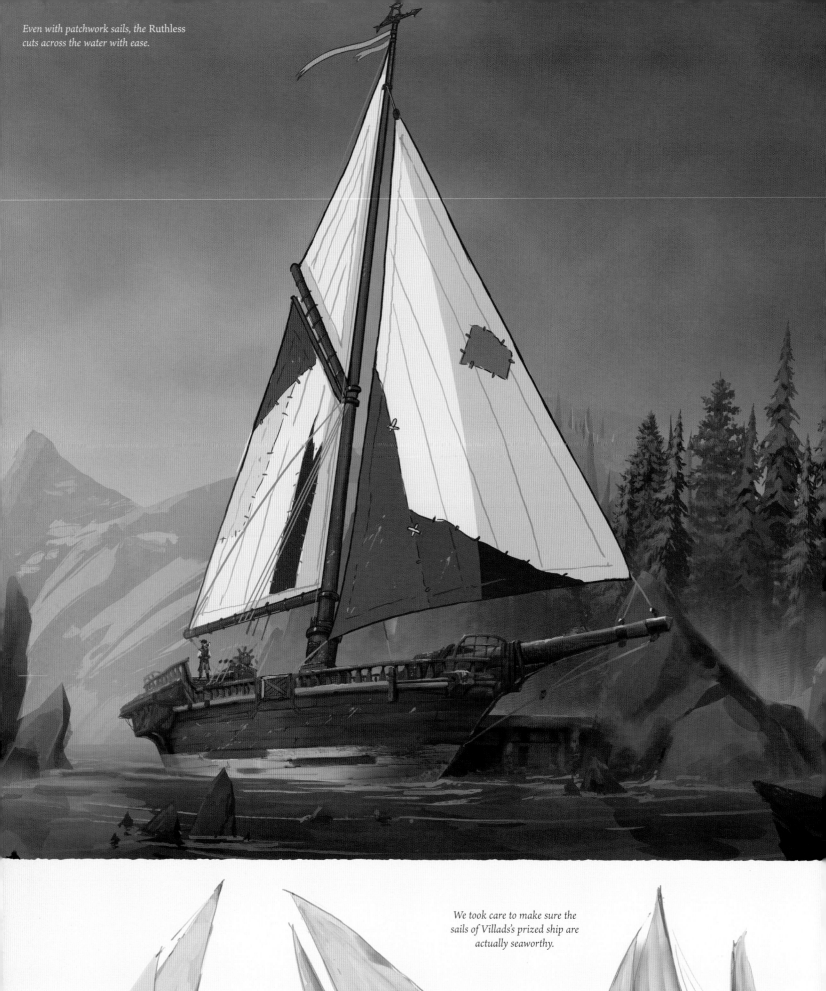

Even with patchwork sails, the Ruthless cuts across the water with ease.

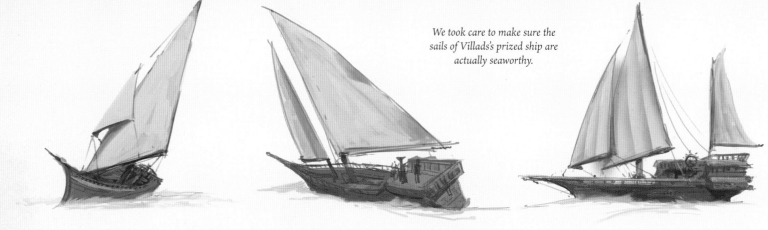

We took care to make sure the sails of Villads's prized ship are actually seaworthy.

The space below deck provides a quiet
place for ship captains, old parrots, and
anxious teens to reflect on their feelings.

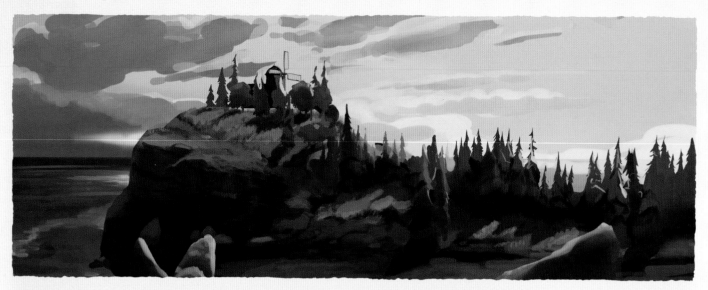

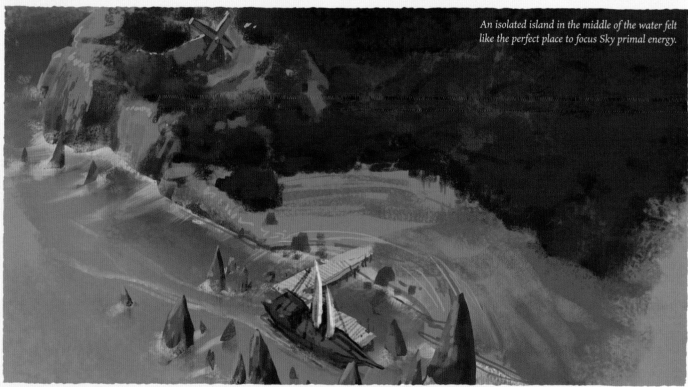

An isolated island in the middle of the water felt like the perfect place to focus Sky primal energy.

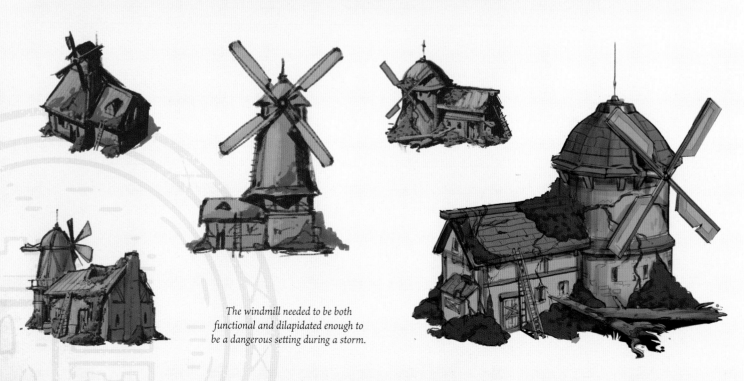

The windmill needed to be both functional and dilapidated enough to be a dangerous setting during a storm.

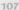

Aaravos's box of mysterious items takes inspiration from 18th century French ormolu jewelry boxes.

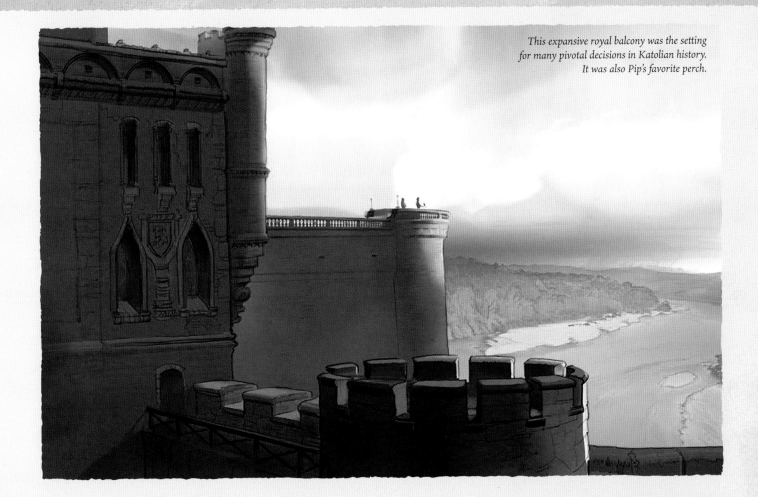

This expansive royal balcony was the setting for many pivotal decisions in Katolian history. It was also Pip's favorite perch.

QUEEN SARAI

CALLUM AND EZRAN'S mother Sarai was the beloved queen of Katolis, a warrior whose brave sacrifice saved the people of two kingdoms from starvation. She is remembered for her "sweet tooth and iron fist," with an unwavering belief in compassion and the strength of heart to fight for it.

We liked the braid and the up-do for Sarai's hair, so she got to have both!

Even after she became queen, Sarai was always most comfortable in her armor.

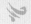

Every heated argument is more dramatic during a sparring match. This scene reminded us that Harrow and Sarai were not just royalty, but warriors too.

QUEEN FAREEDA

FAREEDA IS QUEEN of Evenere, a nation off the western coast of Katolis. While Evenere itself is mostly swampland plagued by dreary weather, Fareeda herself is warm and pleasant.

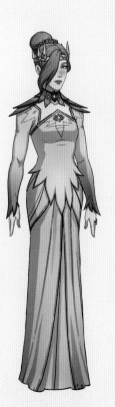

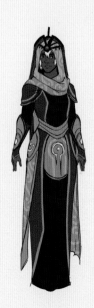

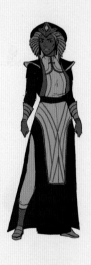

Alternate color palettes and designs for Queen Fareeda.

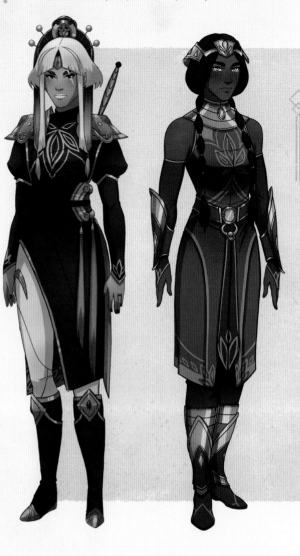

QUEENS OF DUREN

THE QUEENS OF DUREN arrive seeking aid, desperate to make a better future for their people and their infant daughter, Aanya. Neha is typically the voice of reason, while Annika speaks from the heart.

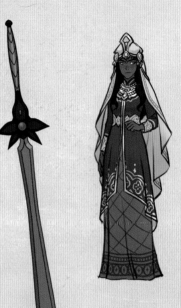

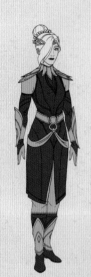

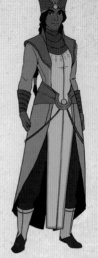

Some of their unused designs became inspirations for other leaders of the Pentarchy.

QUEEN AANYA

QUEEN AANYA INHERITED the throne of Duren at a very young age, and had to grow up fast to defeat those who sought to usurp her rule. Now, Aanya has the will and the savvy to match wits with even Lord Viren.

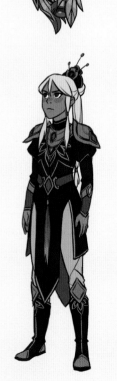

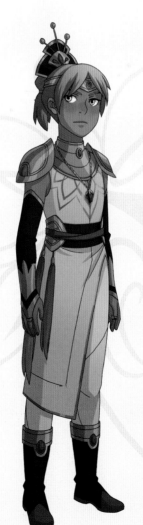

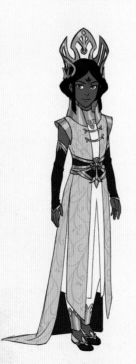

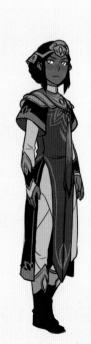

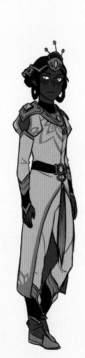

KING FLORIAN

A BEAR OF a man, King Florian has a big, strong heart and bigger, stronger arms. As king of the rugged mountains of Del Bar, he values a hard day's work and a warm hearth at night.

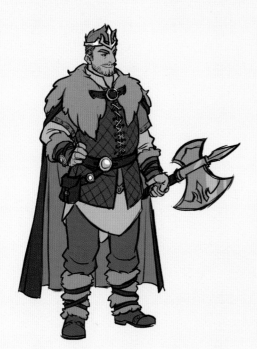

KING AHLING

KING AHLING RULES over the proud and prosperous nation of Neolandia. His wealth and privilege have shielded him from most tough decisions in life, but he's a kind man who loves his many children more than anything.

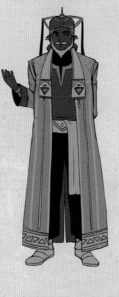

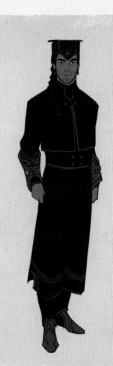

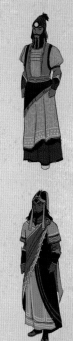

(Left) This alternate design for Ahling became the inspiration for his eldest son, Prince Kasef.

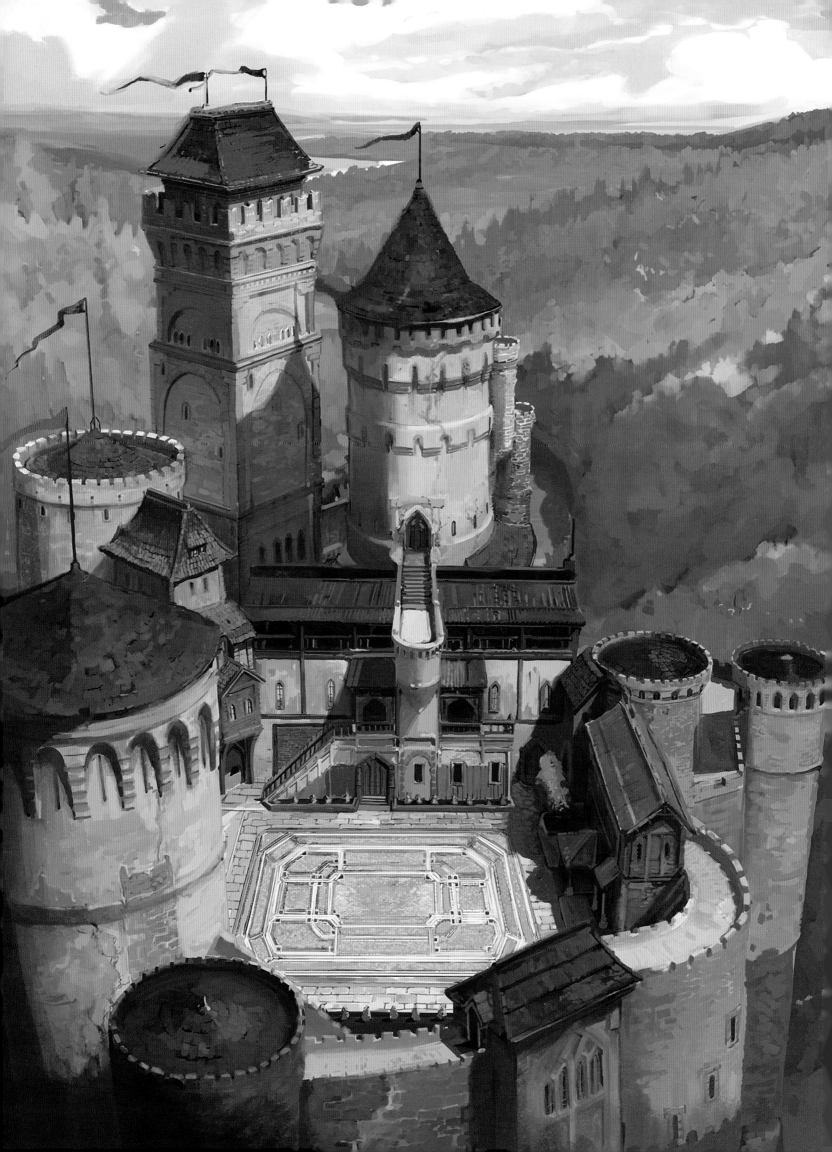

BABY EZRAN

EZRAN WAS JUST a tiny baby when his mother, Queen Sarai, gave her life while on a dangerous mission into Xadia.

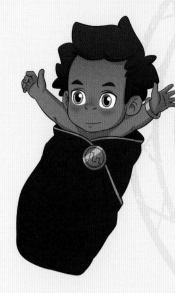

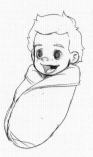

Even as a baby, Ezran's hair was as untamable as his appetite for jelly tarts.

YOUNG CALLUM

CALLUM, ON THE other hand, was old enough to remember his mother when she died. Even now, he feels the pain of her loss every day.

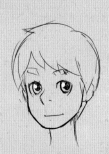
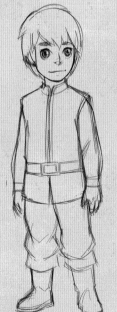
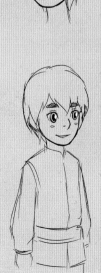
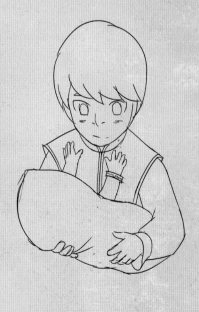

When Ezran was born, Callum promised he'd be the best big brother in the world.

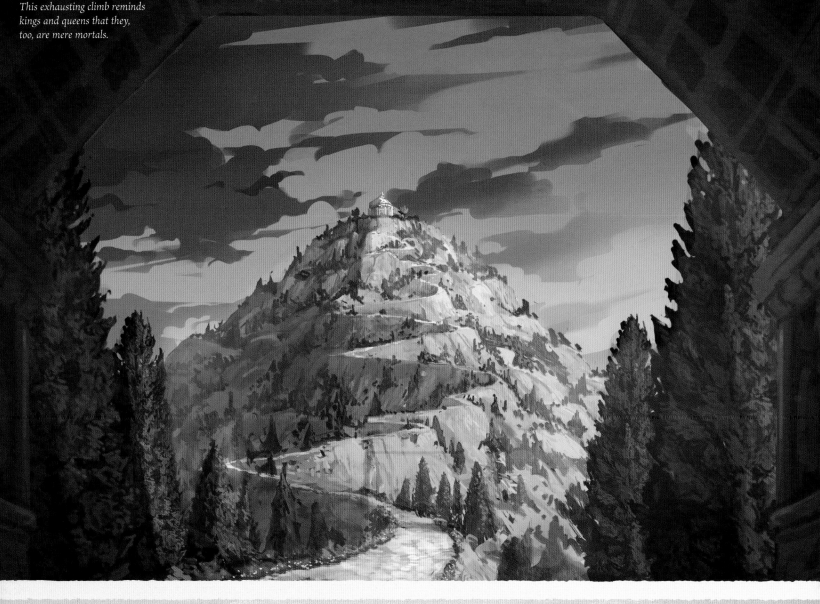

This exhausting climb reminds kings and queens that they, too, are mere mortals.

This archway was inspired by the Arc de Triomphe.

SPOTLIGHT

THE HUMAN KINGDOMS

NEOLANDIA

The towering palace of Neolandia stands as a monument among the barren dunes of the northern desert lands. In the face of great scarcity, the resourceful people of Neolandia have developed a rich culture of trade and barter, while still maintaining a massive, well-trained army.

EVENERE

Before Evenere opened its borders, few had navigated the maze-like swamplands of the west to encounter its people. Evenere's isolation from the helping hands of neighbors has made it fiercely independent, so much so that the intense bonds between its citizens are often misinterpreted as fear and mistrust of foreigners.

DEL BAR

To the average person, the freezing valleys and rocky crags of the western mountains would be uninhabitable. But to the hearty folk of Del Bar, there is no better home. Some say they stay warm because hot beef stew runs through their veins instead of blood. Others say it's just their really thick tunics.

DUREN

Rainwater and snowmelt flow down from the mountains, bringing water to countless farms in the rolling, fertile plains of Duren. As the breadbasket to the Human Kingdoms, Duren is especially at risk from attack by any vengeful neighbors in Xadia.

KATOLIS

Katolis's population and great military strength reflect its status as the largest human kingdom. The magical land of Xadia looms large just over the long stretch of border to the east. In the face of this constant threat, Katolis has endured heartbreaking loss as well as incredible victories over the ages.

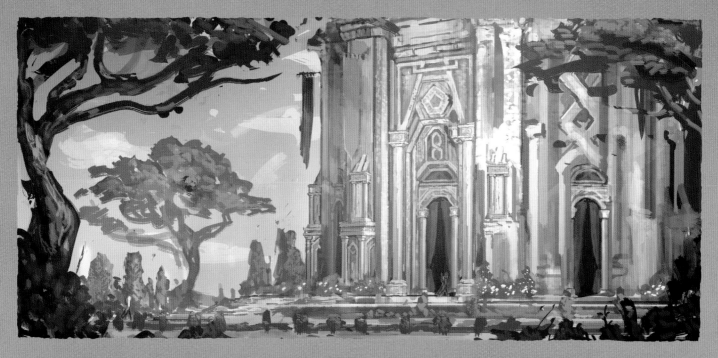

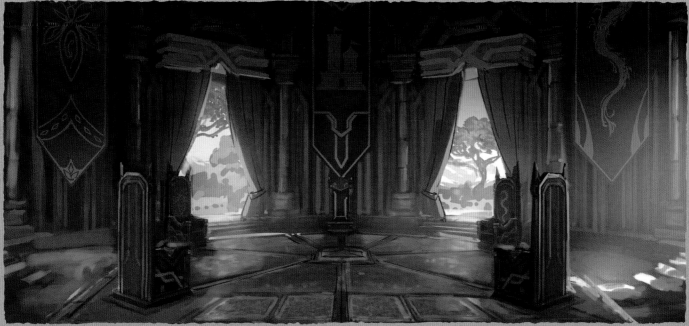

The grand chamber where the Pentarchy meets grants equal stature to each of the monarchs—or regents—in attendance.

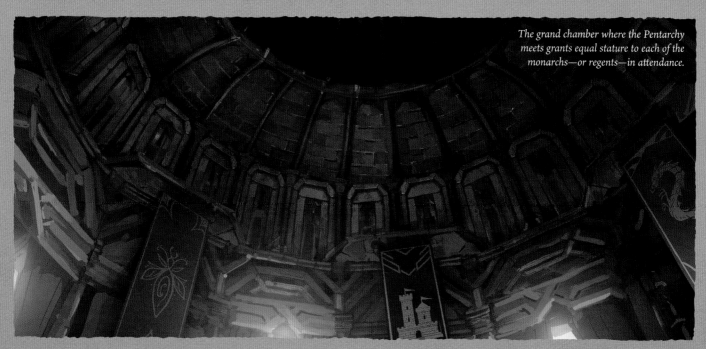

Artists developed both simple and ornate versions of each kingdom's icon for their flags, thrones, and costuming details.

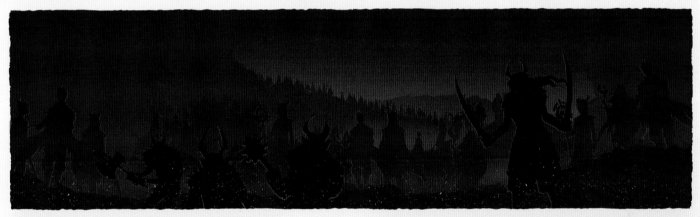

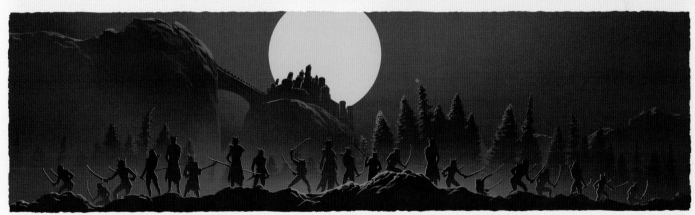

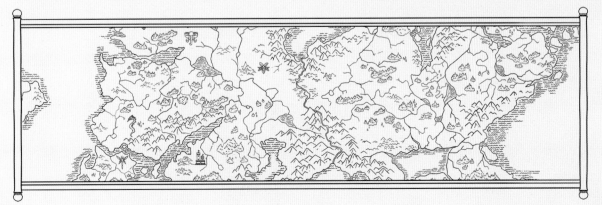

This scroll isn't particularly functional as a map, but it's a useful prop for Viren's extremely dramatic magical speech.

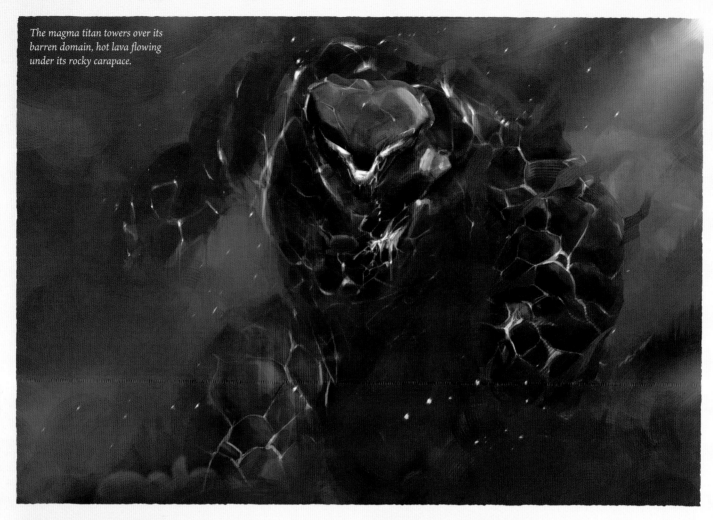

The magma titan towers over its barren domain, hot lava flowing under its rocky carapace.

MAGMA TITAN

MAGMA TITANS ARE huge sentient beings made of burning hot lava and rock. Though dangerous, at heart they are just like so many other creatures of Xadia: peaceful unless provoked. Queen Sarai tried to impress this message of compassion upon the leadership of Katolis, but even Harrow did not heed her words.

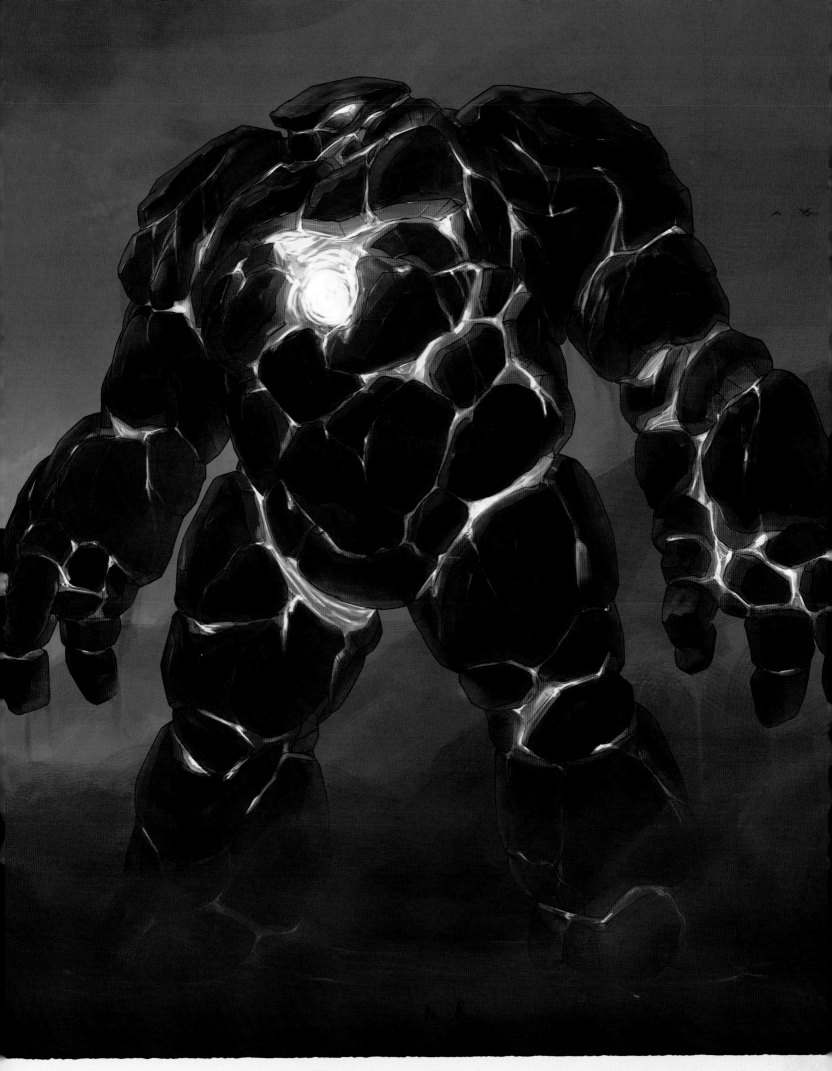

The detailed texture and glowing cracks of the magma titan design were a challenge for the 2D/3D style of the show.

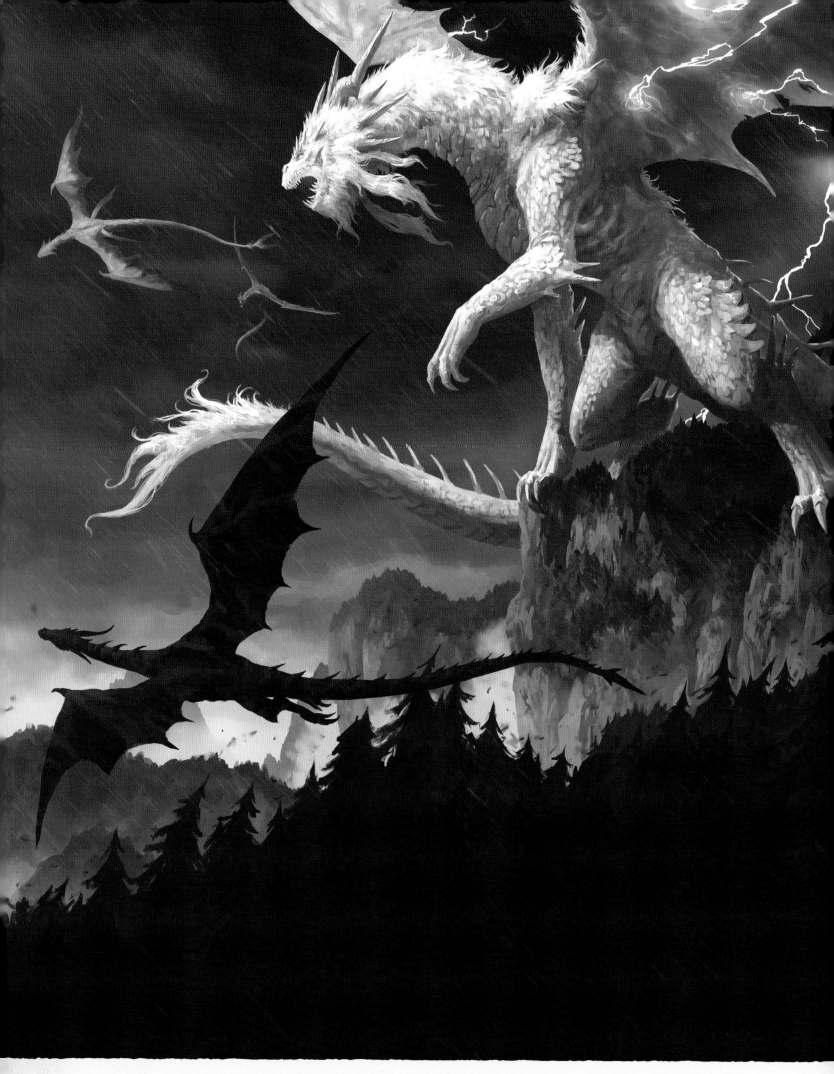

A giant print of this painting covers an entire wall in The Dragon Prince team's office. Every morning we are crushed by Thunder's piercing glower.

THUNDER, THE DRAGON KING

AVIZANDUM, THE INDOMITABLE King of Dragons. The incredible powers imparted to him through his direct connection to the Sky primal are matched only by his commitment to Queen Zubeia and their tireless watch over Xadia.

We decided to save the iconic "crown of horns" for Sol Regem. Thunder instead derives uniqueness from his crackling lightning and furry mane.

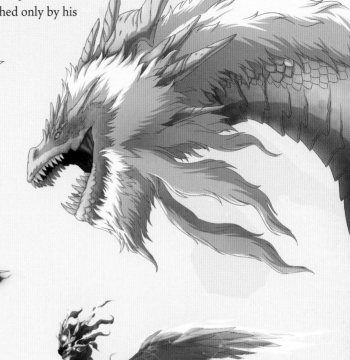

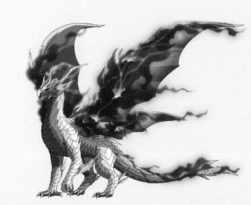

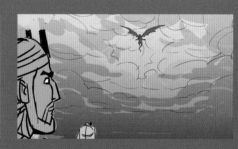

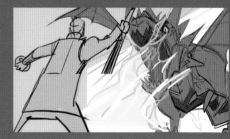

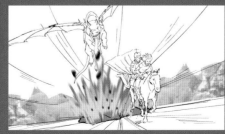

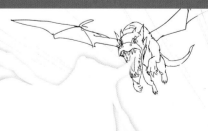

Harrow's compassionate decision to save the injured soldiers of Katolis results in a terrible consequence as Thunder catches up to them.

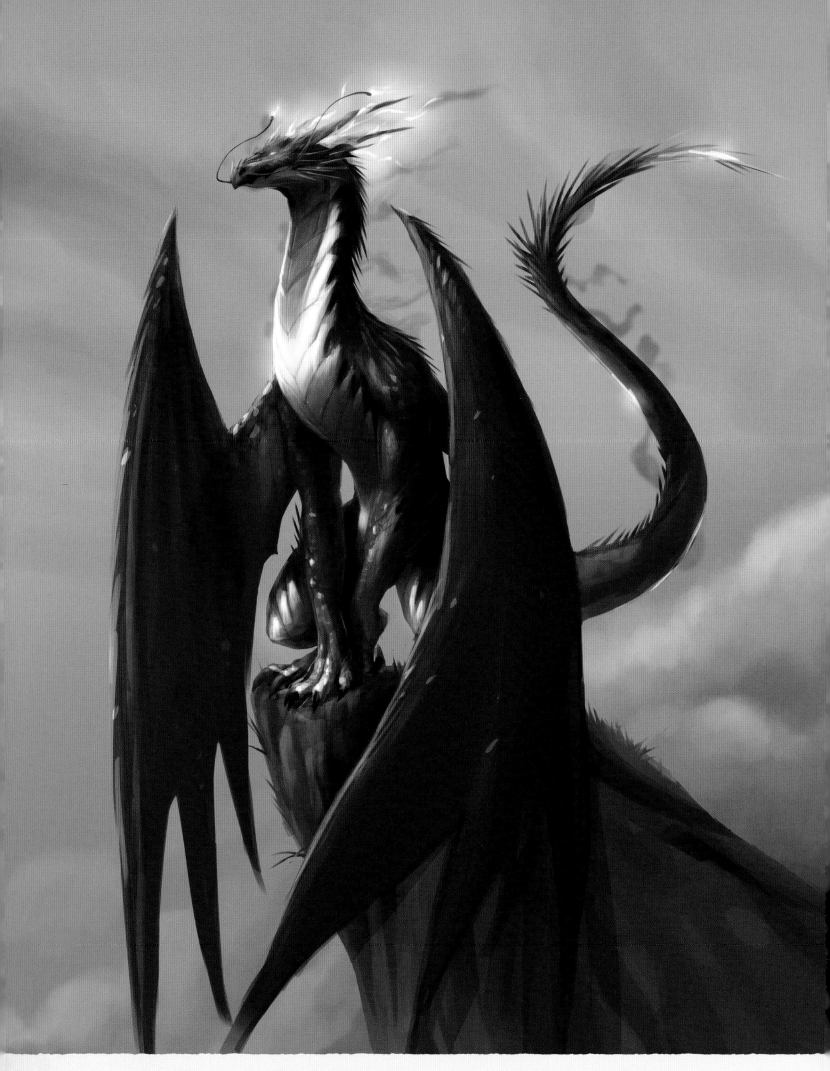

Pyrrah might be younger and less powerful than archdragons like Thunder and Sol Regem, but she's still an imposing and beautiful creature.

PYRRAH

A CLASSIC FIRE-BREATHING dragon, Pyrrah is connected to the Sun primal. She has a quick temper and an itch to pick a fight with humans . . . a fight Soren is all too eager to give her.

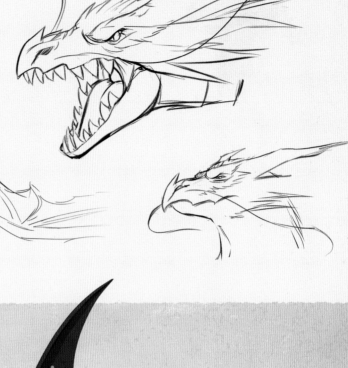

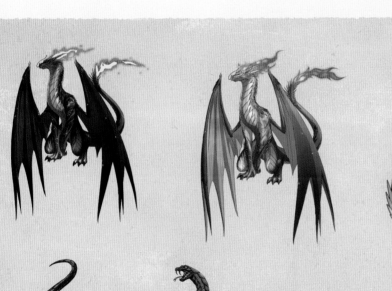

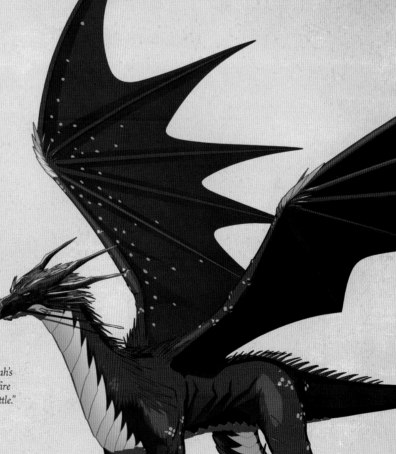

Alternate colors for Pyrrah's scales were used for the fire dragons in "The Final Battle."

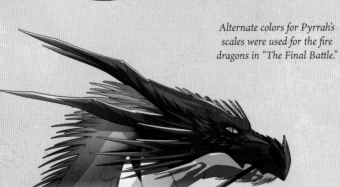

SPOTLIGHT

⌗

DRAGONS OF XADIA

It's right there in the title: dragons are at the heart of *The Dragon Prince*. The seed of the story was planted with the idea of a land ruled by these enormous, majestic creatures, and the humans who coveted their power. We wanted the dragons of Xadia to be distinct and diverse, while still fulfilling the audience's expectations for fiction's most legendary creatures.

In developing Xadia's dragons, we started with magic: as with most other creatures of Xadia, dragons are aligned with one of the six primal sources. In the show's opening we meet two archdragons, the most powerful dragons with the strongest connections to their respective primal. Sol Regem is a classic winged, fire-breathing beast, but his visual design is informed by the Sun, with scales that gleam like gold and a radial horn shape inspired by the sun's rays. The immense Sky dragon Avizandum commands the power of a great storm, and his beard and mane flow like clouds against his sky-blue scales.

Archdragons are rare and enormously powerful, but the vast majority of dragons in Xadia are like Pyrrah: smaller in stature and voiceless, but still connected to a primal source. Though we've only met a few in the show so far, we're excited to discover what's next: a grand earthen wyrm, or a flock of ocean drakes, or perhaps even a Star dragon (if such a thing exists). And, of course, we can't wait to see Zym grow up to be the next King of the Dragons.

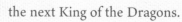

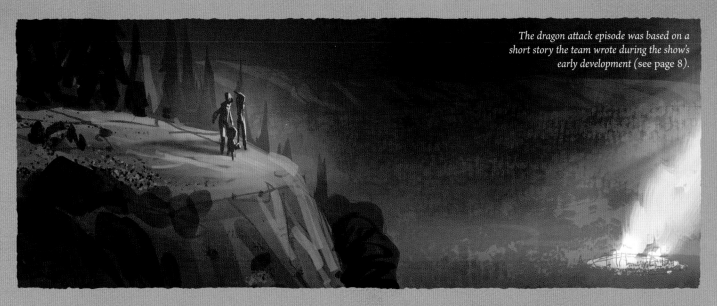

The dragon attack episode was based on a short story the team wrote during the show's early development (see page 8).

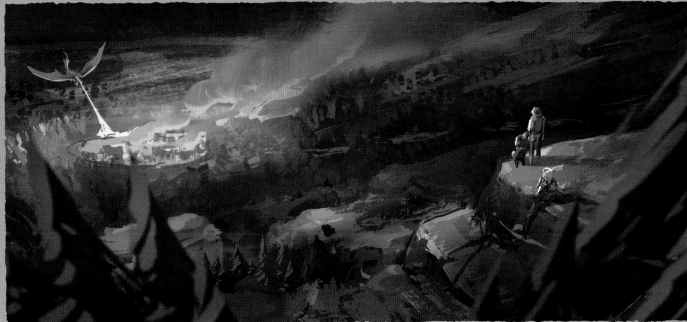

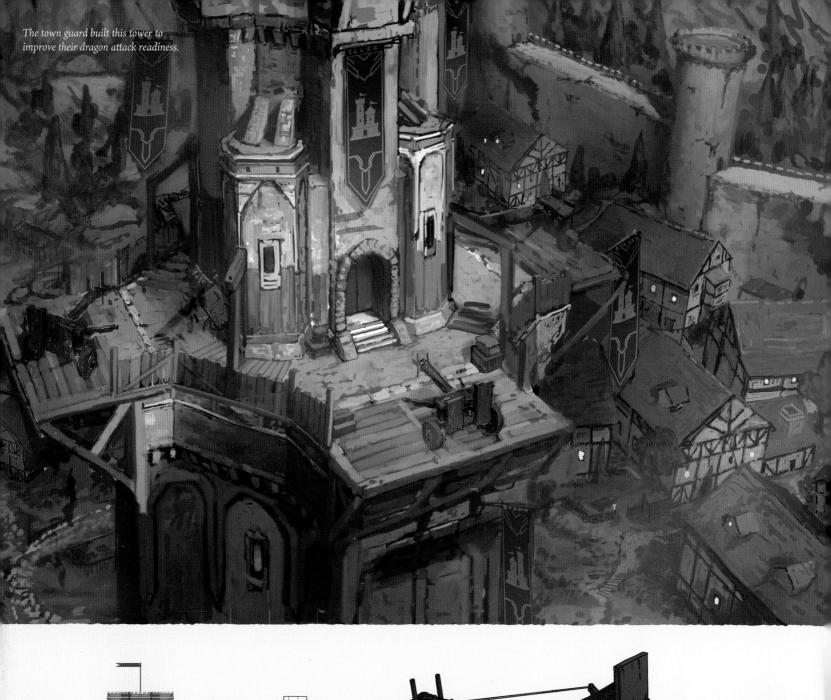

The town guard built this tower to improve their dragon attack readiness.

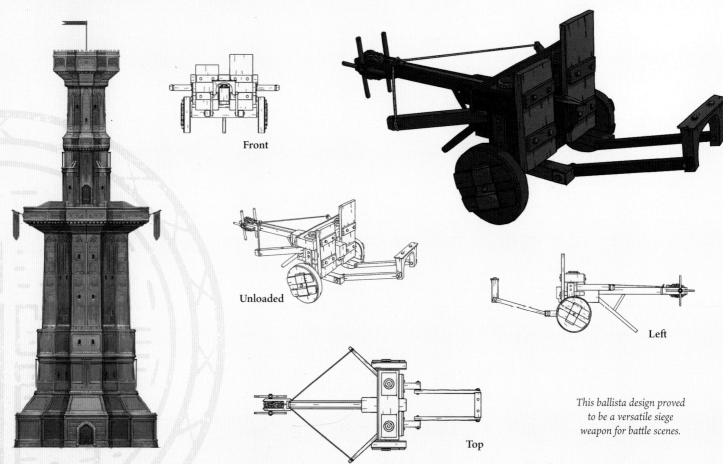

Front

Unloaded

Left

Top

This ballista design proved to be a versatile siege weapon for battle scenes.

This makeshift doctor's office is rustic, cozy, and wildly
overwhelmed in the aftermath of a dragon attack.

DARK MAGIC CALLUM

DARK CALLUM'S PALLID skin and sunken eyes recalled Viren's true form: withered by overusing dark magic. This is what Callum fears he could become.

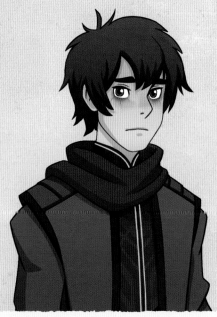

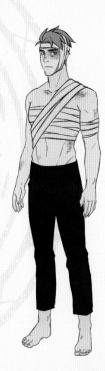

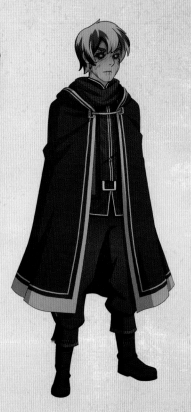

Villads's advice about sails and wings took root and blossomed in Callum's revelatory dream sequence.

PARALYZED SOREN

SOREN'S GRAVE INJURY was a direct result of his reckless attack on a dragon. His difficult recovery marked a critical turning point in his character.

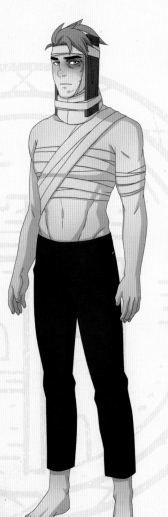

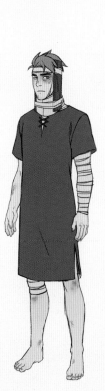

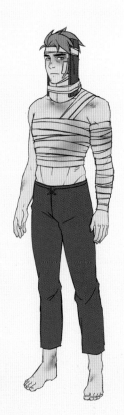

Claudia has extensive knowledge of many Xadian herbs and flowers, and their properties.

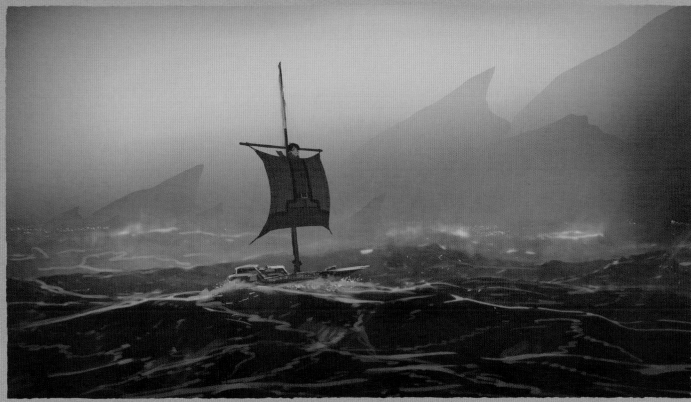

Due to a script formatting oddity, we jokingly
referred to the strange planes of Callum's
subconscious as "Dream Space No Time."

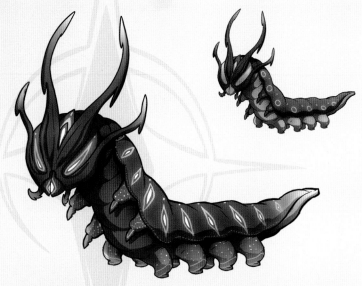

This creature's striking headpiece is inspired by Polyura caterpillars.

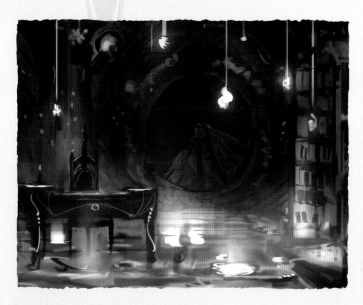

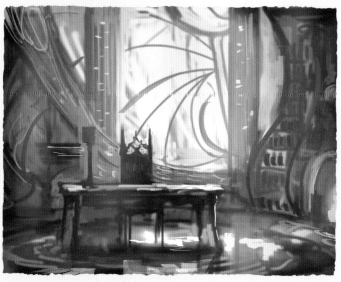

We chose real-world languages for these old tomes to create some shareable secrets for fans.

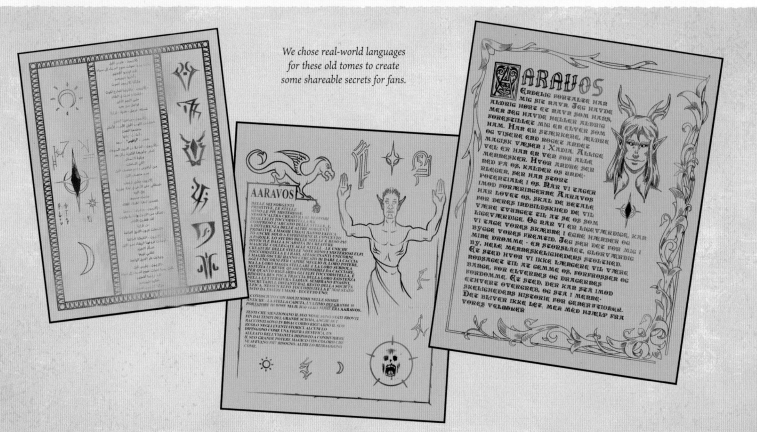

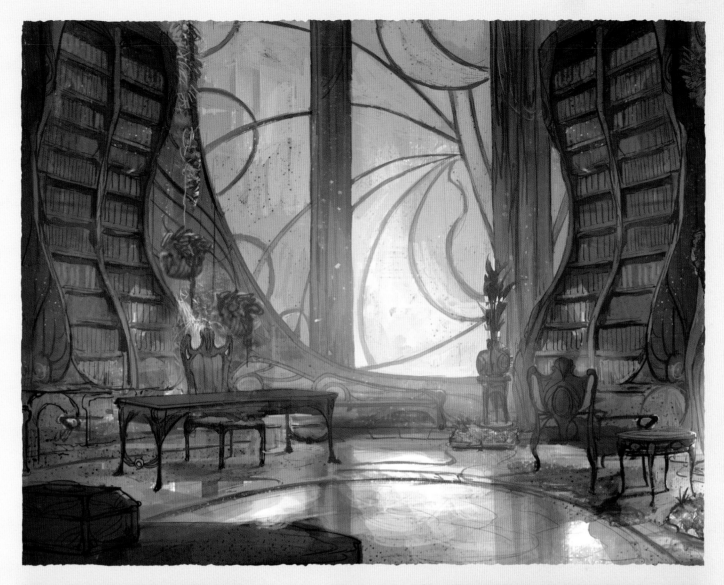

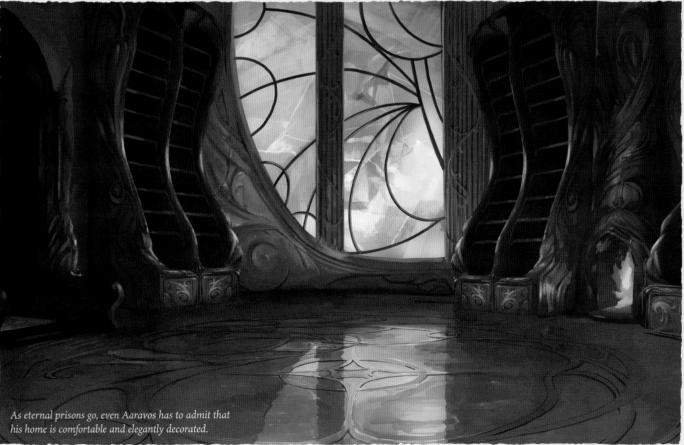

As eternal prisons go, even Aaravos has to admit that his home is comfortable and elegantly decorated.

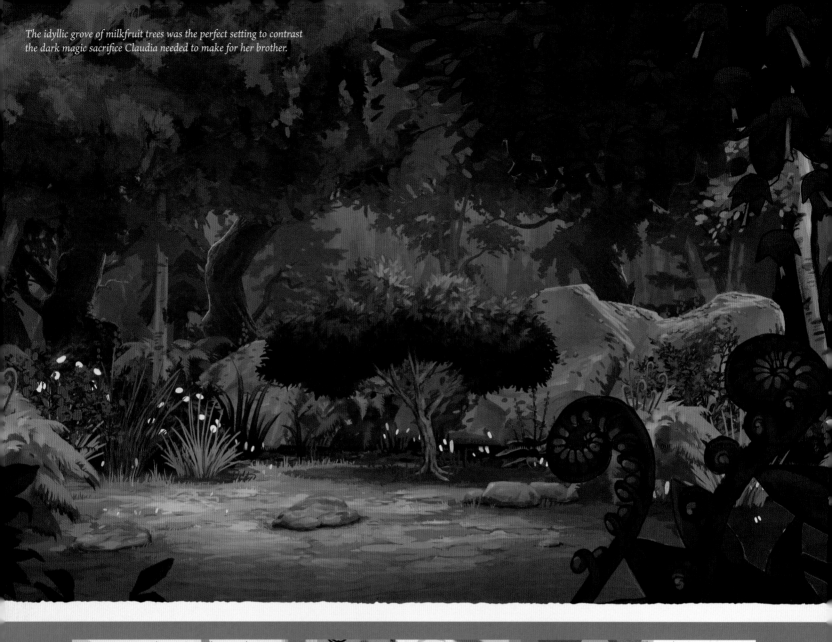

The idyllic grove of milkfruit trees was the perfect setting to contrast the dark magic sacrifice Claudia needed to make for her brother.

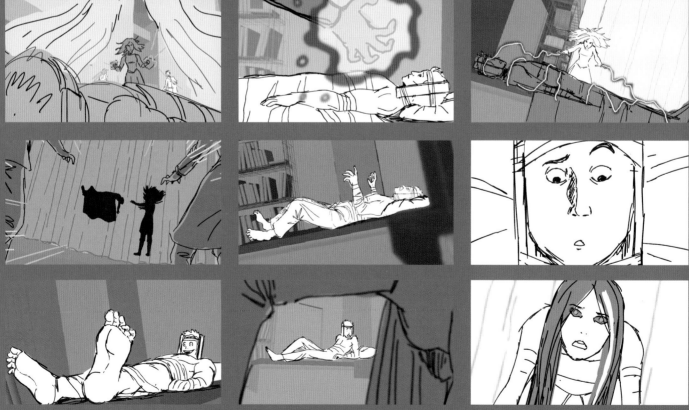

Stripped of his physical strength, this scene shows us Soren at his most vulnerable. With wounded body and pride, will he change for the better?

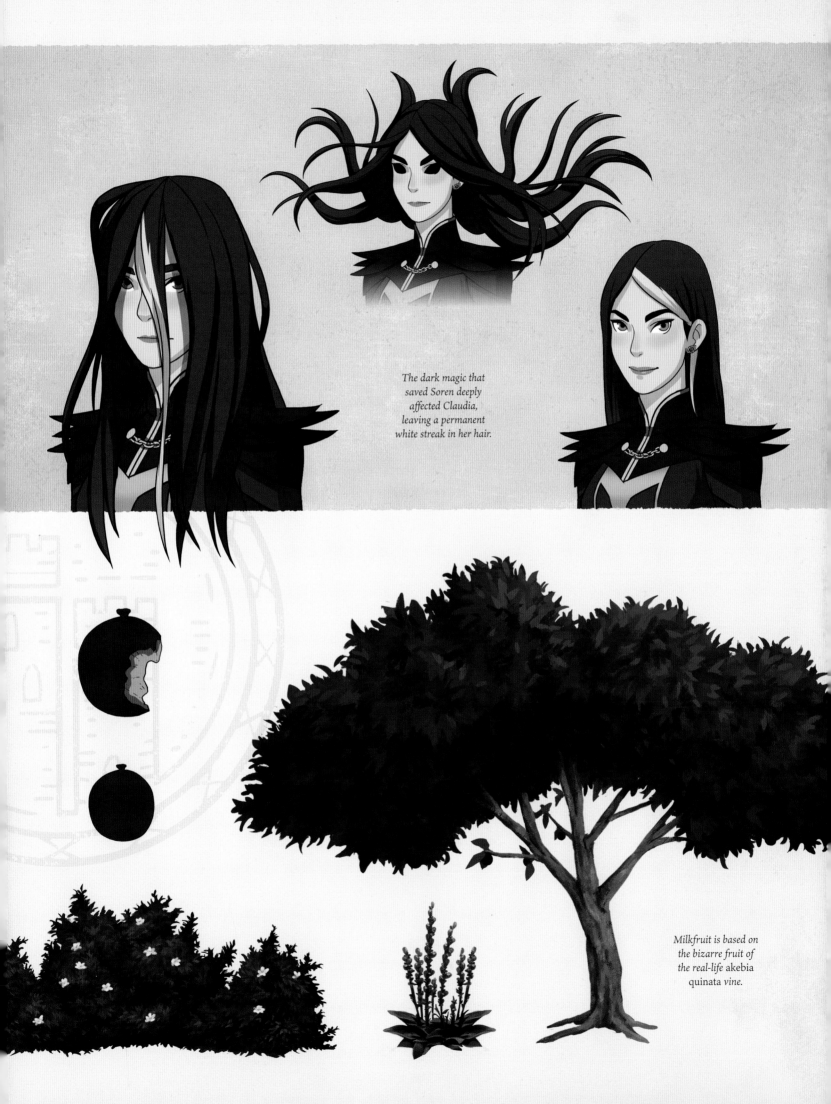

The dark magic that saved Soren deeply affected Claudia, leaving a permanent white streak in her hair.

Milkfruit is based on the bizarre fruit of the real-life akebia quinata vine.

SPOTLIGHT

CREATING THE LANGUAGE OF DARK MAGIC

Unable to harness primal magic, ancient humans learned to harvest magical creatures to cast potent and devastating spells, a practice the races of Xadia condemned as "dark magic." As a driving force behind the conflict in *The Dragon Prince*, dark magic had to feel corrupted and wrong on a fundamental level.

Dark magic starts with an ingredient, a piece of a magical creature thematically linked to the intent of the spell (a cat's paw for silence, a griffon's eye for accuracy).

While we couldn't get too creepy, we wanted to suggest horror and sacrifice in dark magic. For example, we couldn't actually show a griffon's plucked eyeball, but Soren's reaction to seeing it implies the grotesque stuff Claudia is comfortable with.

With a dark magic spell, the mage's eyes glow a vivid violet as they are infused with power stolen from an ingredient of choice. When the spell is cast, the mage's eyes fade to a deep void of black as that power leaves their body . . . perhaps taking a piece of the mage with it.

Finally, dark magic incantations are spoken backward. While primal magic uses Latin and has a very "classic fantasy" vibe, we wanted dark magic to sound like the exact opposite. Inspired by the creep factor of records played backwards, dark magic incantations hit the spooky vibe we were going for. It also left behind a fun Easter egg: fans could reverse the spell incantation and find out what the mage actually said!

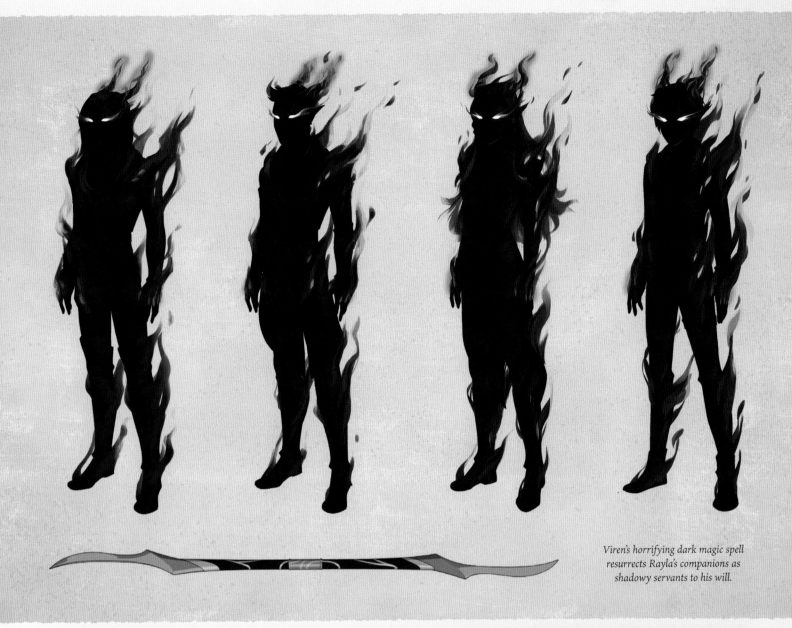

Viren's horrifying dark magic spell resurrects Rayla's companions as shadowy servants to his will.

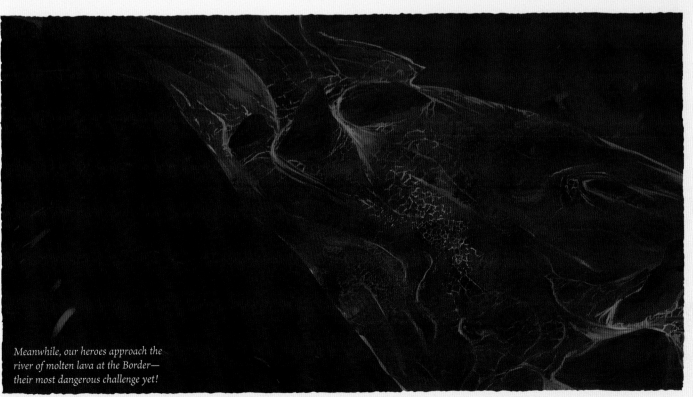

Meanwhile, our heroes approach the river of molten lava at the Border—their most dangerous challenge yet!

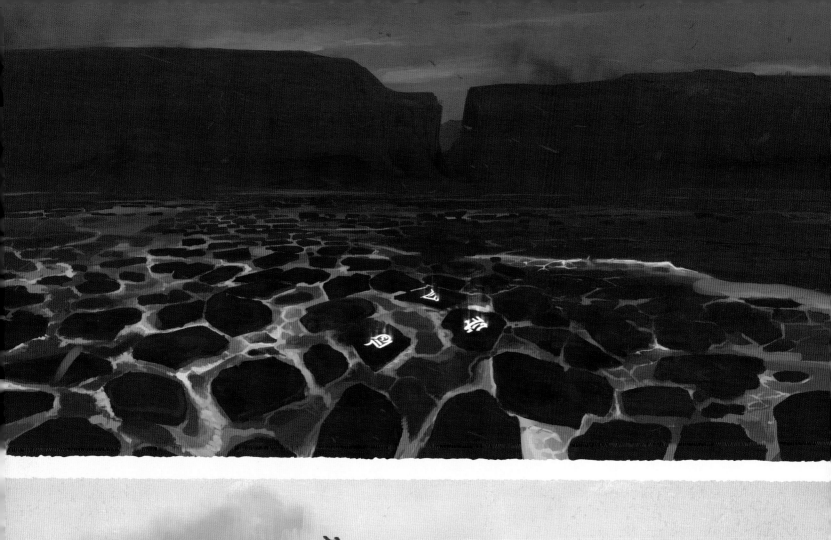

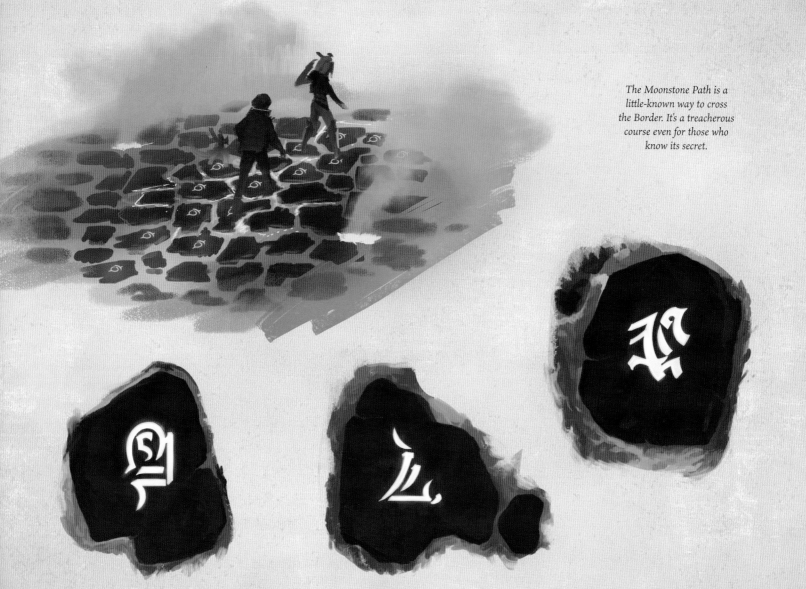

The Moonstone Path is a little-known way to cross the Border. It's a treacherous course even for those who know its secret.

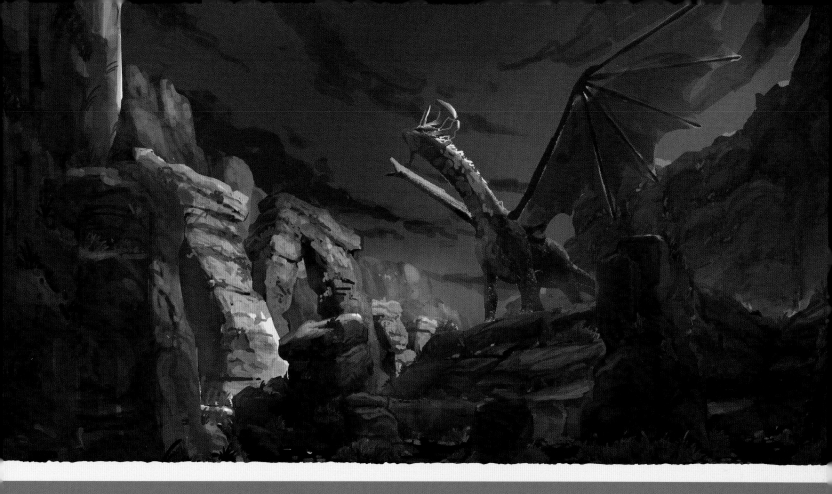

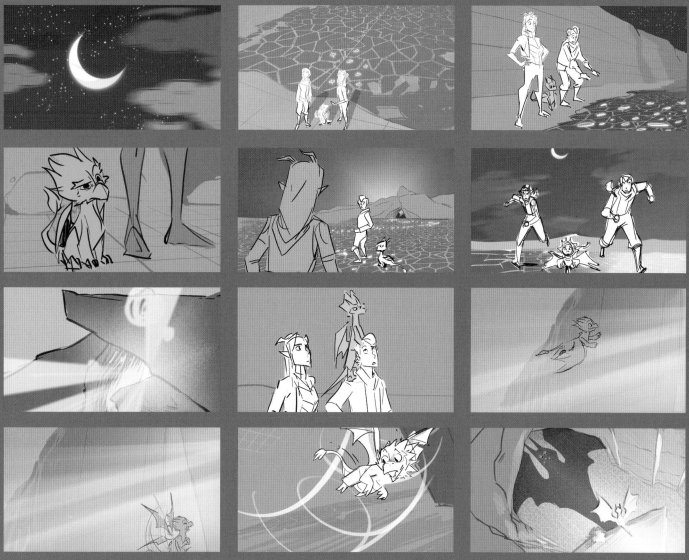

Crossing into Xadia was a challenging sequence to storyboard, with a complex night-to-day transition, a dragon/human mind-meld, and Zym's triumphant first flight.

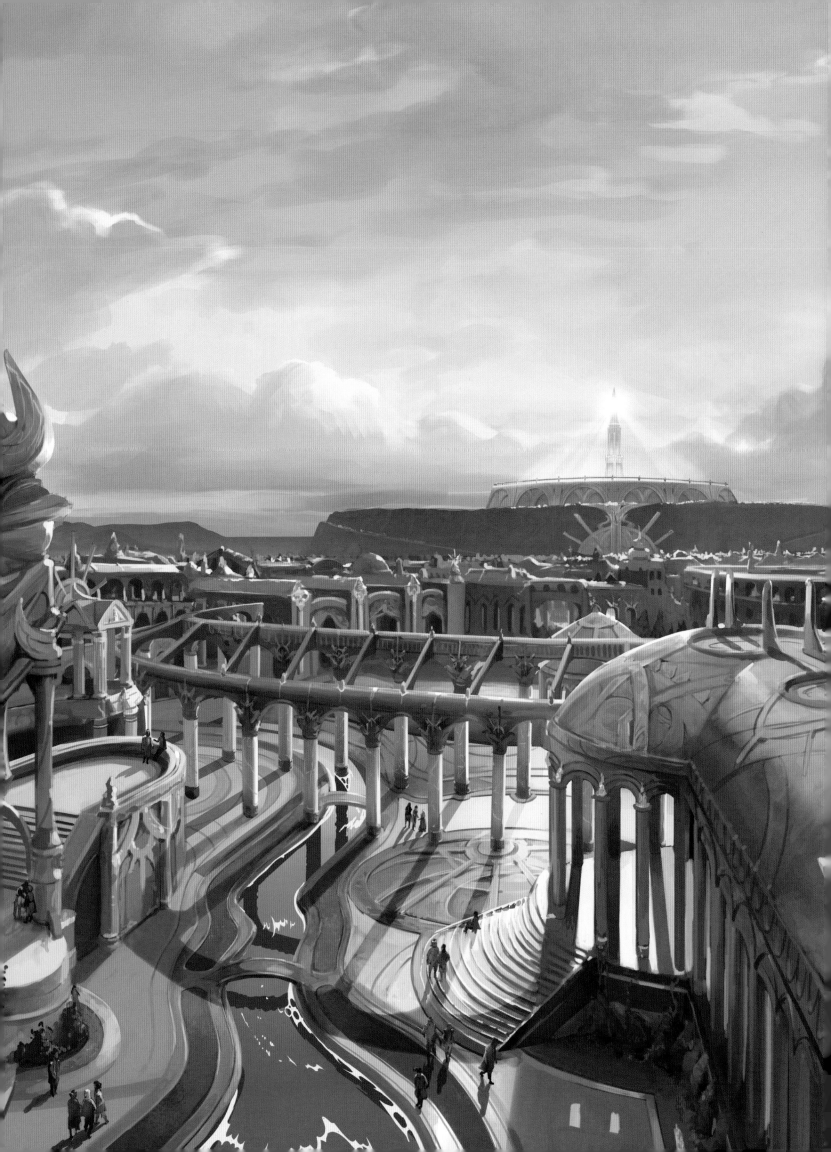

BOOK THREE
SUN

XADIA! Callum and Rayla have finally crossed the Border and the final stretch of their journey begins. Ezran returns home to take his place on the throne, where he hopes to stand against the calls for bloodshed. All the while, Viren plots from jail as Aaravos's mysterious influence grows. Will little Zym be reunited with his mother before the two worlds erupt in all-out war?

SOL REGEM

SOL REGEM IS a powerful Sun archdragon, and former King of the Dragons. Left blind after a faceoff with the original dark mage, Ziard, Sol Regem's hatred for humans smolders in his ancient heart.

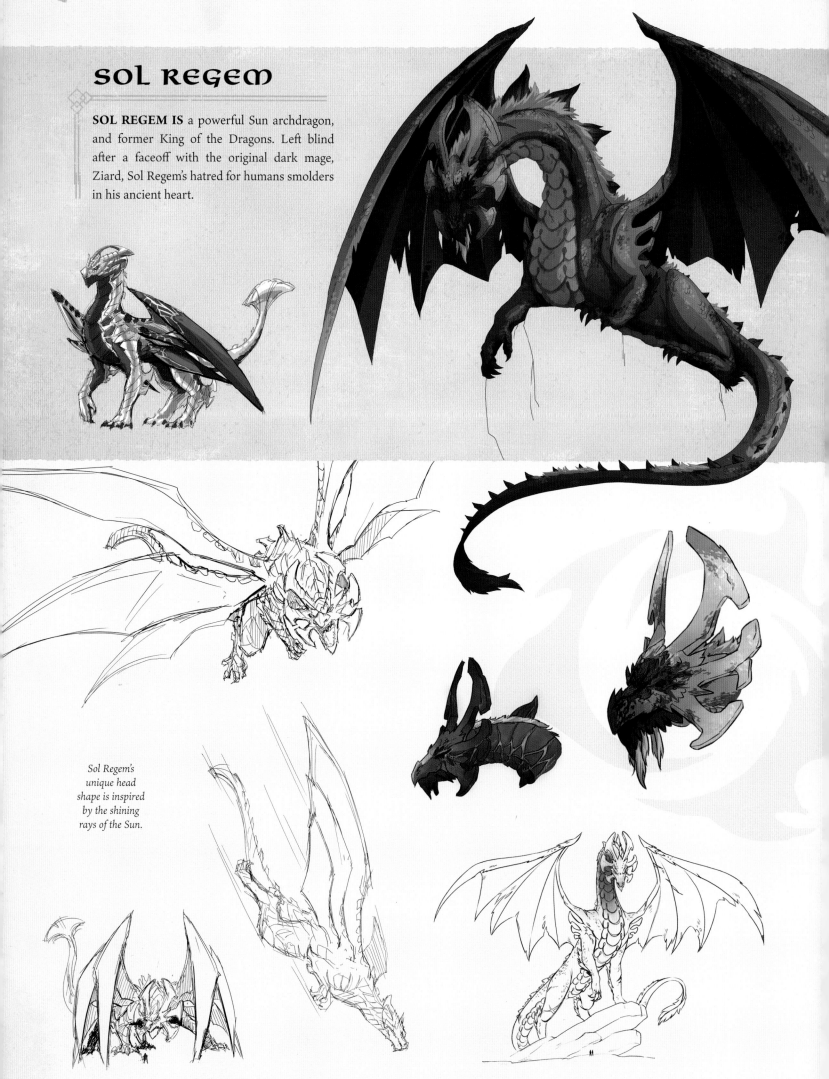

Sol Regem's unique head shape is inspired by the shining rays of the Sun.

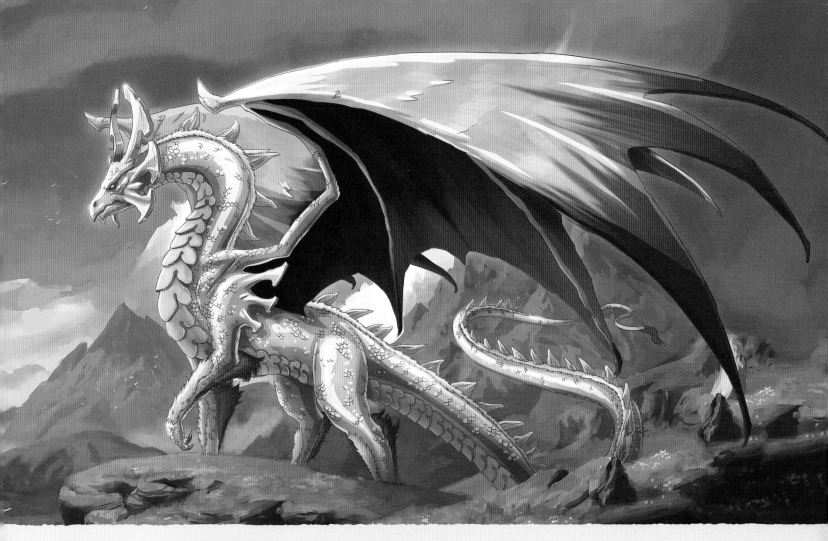

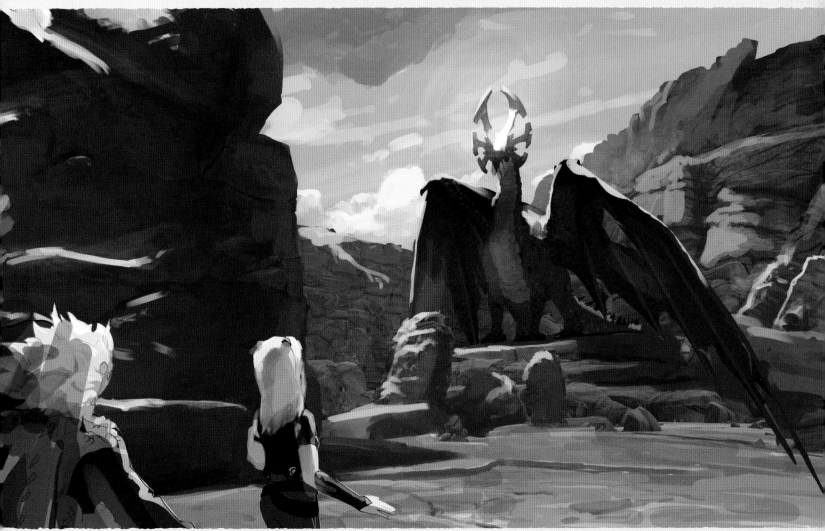

Basking in the sunlight and filled with rage, Sol Regem keeps an endless watch at the Border.

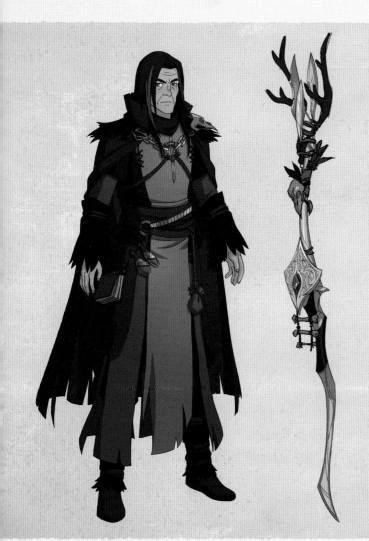

ZIARD

AS THE FIRST human to learn dark magic, Ziard taught others the craft and helped guide humanity to prosperity, but he incurred the wrath of all of Xadia.

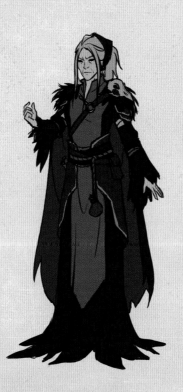

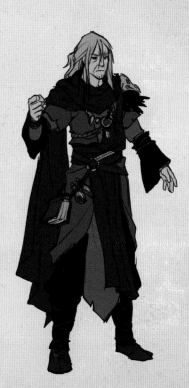

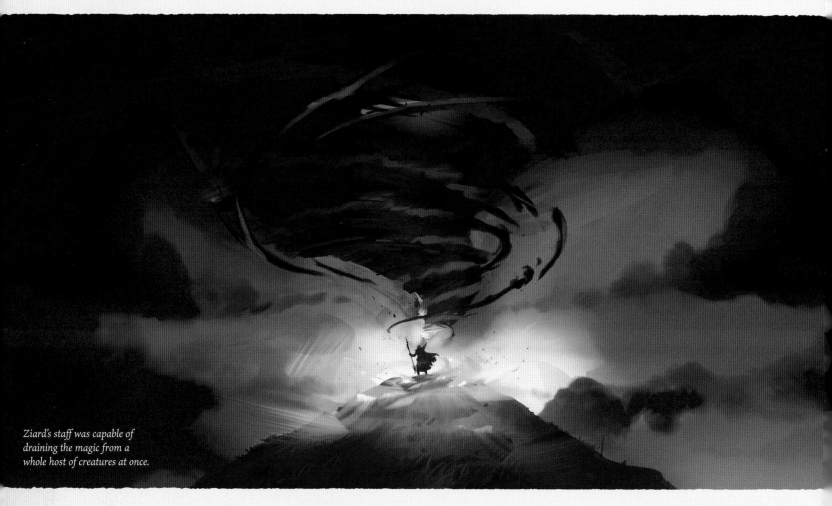

Ziard's staff was capable of draining the magic from a whole host of creatures at once.

ADORABURRS

THESE CUTE LITTLE fuzzballs latch on to bigger creatures to travel great distances. Young elf children love to play with them, and the adoraburrs don't seem to mind.

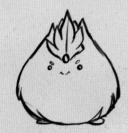

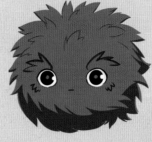

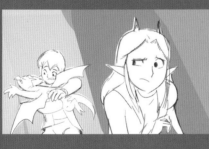

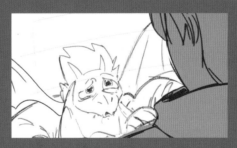

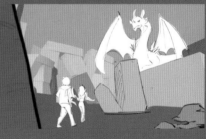

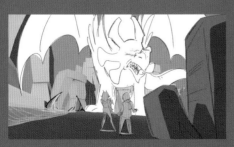

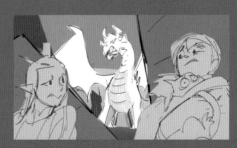

If you can imagine a color and pattern, there's probably an adoraburr to match.

Rayla tries to guide Callum and Zym safely past Sol Regem. These shots had to capture the scale and fierceness of the old archdragon.

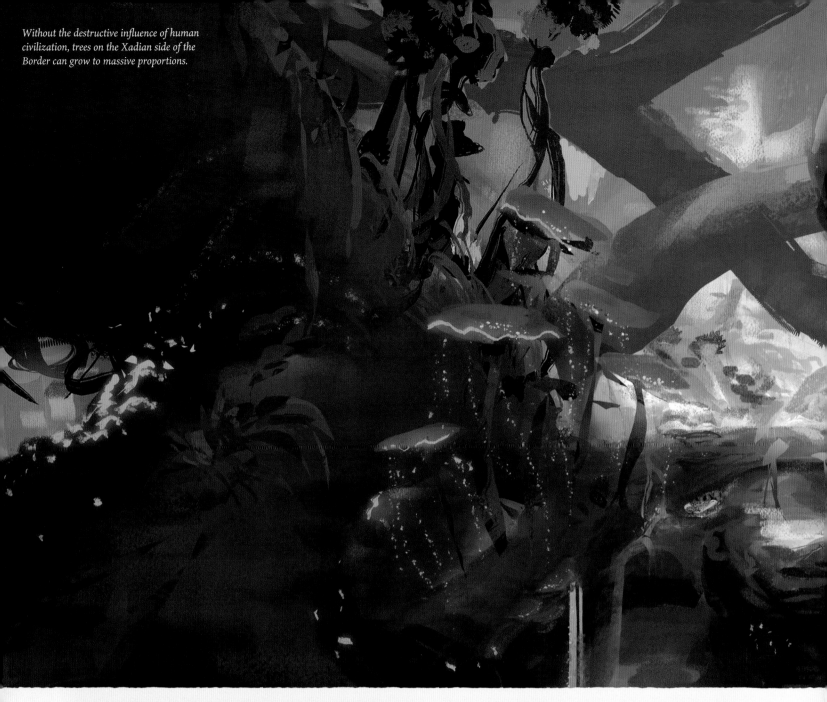

Without the destructive influence of human civilization, trees on the Xadian side of the Border can grow to massive proportions.

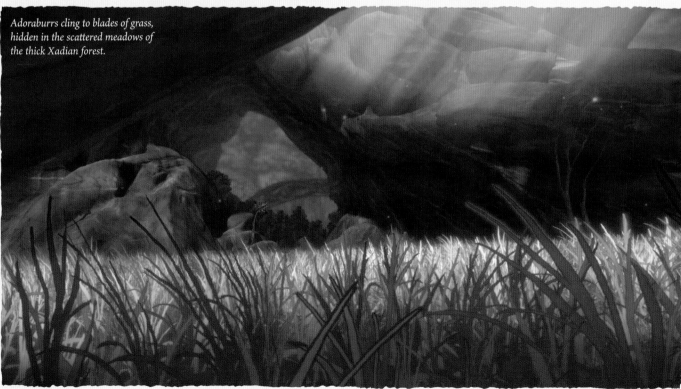

Adoraburrs cling to blades of grass, hidden in the scattered meadows of the thick Xadian forest.

*Gargantuan fallen trees create gargantuan
hiding spots for undiscovered Xadian creatures.*

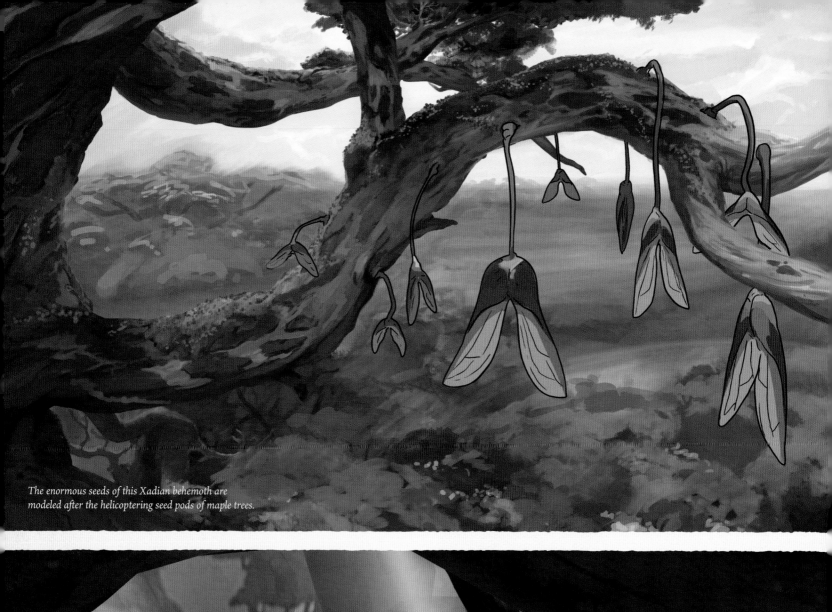

The enormous seeds of this Xadian behemoth are modeled after the helicoptering seed pods of maple trees.

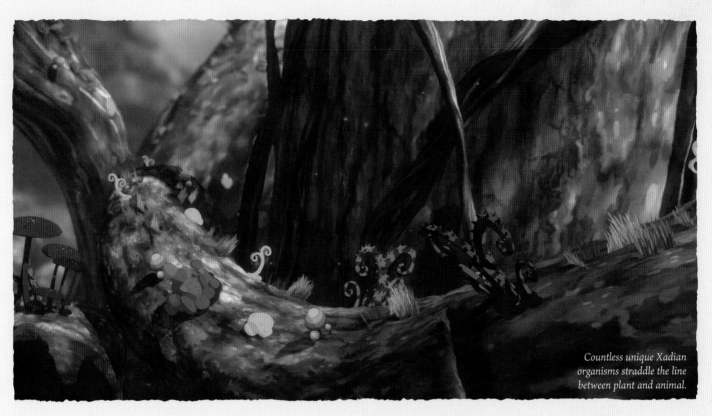

Countless unique Xadian
organisms straddle the line
between plant and animal.

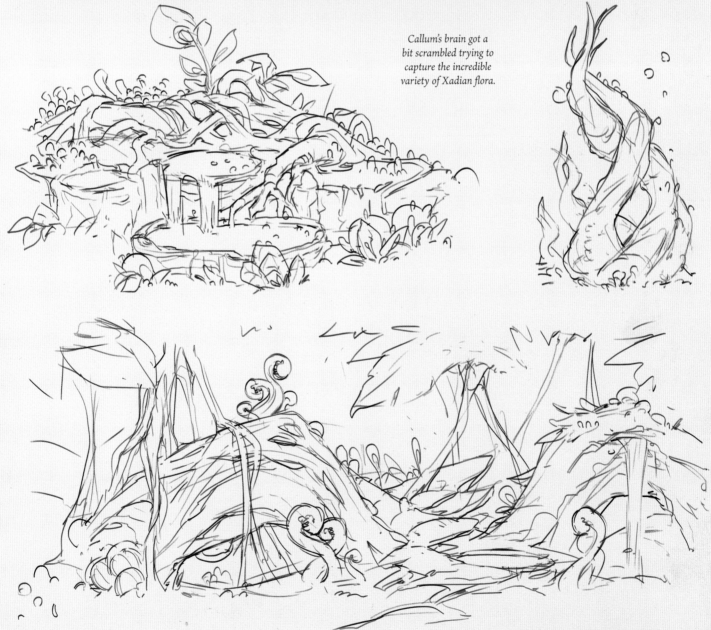

Callum's brain got a
bit scrambled trying to
capture the incredible
variety of Xadian flora.

PRINCE KASEF

KASEF IS THE hot-headed Prince of Neolandia, and heir to its throne. When his father, King Ahling, is critically injured by supposed Xadian assassins, Kasef seizes control of Neolandia and its army with a vengeful goal: war.

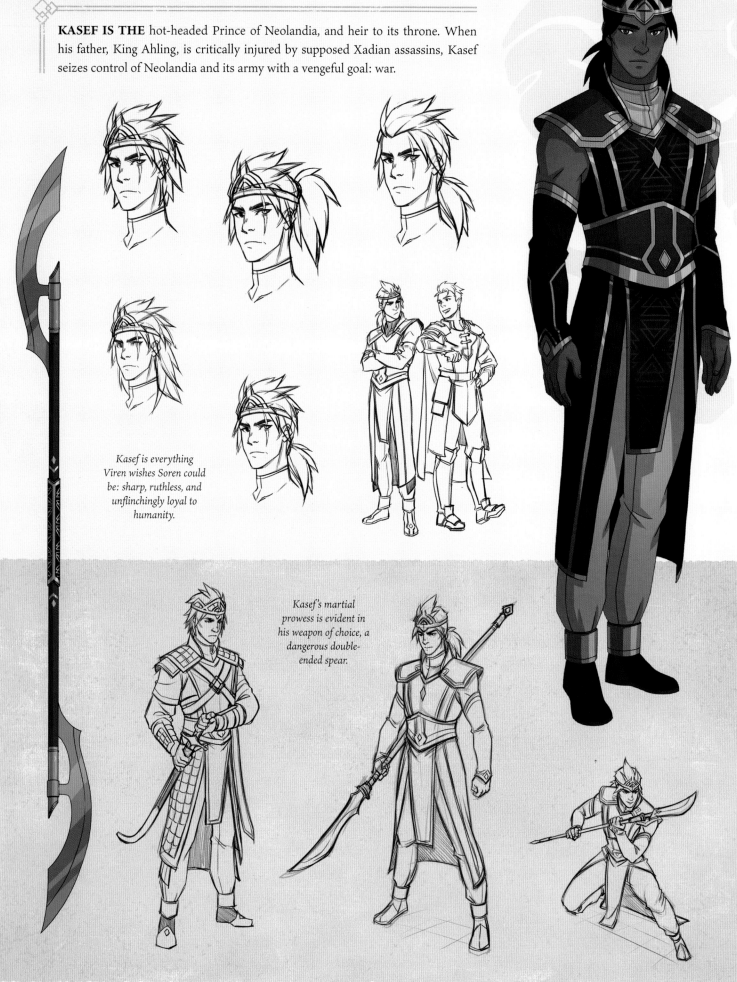

Kasef is everything Viren wishes Soren could be: sharp, ruthless, and unflinchingly loyal to humanity.

Kasef's martial prowess is evident in his weapon of choice, a dangerous double-ended spear.

SPOTLIGHT

PRIMAL SOURCE: SUN

"We'll let the light decide!" —Queen Khessa

At sunrise, all of Xadia is coaxed awake from the cold dark of night. Guided by the Sun's warmth and incandescence, seeds find the courage to become sprouts, flowers are nurtured to bloom and fruit, and life strides forward with confident clarity. Unlike her sister, the shifting, unknowable Moon, the Sun is forthright, radiant, immutable.

With such a potent source of power at their beck and call, Sun mages can learn to master light and fire. Through strength of will, some of the most powerful can use the light to heal and purify, to banish sickness and decay like fleeting shadows.

But Sun magic is as volatile as it is grand: the duality of light and fire, of purification and destruction, make it among the most dangerous magics to master. Sun mages must maintain diligent control of their emotions and impulses, for fire is its own master, longing to burn free of their meddling. It only takes one spark to start an inferno.

Sunfire elves are the Sun's stewards and loyal warriors. They are natural leaders, courageous and heroic, and in all things they seek to elevate themselves to the magnificence of the Sun. Some say that fire runs through their most powerful warriors like blood. While the Sunfire elves strive to be the golden protectors of all of Xadia, the wisest among them remember that the Sun, for all its light and glory, can blind.

ETHARI

RUNAAN'S HUSBAND ETHARI is the Silvergrove's master craftsman. His work ranges from the elegant lethality of Moonshadow elf weapons to the delicate metalwork of trinkets and jewelry.

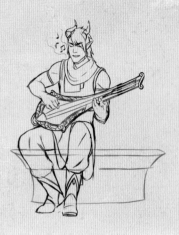

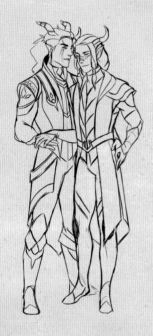

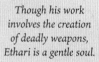

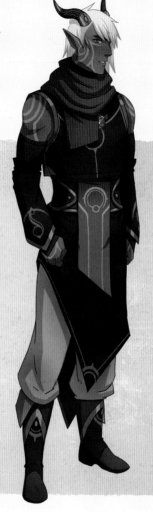

Though his work involves the creation of deadly weapons, Ethari is a gentle soul.

QUEEN KHESSA

THE IMPERIOUS RULER of the Sunfire elves, Queen Khessa embodies the power and glory of the Sun. She demands complete fealty and forthrightness from her subjects, and her disdain for humans is absolute.

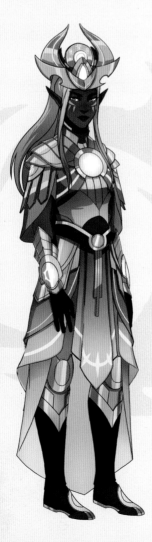

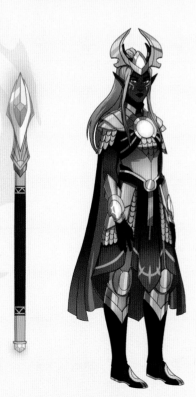

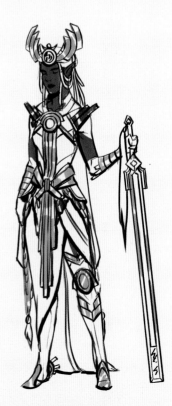

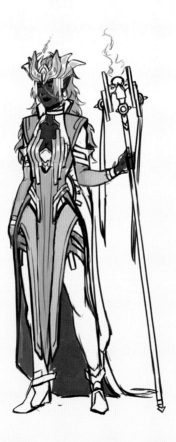

Khessa's younger sister Janai is next in line to the throne.

KAZI

KAZI IS A student of language, translation, and interpretation in Lux Aurea. They take their studies very seriously and were top of their class in linguistics.

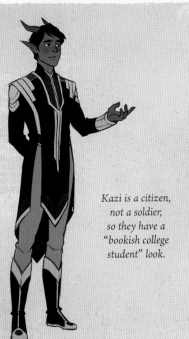

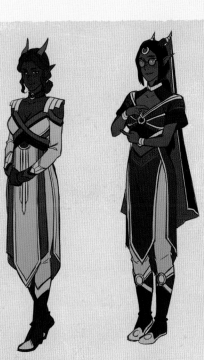

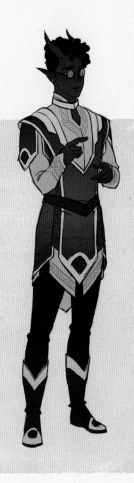

Kazi is a citizen, not a soldier, so they have a "bookish college student" look.

SUNFIRE HIGH PRIEST

THE SUNFIRE HIGH priest is a fixture at Queen Khessa's side. His direct connection to the Sun primal helps him channel the incalculable power of the Sunforge.

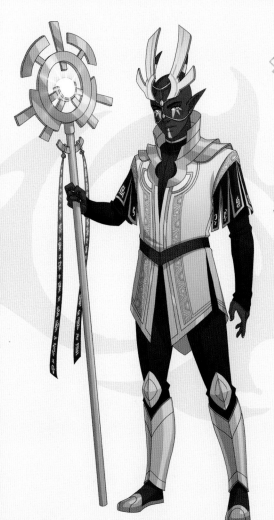

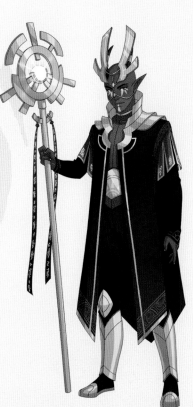

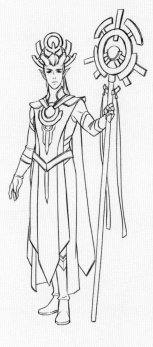

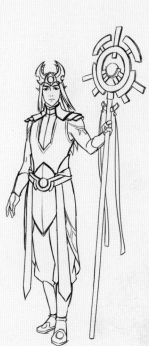

The priest's golden staff holds a Sun primal stone at its head.

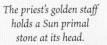

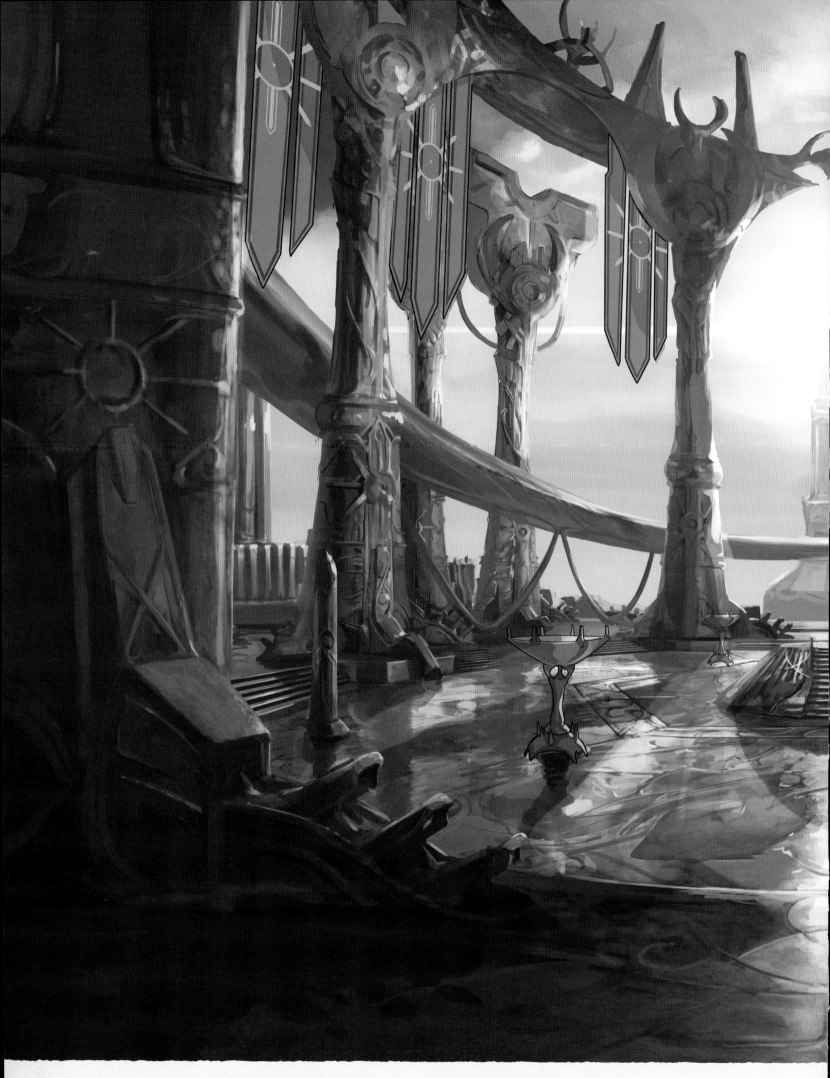

Lux Aurea is the first large elven city we see in Xadia, and is a blinding contrast to the less extravagant kingdom of Katolis. In this gilded throne room, the Sunfire

Queen is almost silhouetted by the brilliance of the Sunforge as she looks down upon her visitors and judges them unworthy.

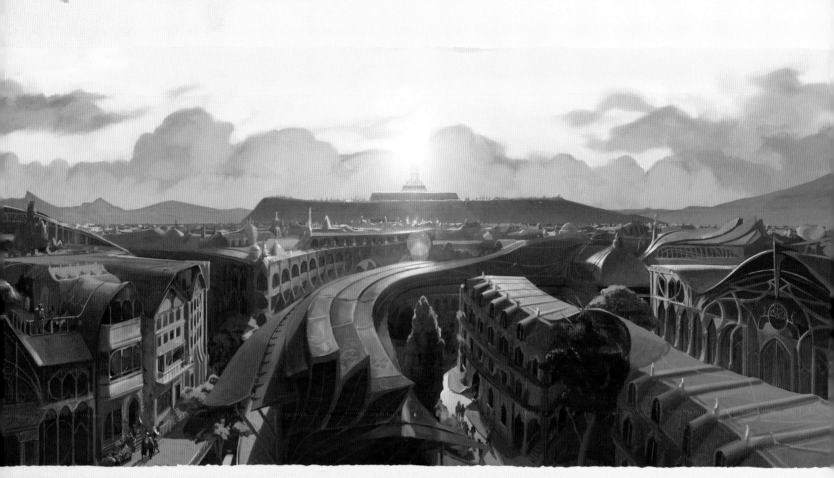

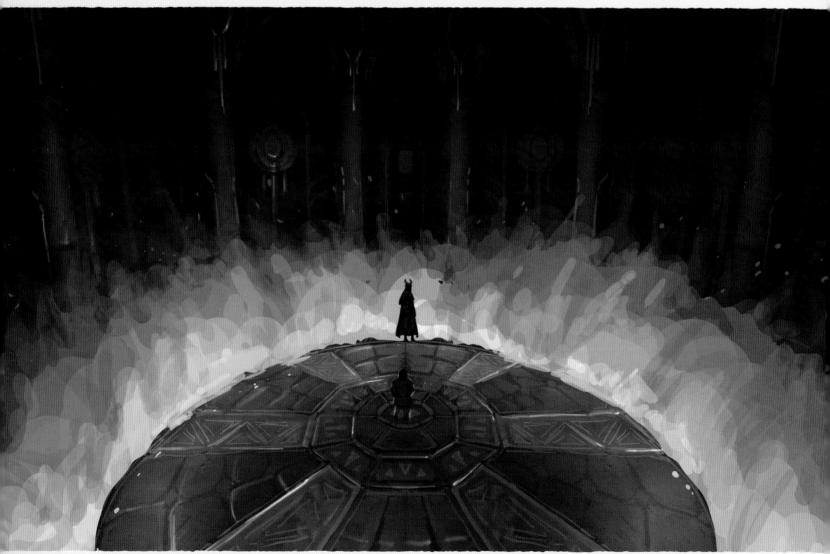

Lux Aurea's prison keeps the worst of its wrongdoers in a blisteringly uncomfortable ring of fire as punishment for their crimes.

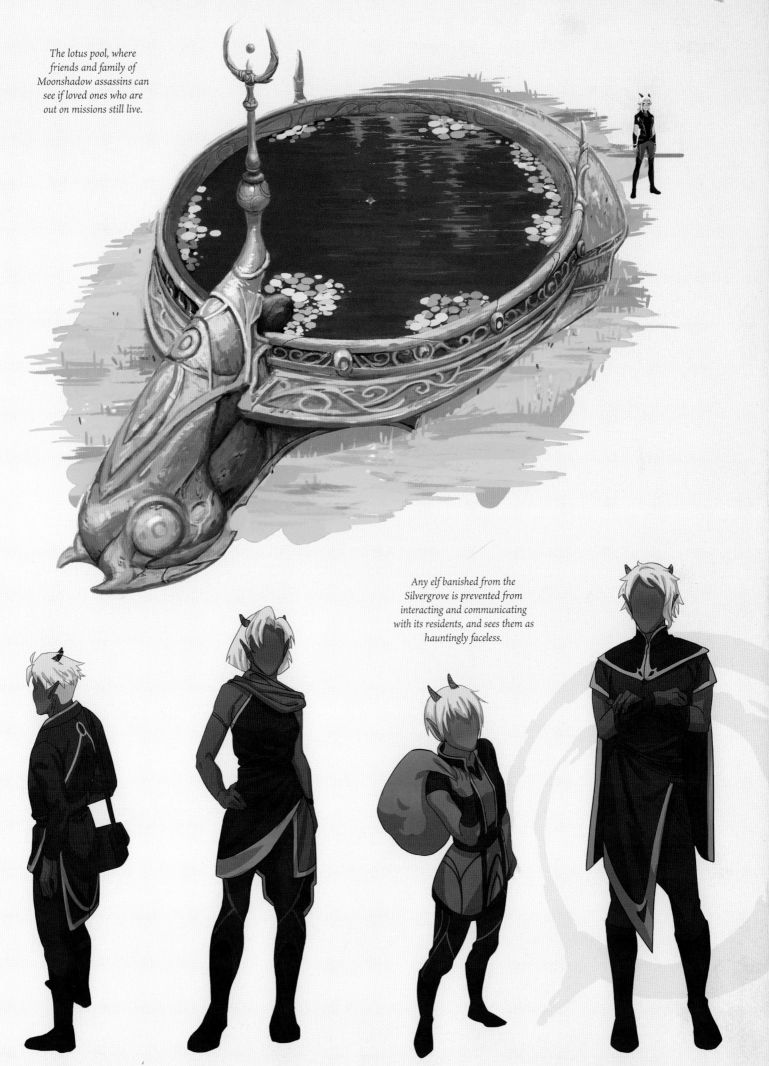

The lotus pool, where friends and family of Moonshadow assassins can see if loved ones who are out on missions still live.

Any elf banished from the Silvergrove is prevented from interacting and communicating with its residents, and sees them as hauntingly faceless.

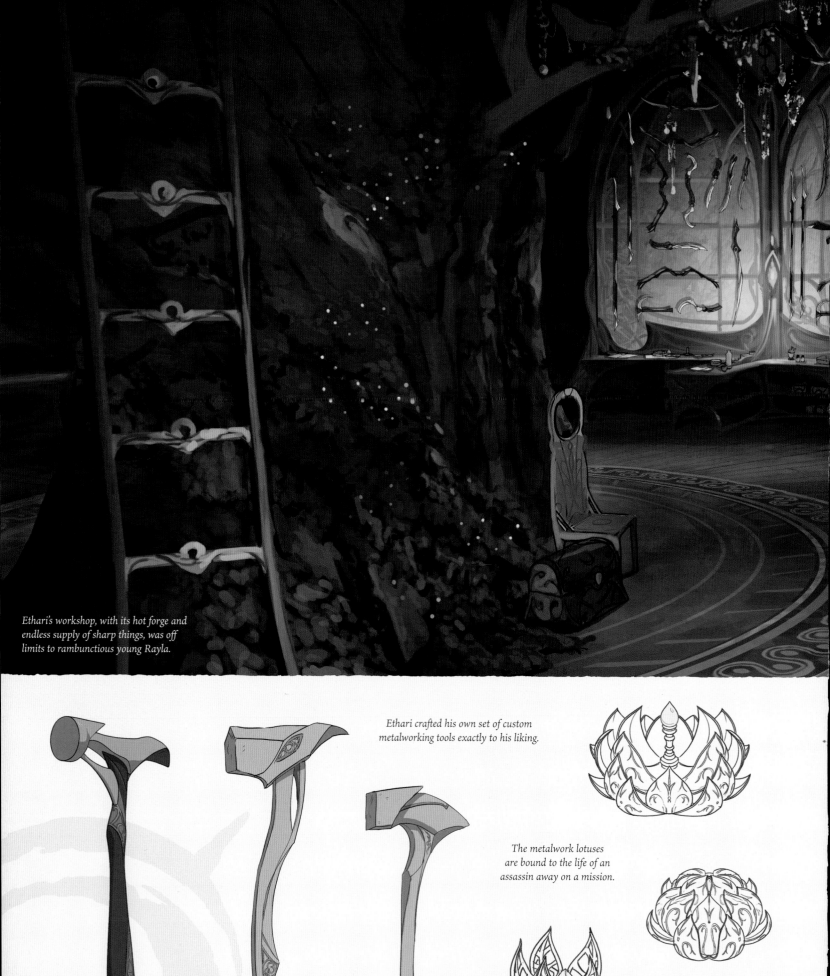

Ethari's workshop, with its hot forge and endless supply of sharp things, was off limits to rambunctious young Rayla.

Ethari crafted his own set of custom metalworking tools exactly to his liking.

The metalwork lotuses are bound to the life of an assassin away on a mission.

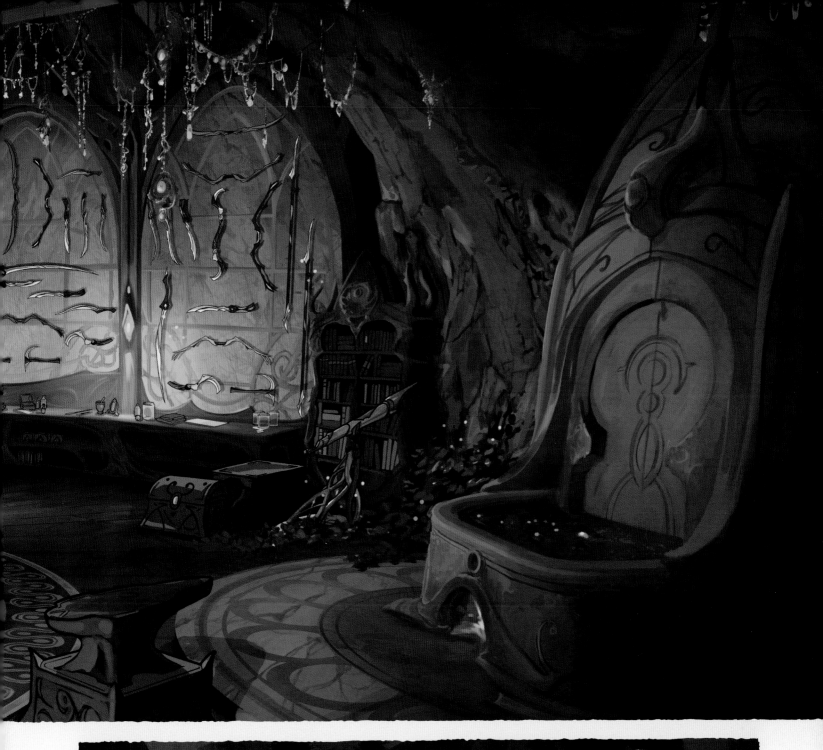

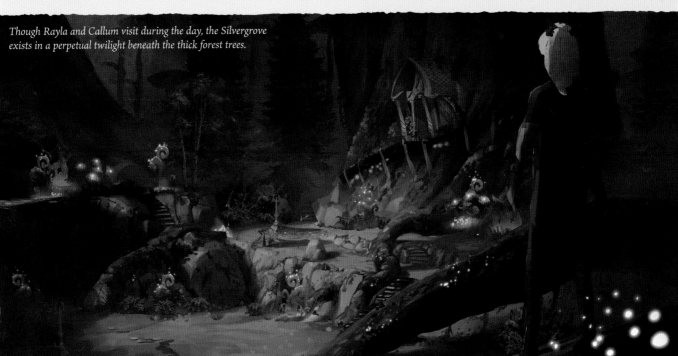

Though Rayla and Callum visit during the day, the Silvergrove
exists in a perpetual twilight beneath the thick forest trees.

NYX

NYX LIVES A life as free as the blue sky above: free from obligations, expectations, and rules. With her wings and her ambler friend she roams Xadia, charming and duping anyone who'll fall for her schemes.

Before she was Nyx, we nicknamed this lovable rogue "Hanna Solo."

We explored a wider range of colors for Nyx than for almost any other character.

Nyx's versatile boomerang-holding spear-staff. We hope to see her wield it again someday!

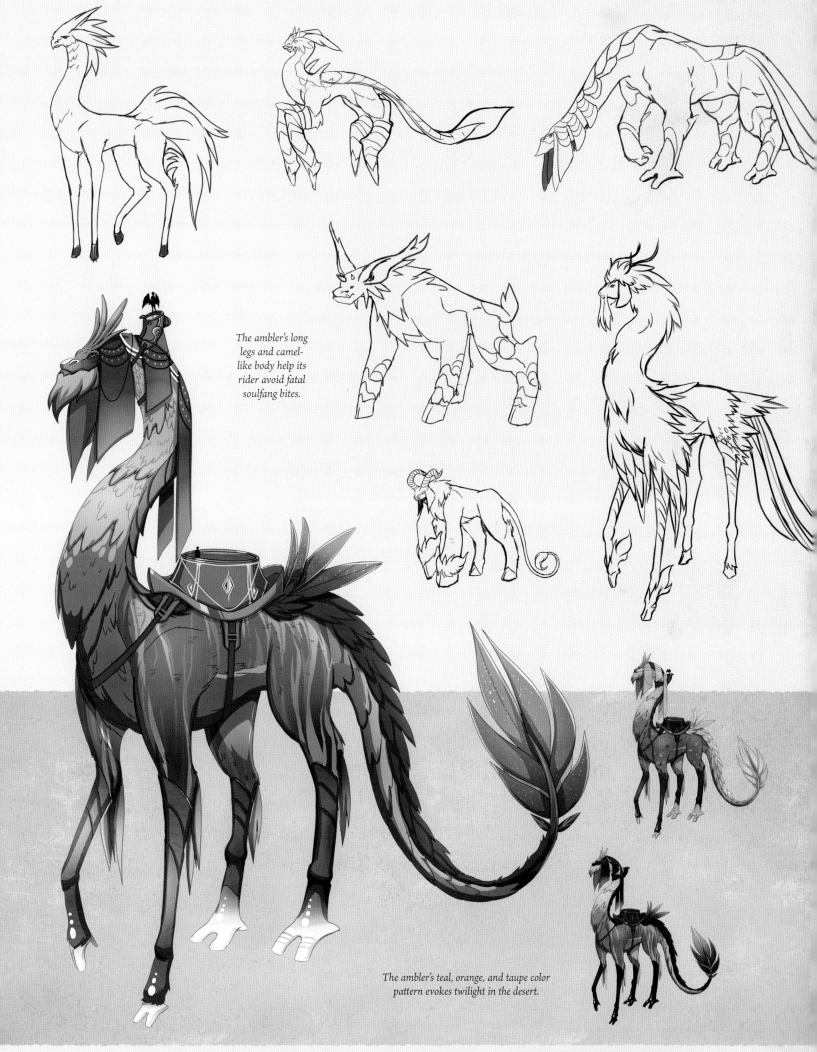

The ambler's long legs and camel-like body help its rider avoid fatal soulfang bites.

The ambler's teal, orange, and taupe color pattern evokes twilight in the desert.

When ancient mages erected the
Wonderwall, they knew their spell was
gonna be the one that saved them.

As if a barren wasteland wasn't already treacherous
enough, the black sands of the desert absorb the
energy of the sun to make it even hotter.

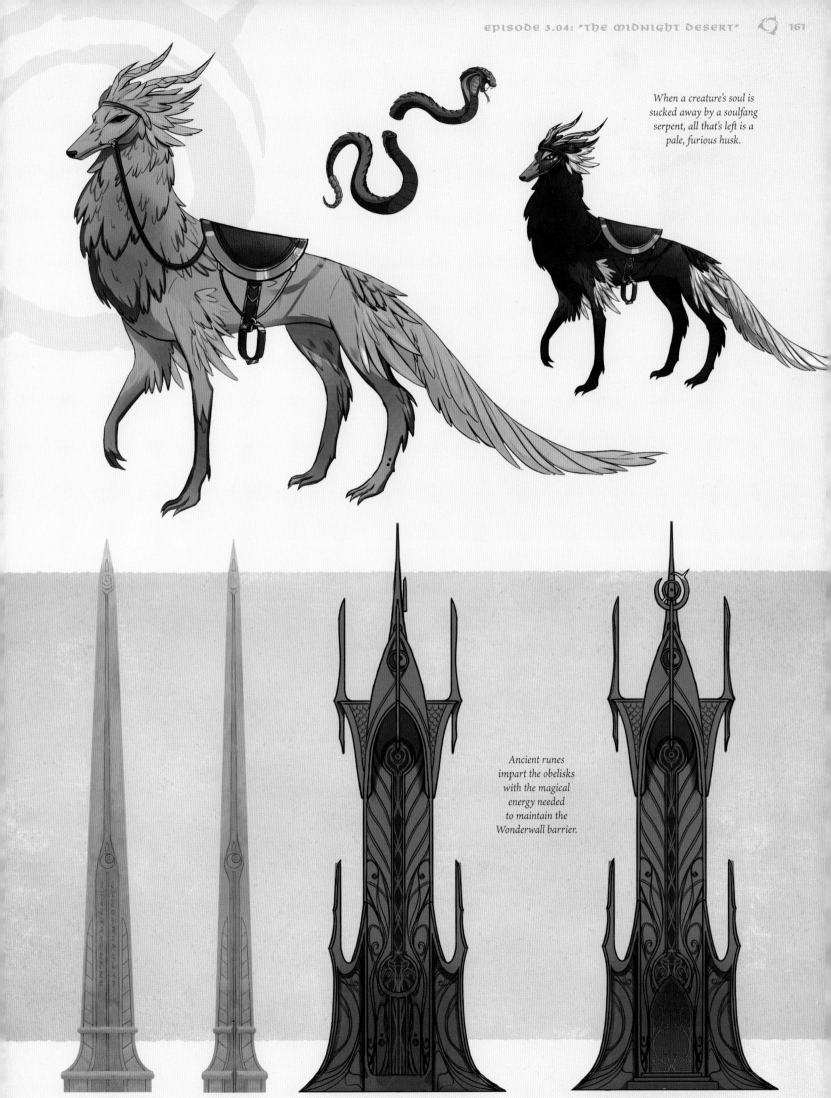

When a creature's soul is sucked away by a soulfang serpent, all that's left is a pale, furious husk.

Ancient runes impart the obelisks with the magical energy needed to maintain the Wonderwall barrier.

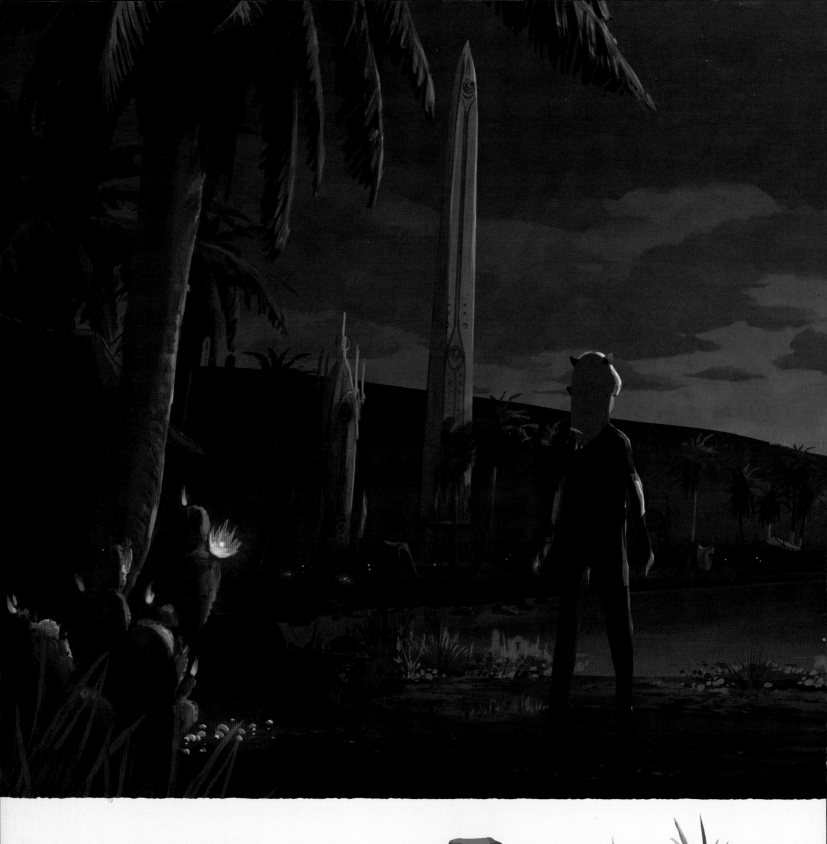

A few plants can still eke out survival among the rocks in the constant brutal heat.

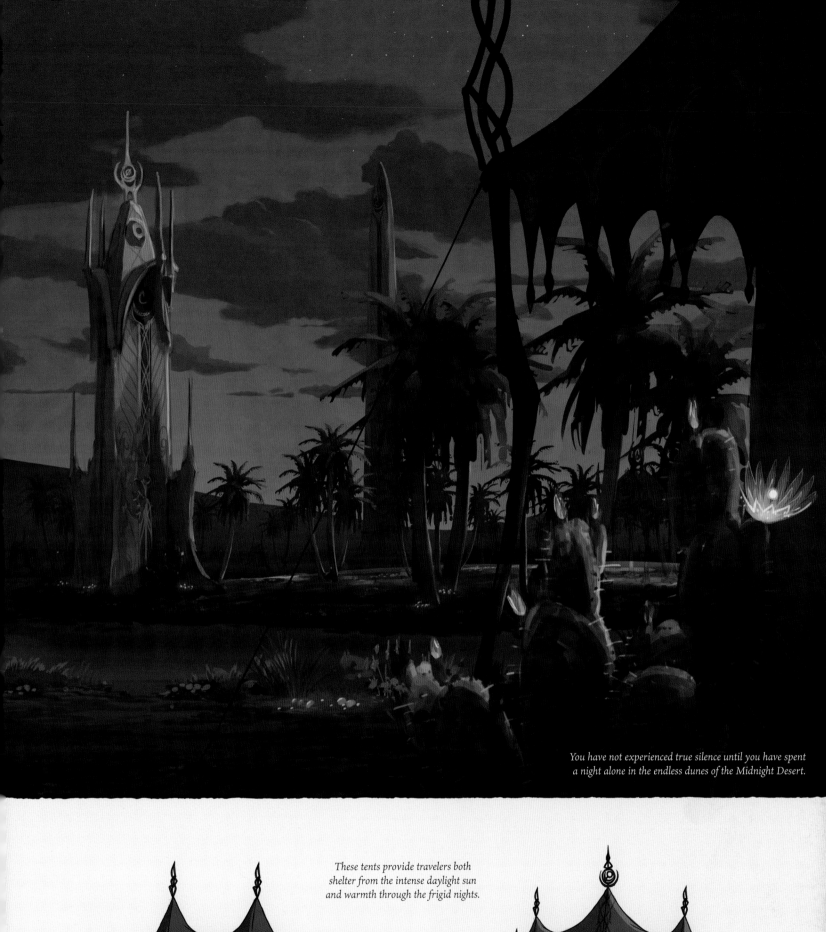

*You have not experienced true silence until you have spent
a night alone in the endless dunes of the Midnight Desert.*

*These tents provide travelers both
shelter from the intense daylight sun
and warmth through the frigid nights.*

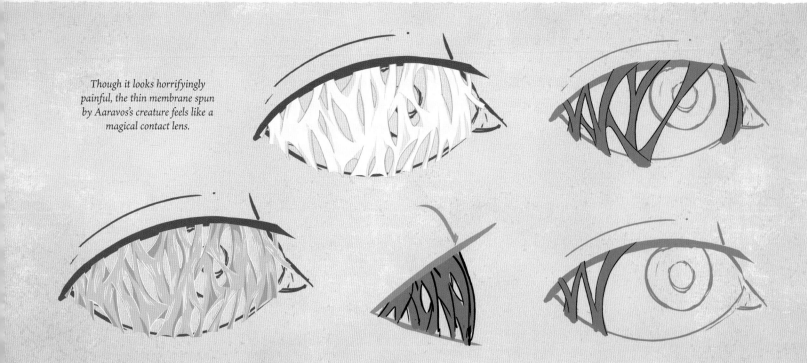

Though it looks horrifyingly painful, the thin membrane spun by Aaravos's creature feels like a magical contact lens.

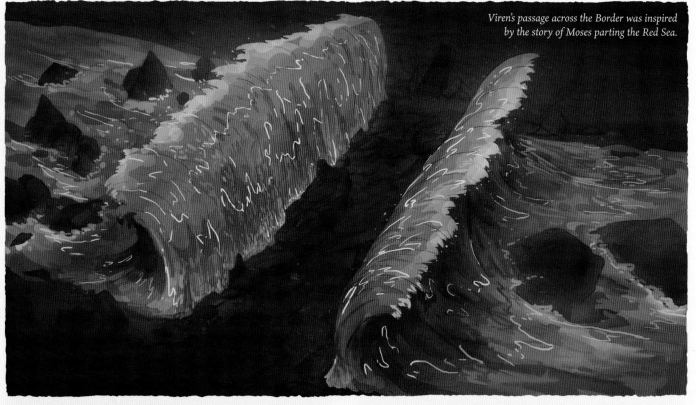

Viren's passage across the Border was inspired by the story of Moses parting the Red Sea.

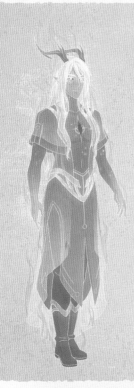

Viren intended this broken link symbol to be a badge of shame for soldiers who refused to join him.

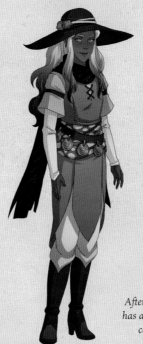

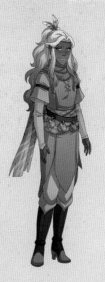

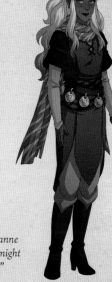

After decades of near-isolation, Lujanne has a strange idea of what humans might consider a "normal party outfit."

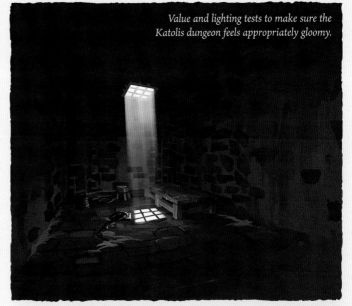

Value and lighting tests to make sure the Katolis dungeon feels appropriately gloomy.

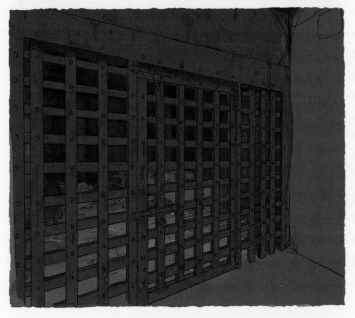

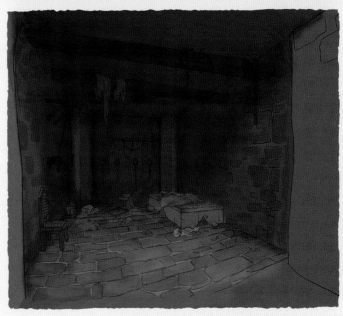

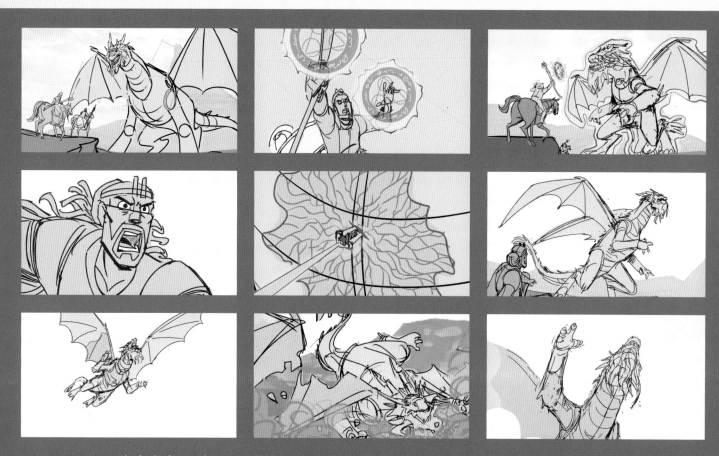

The death of Avizandum is arguably the inciting incident of The Dragon Prince, *and we finally learn how it happened.*

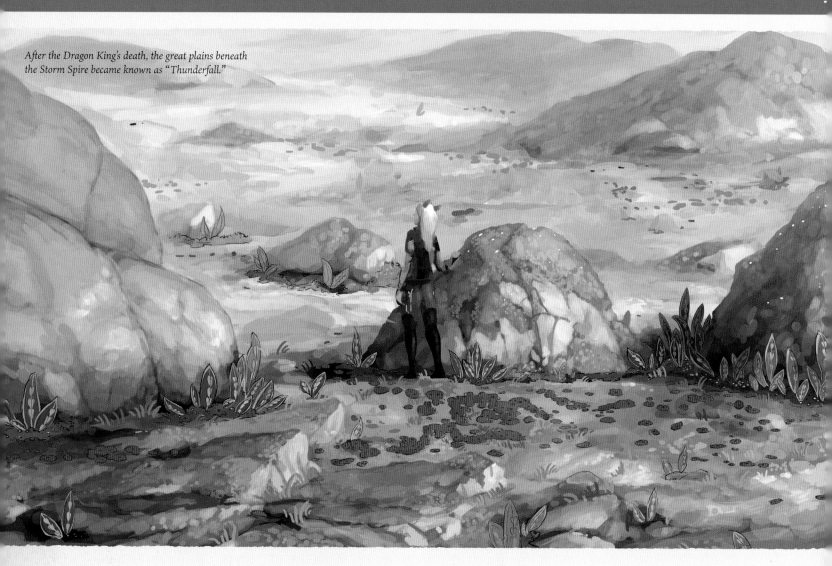

After the Dragon King's death, the great plains beneath the Storm Spire became known as "Thunderfall."

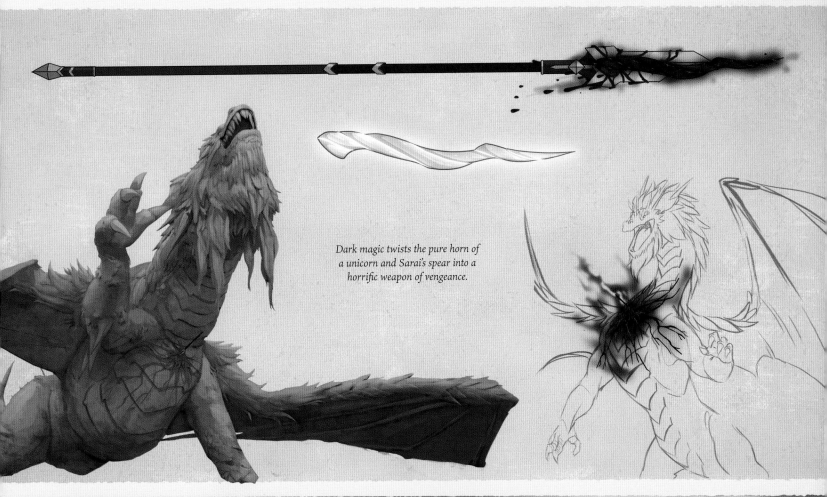

Dark magic twists the pure horn of a unicorn and Sarai's spear into a horrific weapon of vengeance.

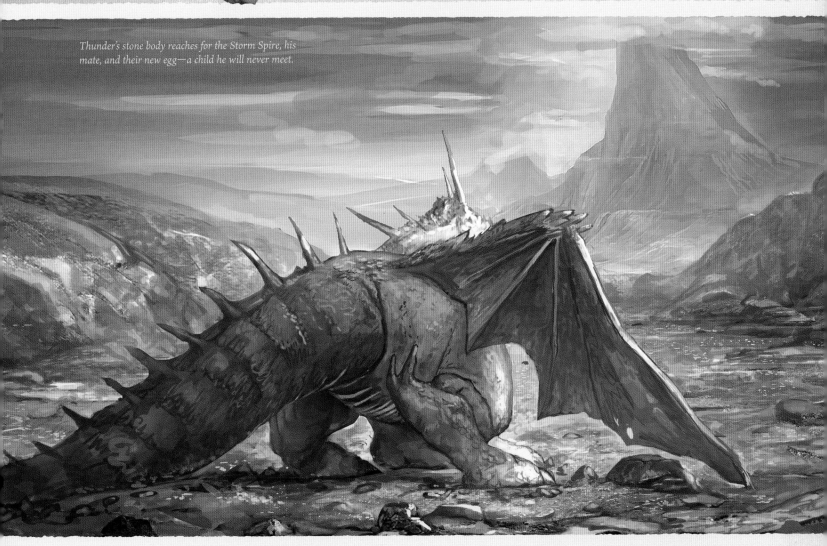

Thunder's stone body reaches for the Storm Spire, his mate, and their new egg—a child he will never meet.

IBIS

IBIS IS A powerful and wise Skywing elf mage who watched over the Dragon Queen during her great slumber. Though he was not born with wings, he is one of the rare few who can fly by conjuring "Magewings."

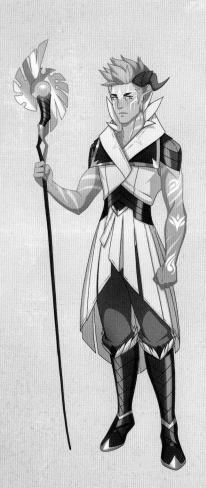

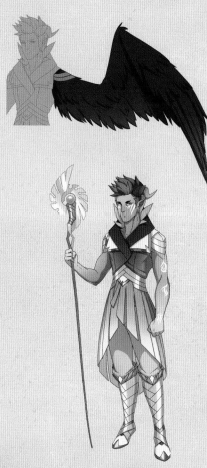

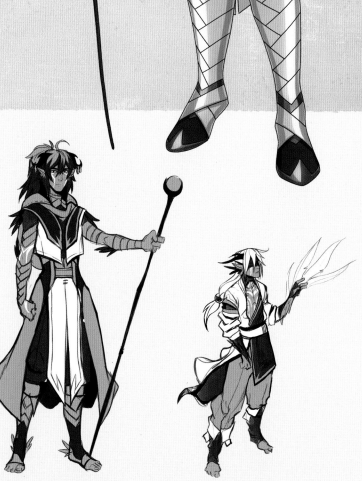

Artists sketched a wide array of Skywing elves in early development.

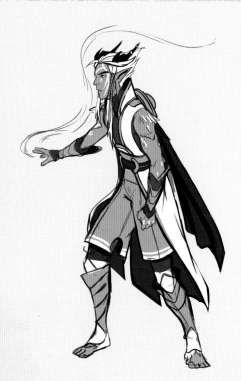

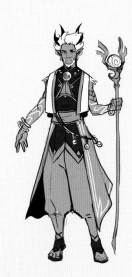

kasef evolved

DRIVEN BY A hunger for vengeance, Kasef eagerly allows Viren to magically "strengthen" him for their strike against Xadia. The result is a twisted and horrific monstrosity that reflects the searing hatred in Kasef's heart.

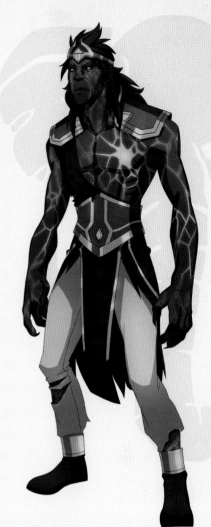

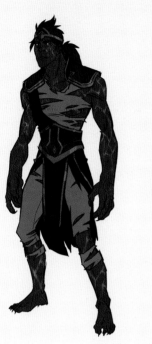
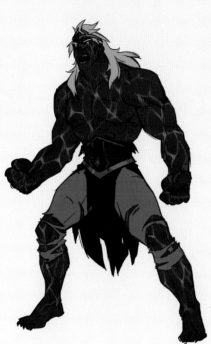
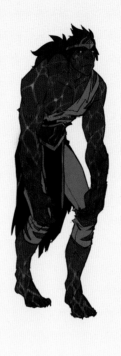

final battle viren

WITH THE CROWN of Katolis, the plain robes of a Lux Aurea prisoner, and his hideous true face, Viren's presence is terrifying as he enters the battle at the Storm Spire.

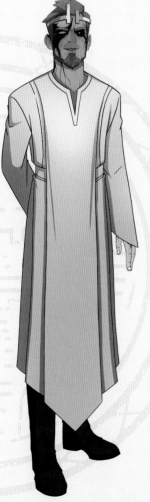
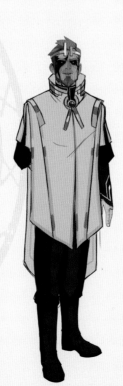
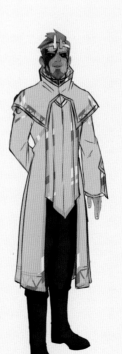
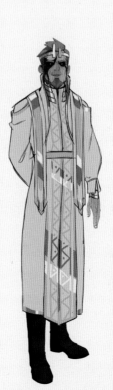
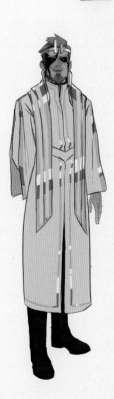

These alternate costumes were a little too grand for the "purification" ritual at the Sunforge.

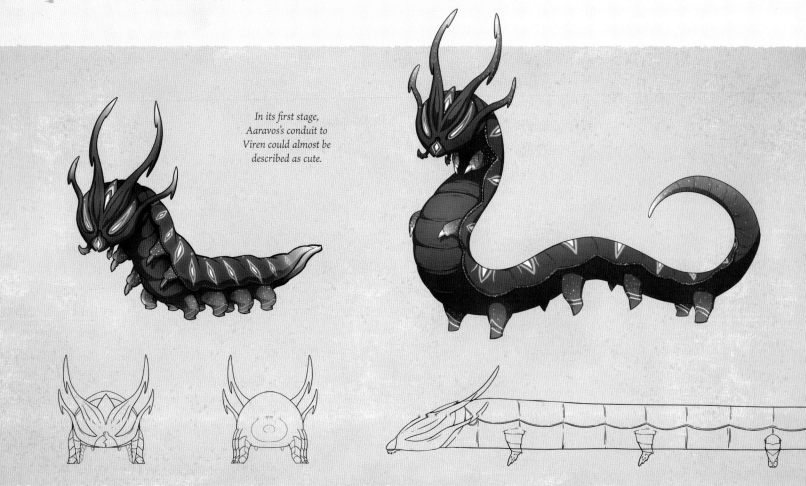

In its first stage, Aaravos's conduit to Viren could almost be described as cute.

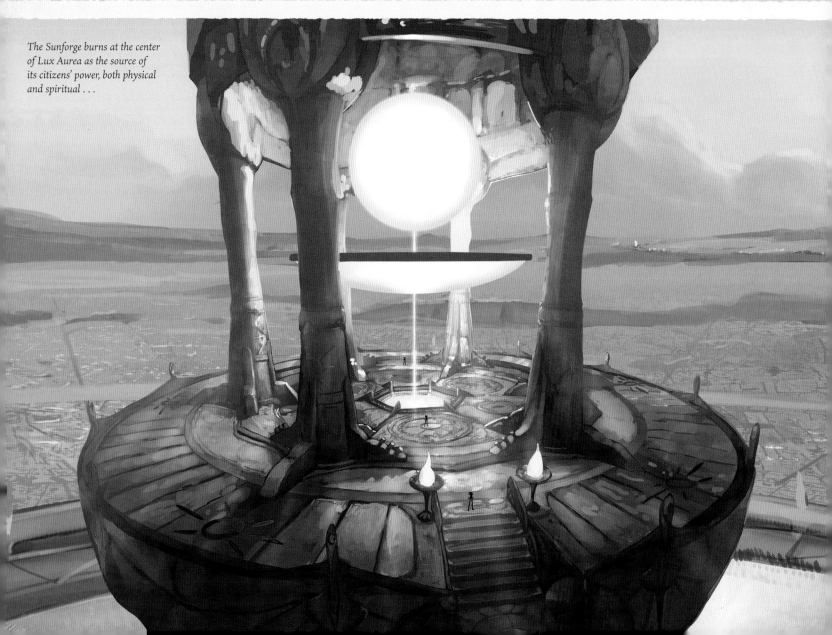

The Sunforge burns at the center of Lux Aurea as the source of its citizens' power, both physical and spiritual . . .

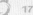

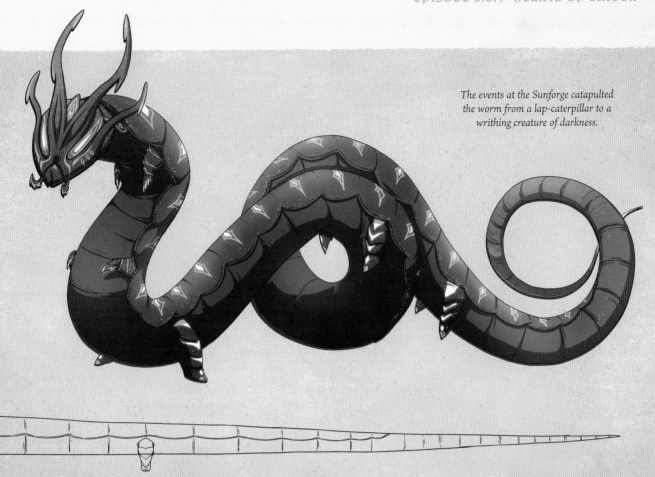

The events at the Sunforge catapulted the worm from a lap-caterpillar to a writhing creature of darkness.

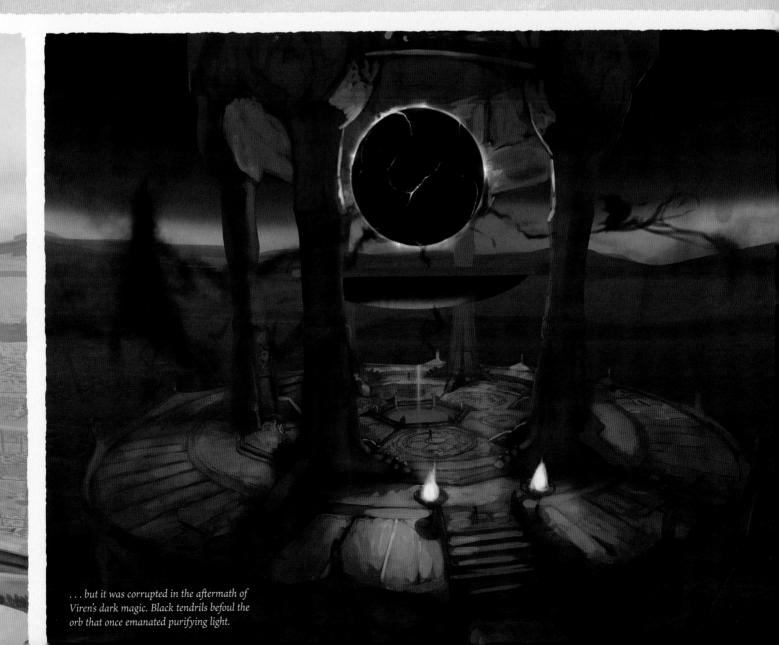

... but it was corrupted in the aftermath of Viren's dark magic. Black tendrils befoul the orb that once emanated purifying light.

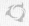

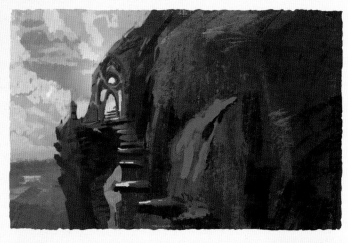

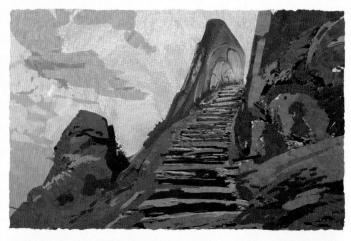

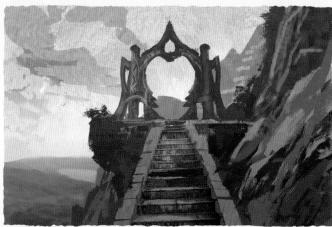

At the towering peak of the Storm Spire is the Dragon Queen's lair, our heroes' final destination.

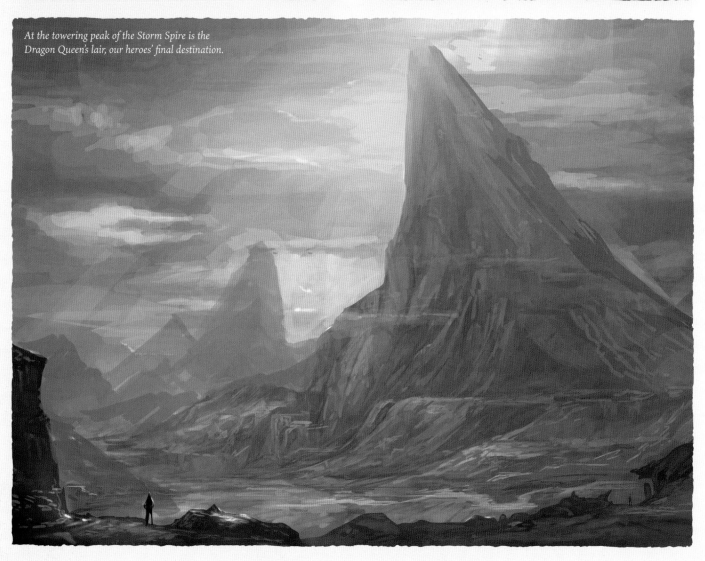

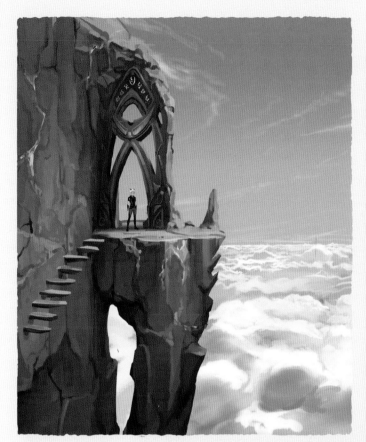

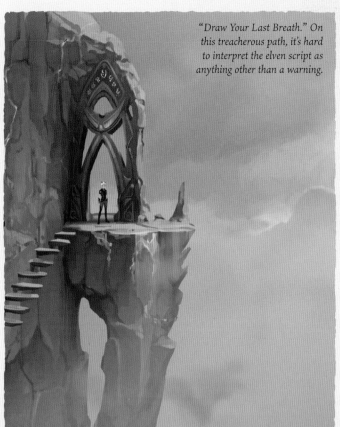

"Draw Your Last Breath." On this treacherous path, it's hard to interpret the elven script as anything other than a warning.

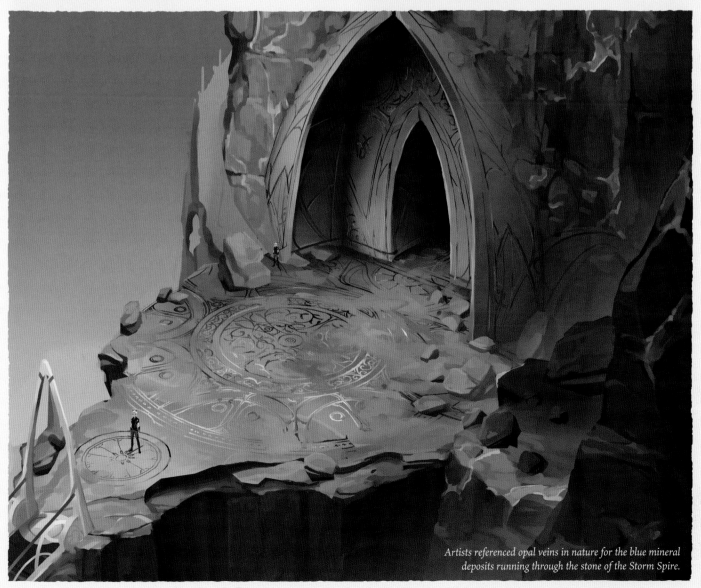

Artists referenced opal veins in nature for the blue mineral deposits running through the stone of the Storm Spire.

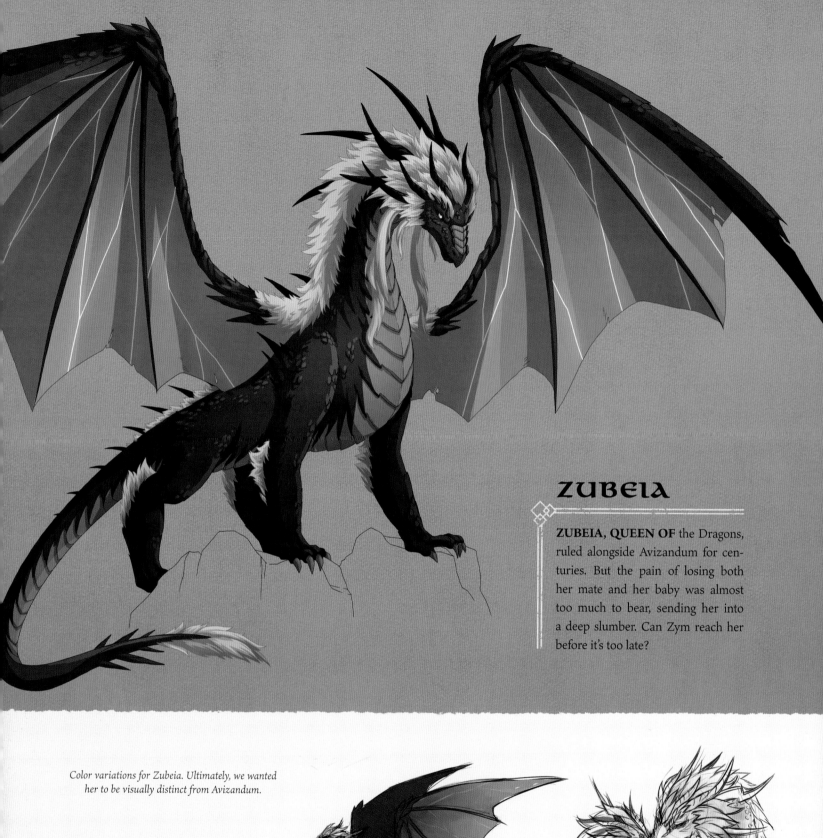

ZUBEIA

ZUBEIA, QUEEN OF the Dragons, ruled alongside Avizandum for centuries. But the pain of losing both her mate and her baby was almost too much to bear, sending her into a deep slumber. Can Zym reach her before it's too late?

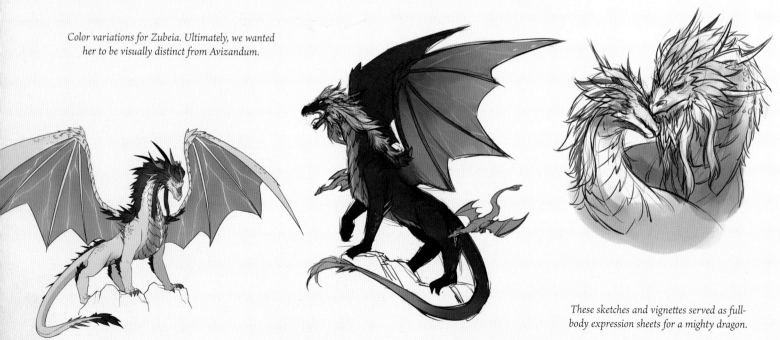

Color variations for Zubeia. Ultimately, we wanted her to be visually distinct from Avizandum.

These sketches and vignettes served as full-body expression sheets for a mighty dragon.

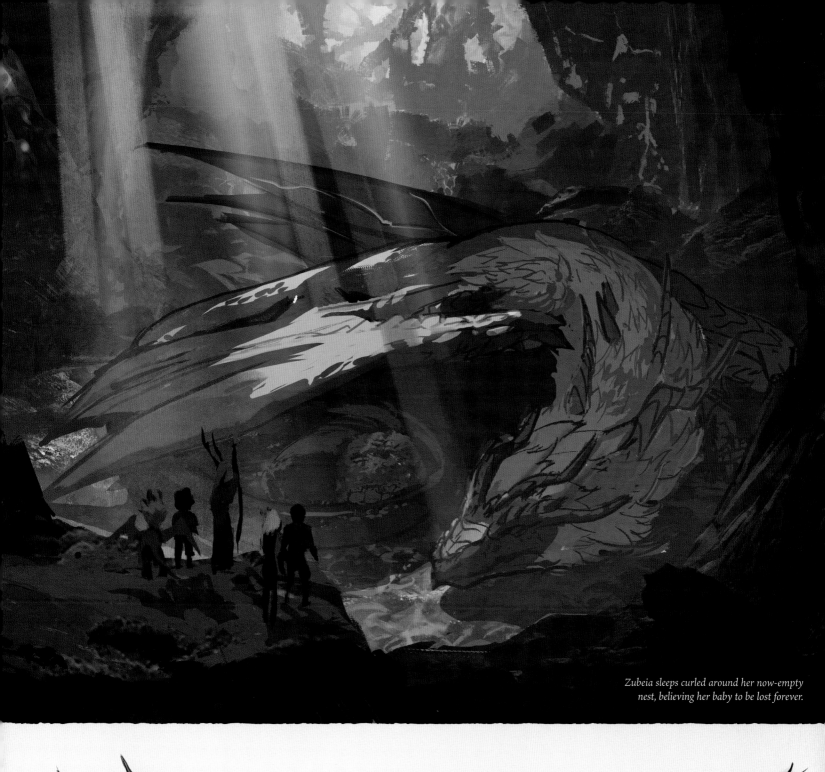

Zubeia sleeps curled around her now-empty nest, believing her baby to be lost forever.

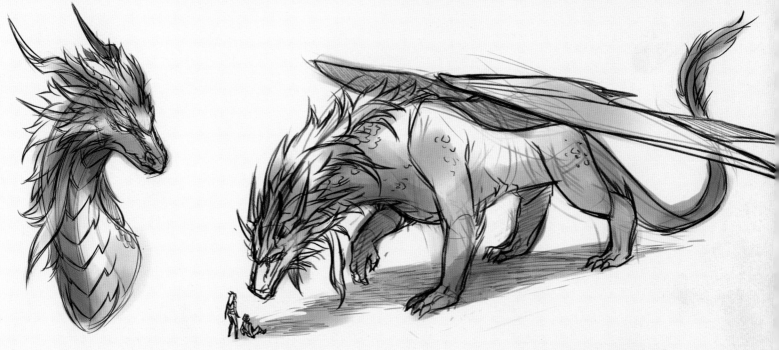

TIADRIN AND LAIN

RAYLA TELLS CALLUM that her parents are dead because the truth is much more complicated and painful. Tiadrin and Lain, once part of the honored Dragonguard, were believed to be cowards and oathbreakers and were banished from the Silvergrove. Rayla later learns that they both kept their oaths and fought Viren to the bitter end . . . but is there more to their story?

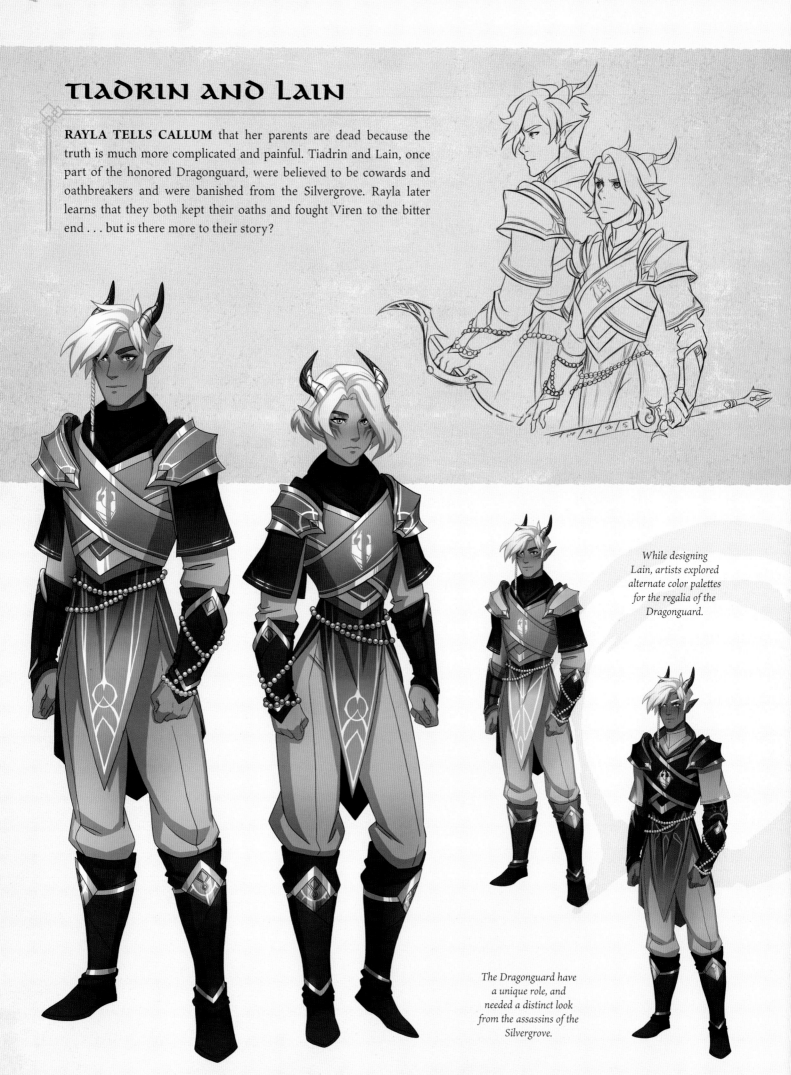

While designing Lain, artists explored alternate color palettes for the regalia of the Dragonguard.

The Dragonguard have a unique role, and needed a distinct look from the assassins of the Silvergrove.

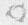

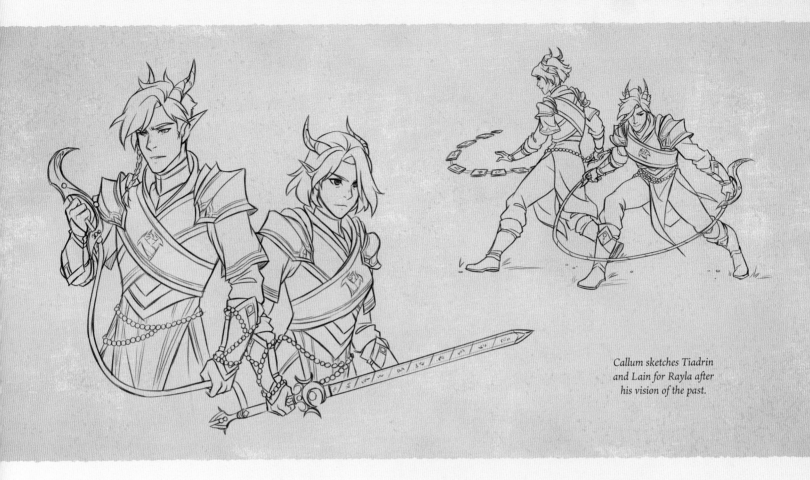

Callum sketches Tiadrin and Lain for Rayla after his vision of the past.

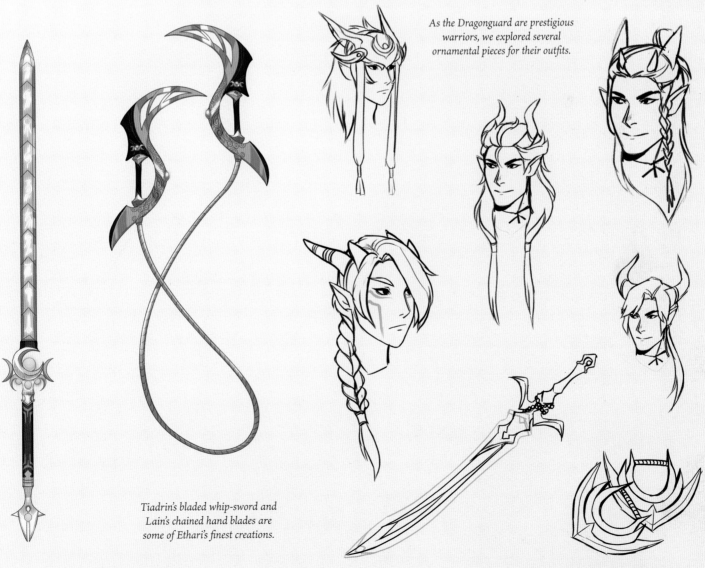

As the Dragonguard are prestigious warriors, we explored several ornamental pieces for their outfits.

Tiadrin's bladed whip-sword and Lain's chained hand blades are some of Ethari's finest creations.

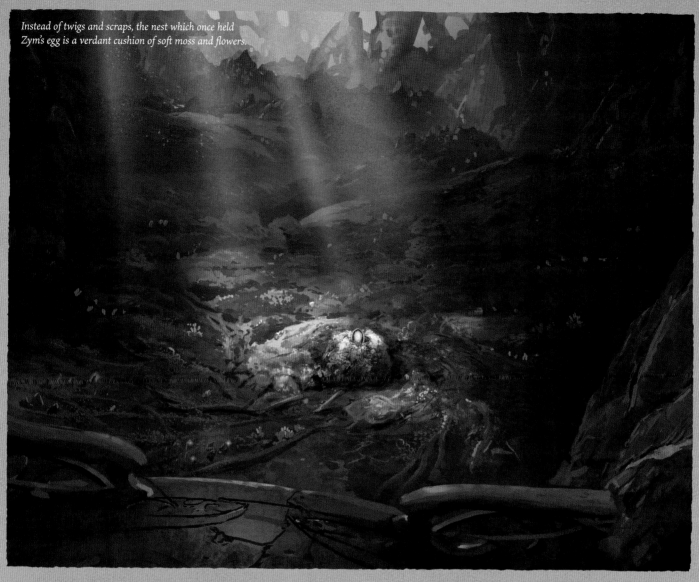

Instead of twigs and scraps, the nest which once held Zym's egg is a verdant cushion of soft moss and flowers.

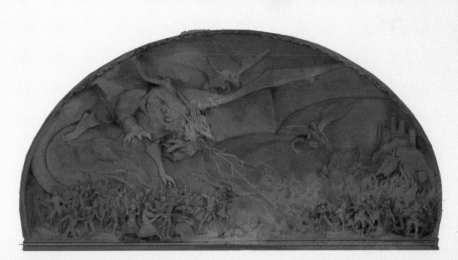

These decorations were not brought to the cave, but rather were carved into the solid rock face.

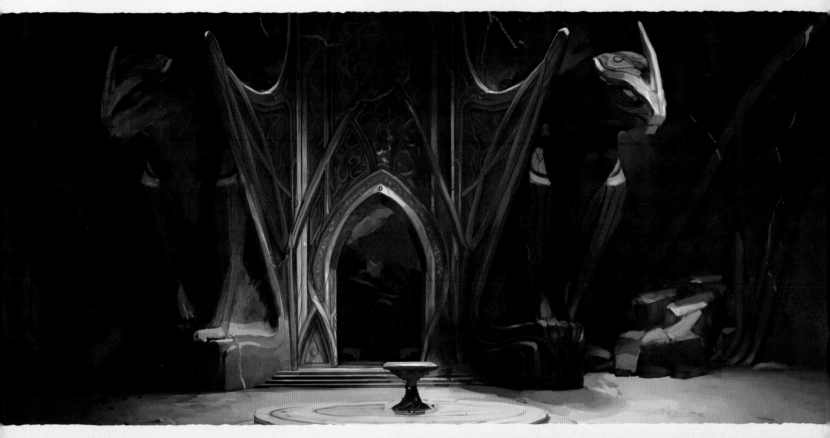

The sculptures and friezes depict great moments from generations of Sky dragon history. Perhaps a stony image of Zym will join them one day.

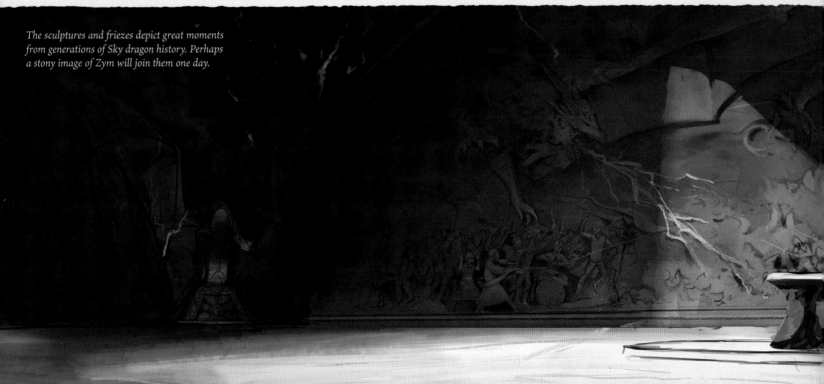

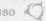
WINGED CALLUM

"MANUS, PLUMA, VOLANTIS!" Callum's new spell allows him to transform his arms into "Magewings," a trick he picked up from Ibis but couldn't perform until the last desperate moment.

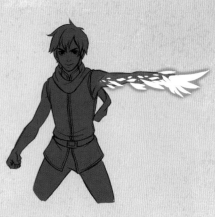

Artists referenced the feather growth in Black Swan for Callum's transformation.

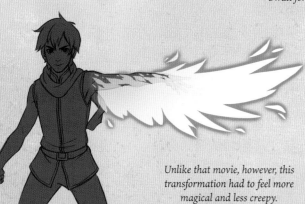

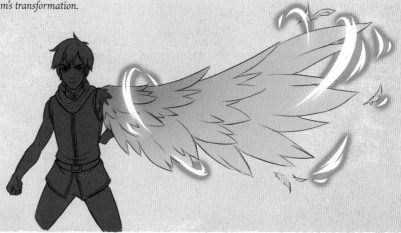

Unlike that movie, however, this transformation had to feel more magical and less creepy.

The Storm Spire's cloud-piercing Pinnacle is the stage for the heroes' final confrontation with Viren.

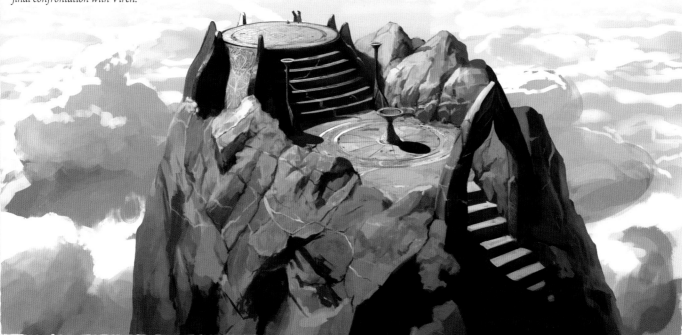

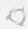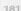

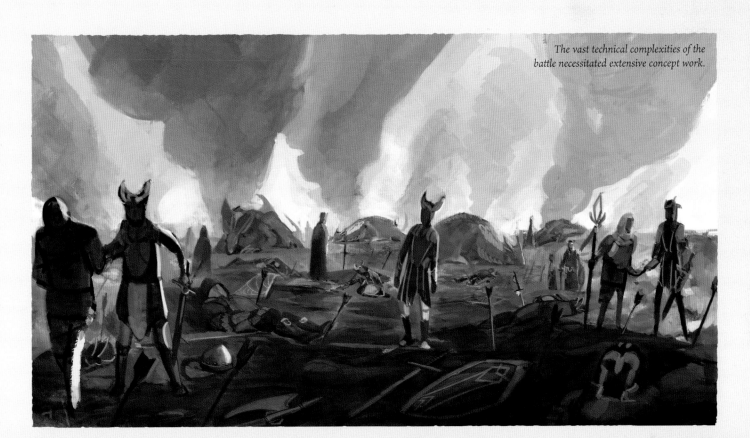

The vast technical complexities of the battle necessitated extensive concept work.

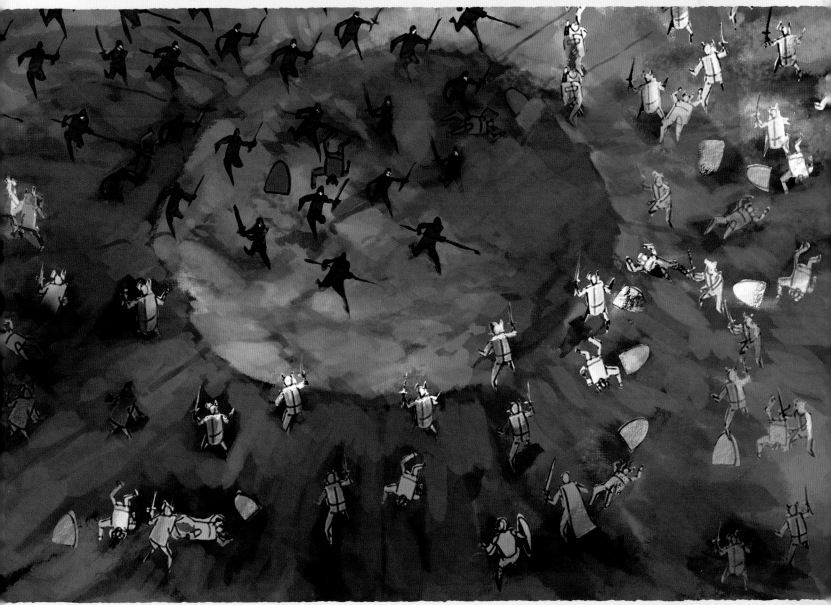

THE FINAL BATTLE

OUR HEROES MAKE their last stand with the remaining Sunfire elf soldiers, hopelessly outnumbered by Viren's army of darkness. The final battle was the greatest artistic and technical challenge the team had yet undertaken, and everyone rose up to bring this chaotic, magical, epic siege to life and close out the first chapter of *The Dragon Prince* saga.

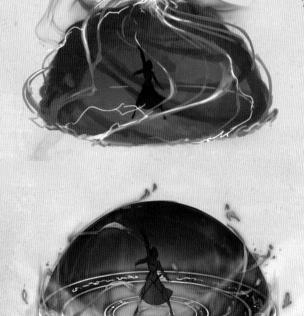

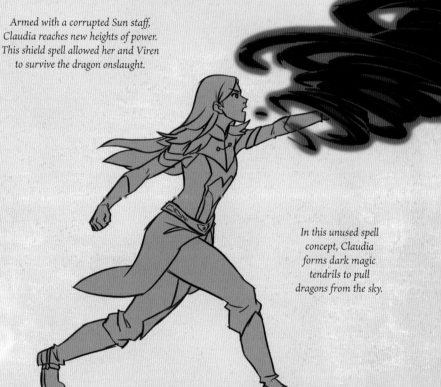

Armed with a corrupted Sun staff, Claudia reaches new heights of power. This shield spell allowed her and Viren to survive the dragon onslaught.

In this unused spell concept, Claudia forms dark magic tendrils to pull dragons from the sky.

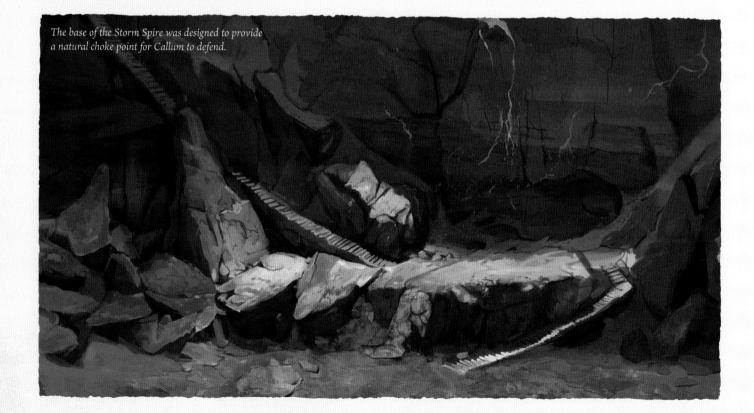

The base of the Storm Spire was designed to provide a natural choke point for Callum to defend.

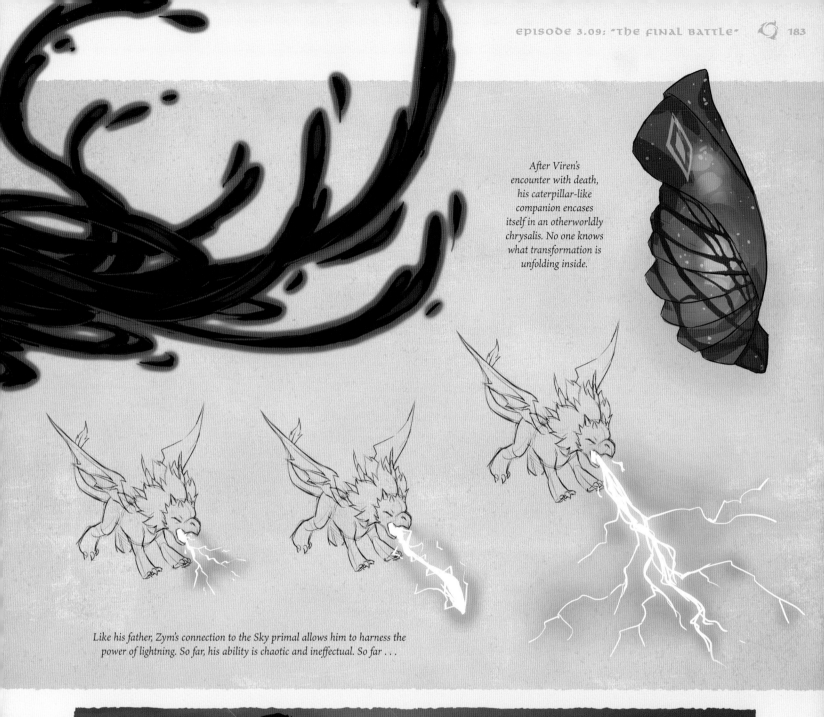

After Viren's encounter with death, his caterpillar-like companion encases itself in an otherworldly chrysalis. No one knows what transformation is unfolding inside.

Like his father, Zym's connection to the Sky primal allows him to harness the power of lightning. So far, his ability is chaotic and ineffectual. So far . . .

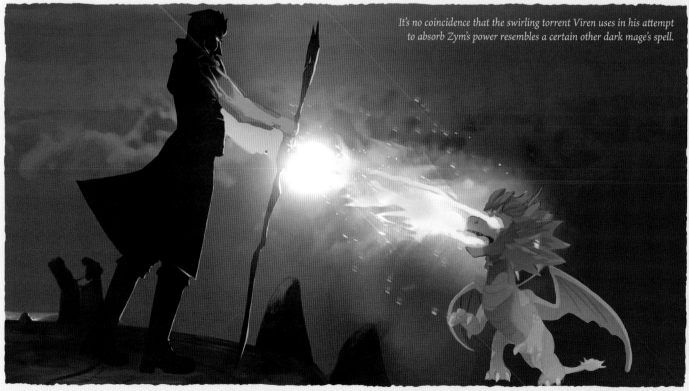

It's no coincidence that the swirling torrent Viren uses in his attempt to absorb Zym's power resembles a certain other dark mage's spell.

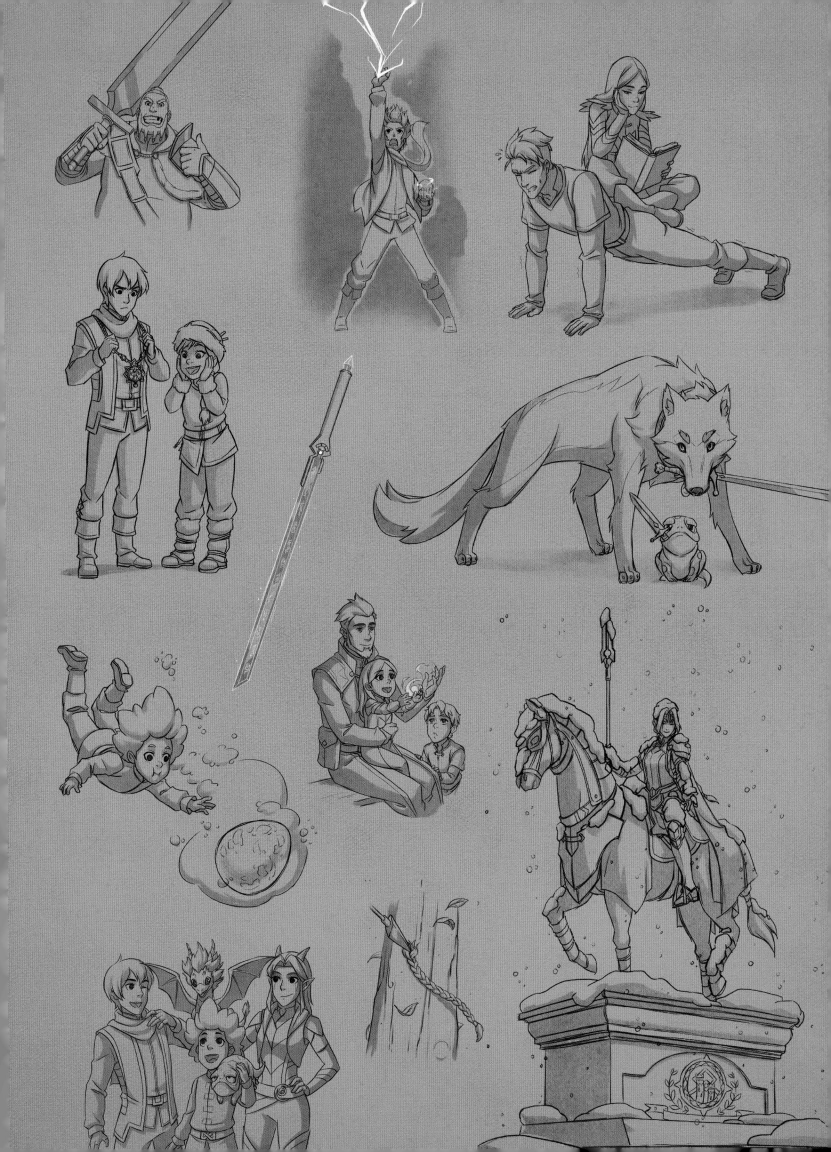

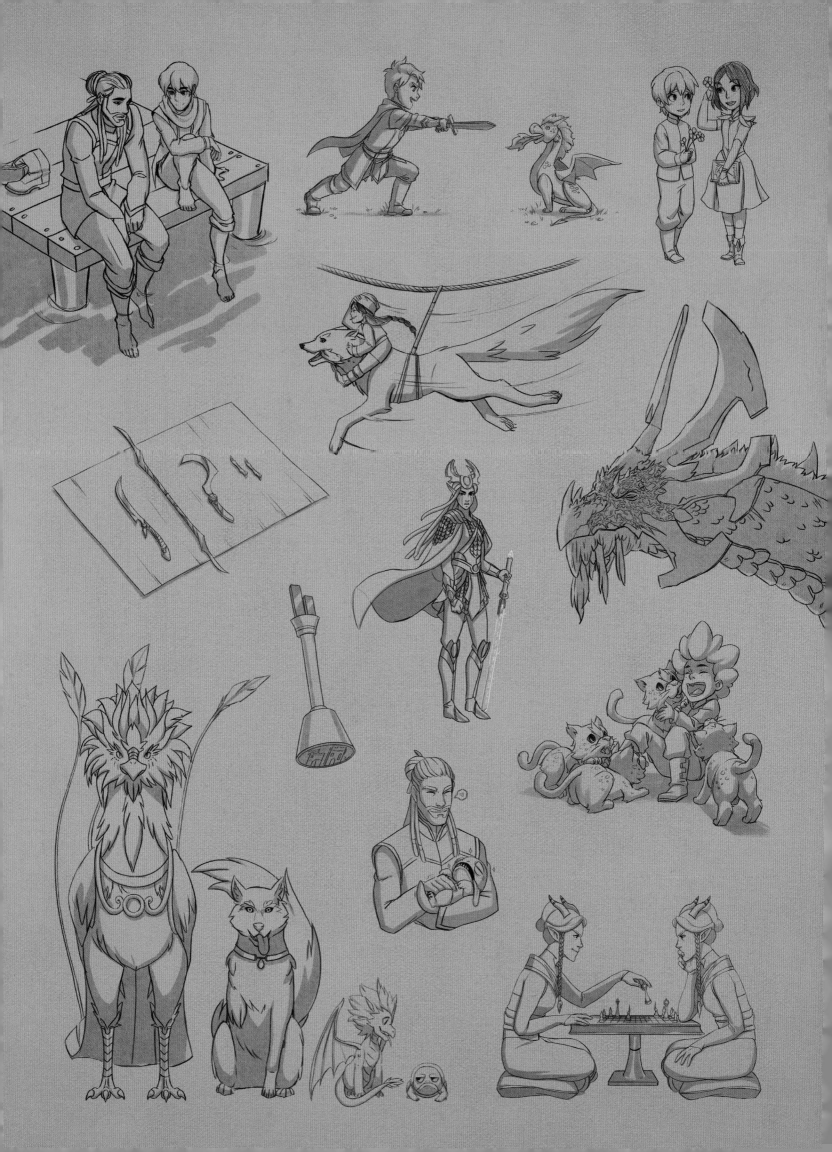

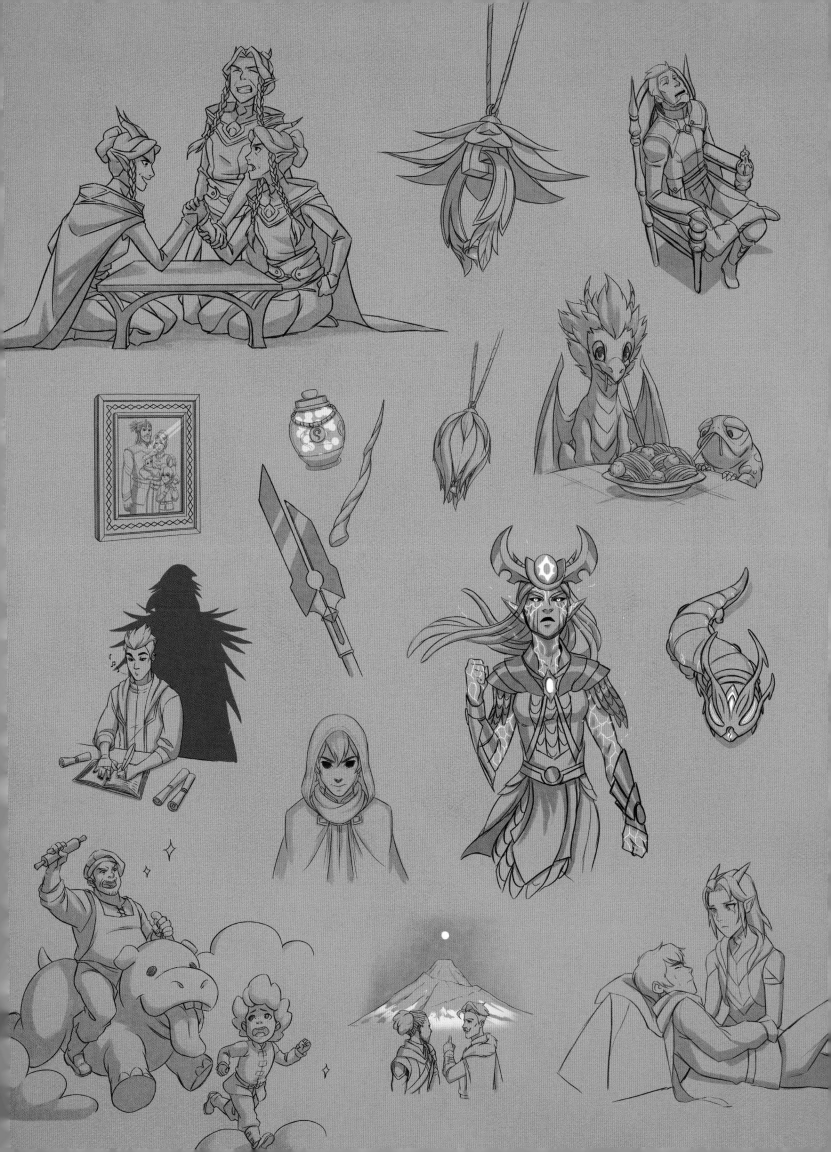

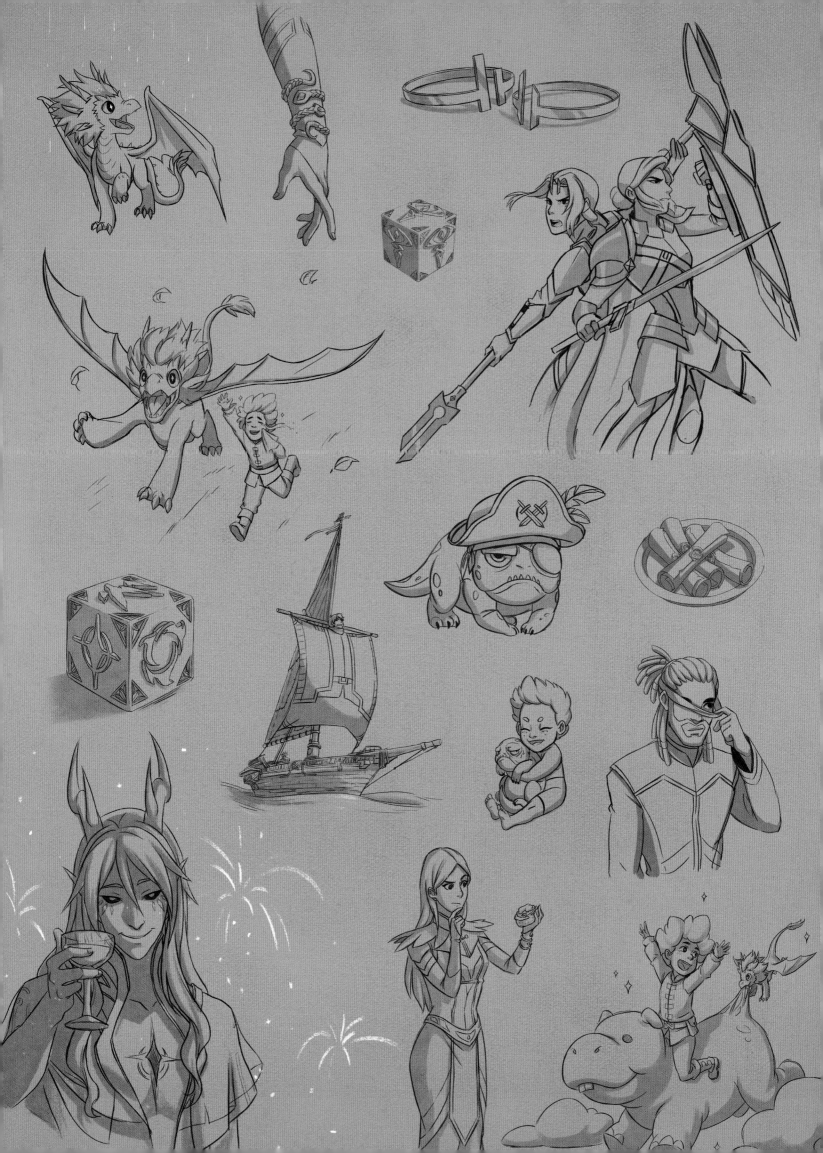

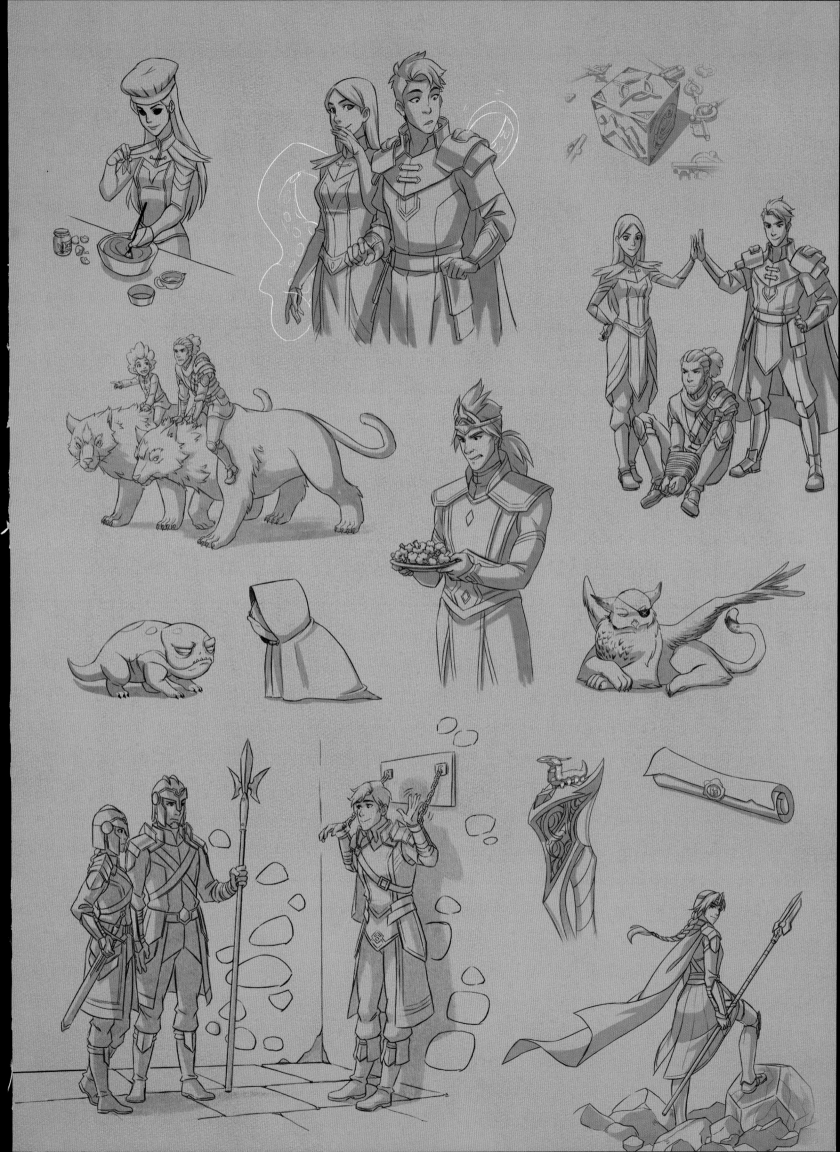

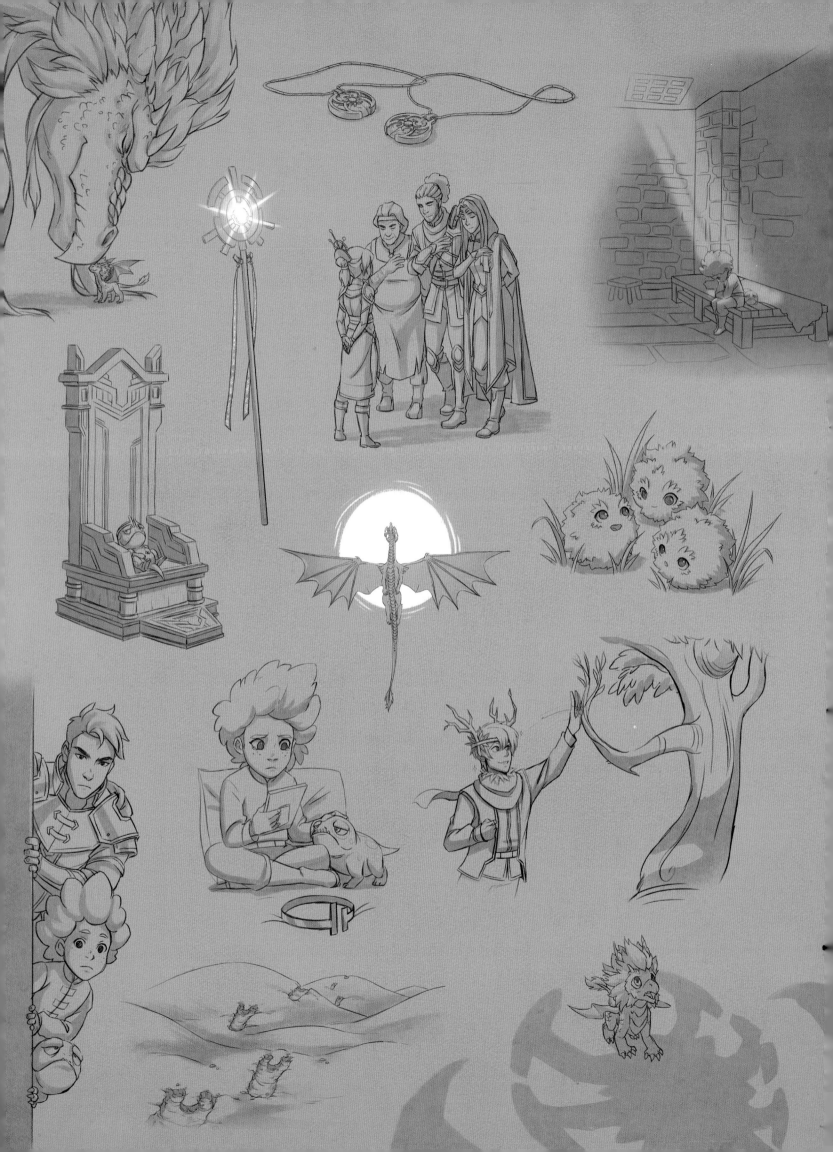

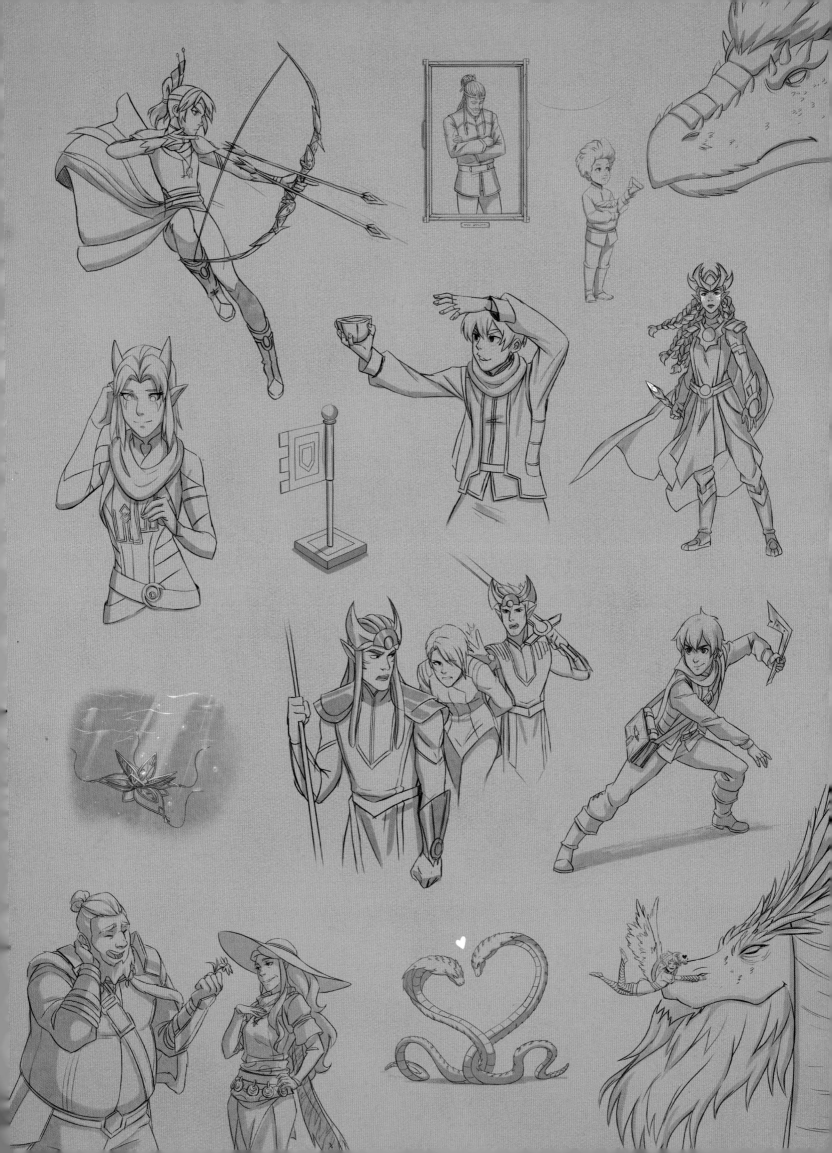

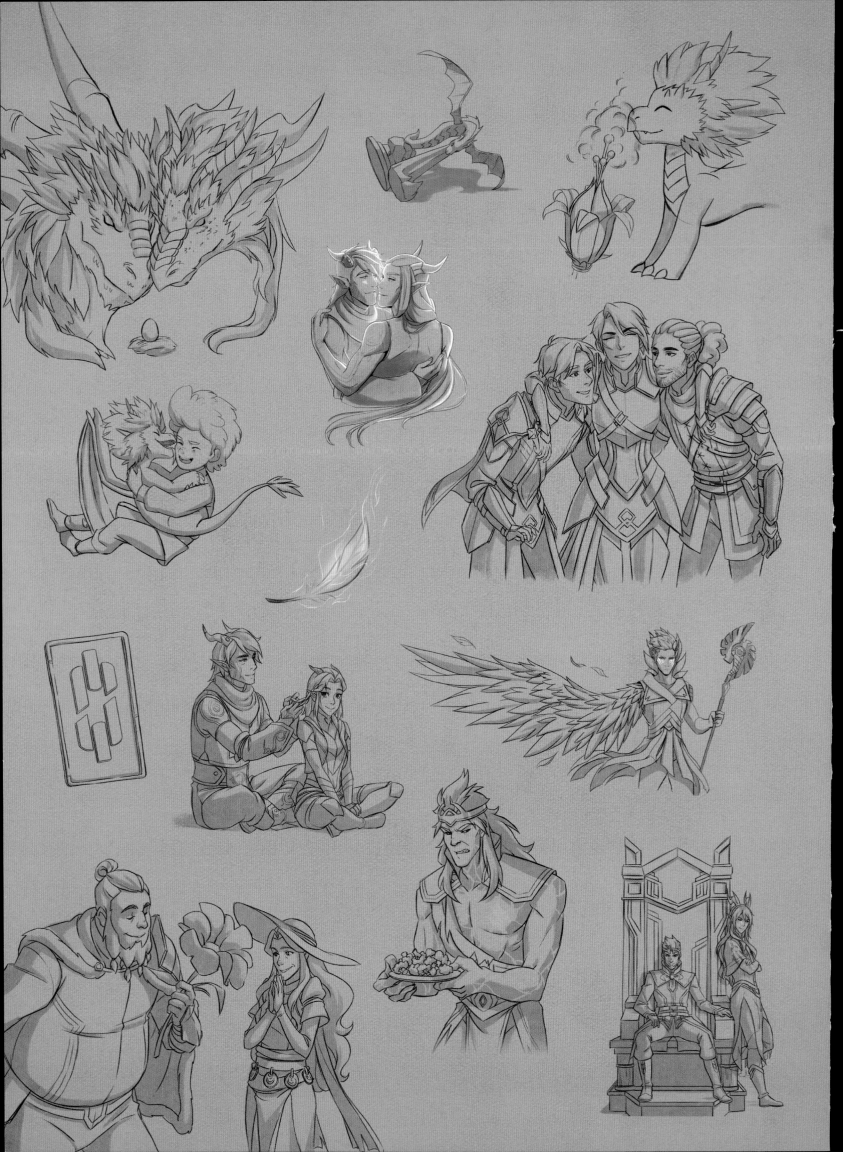

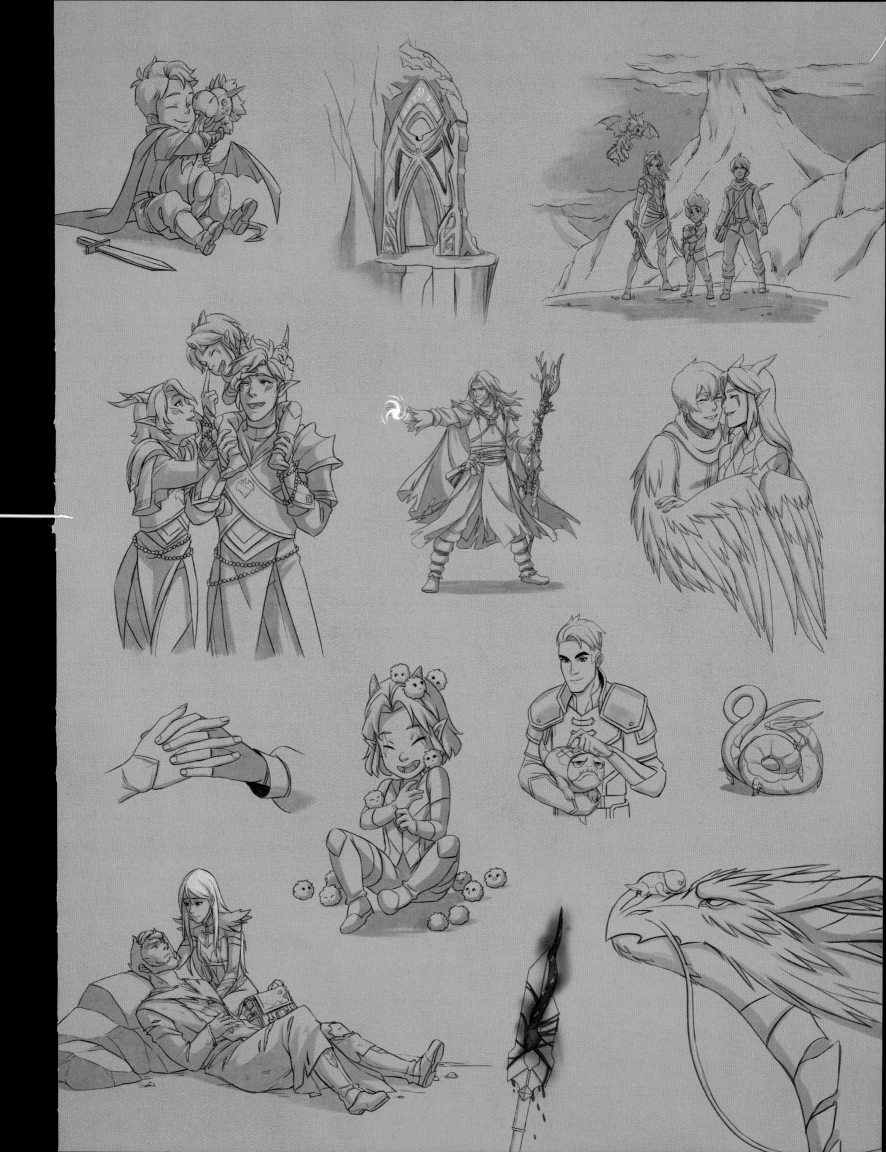

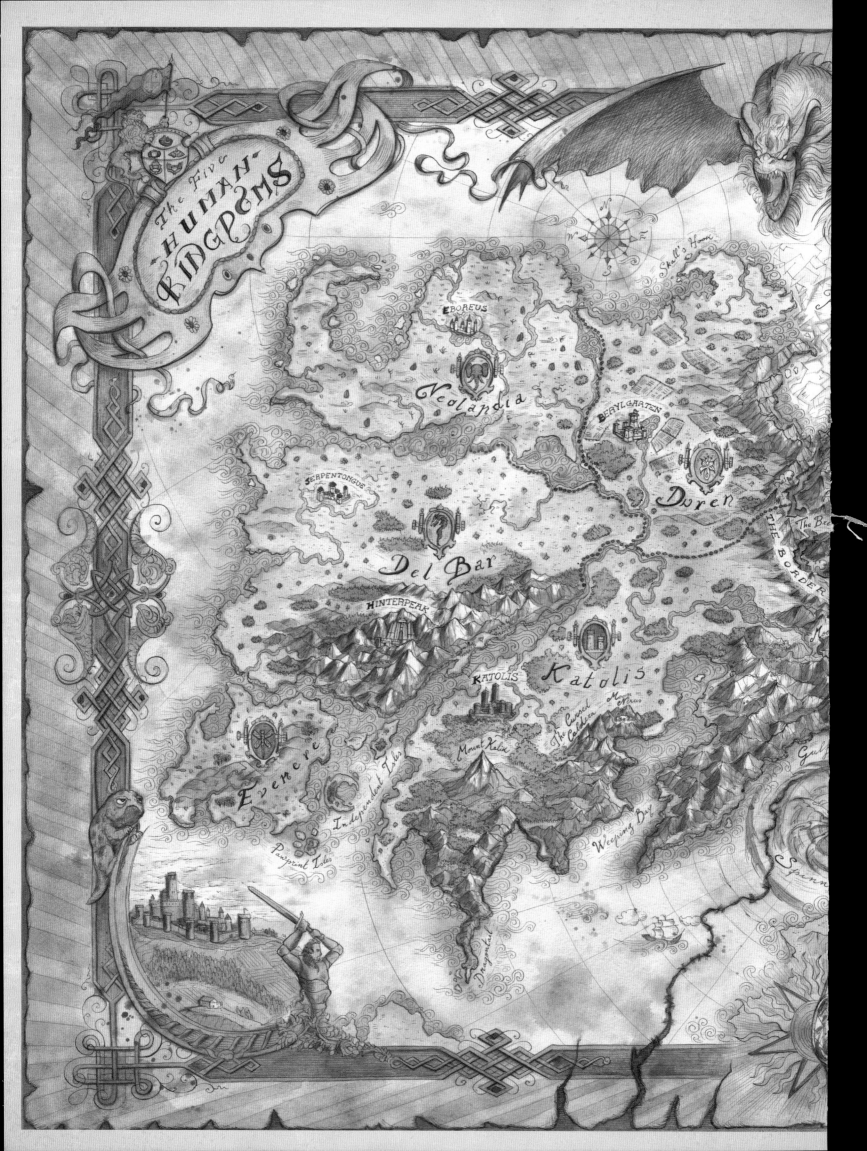

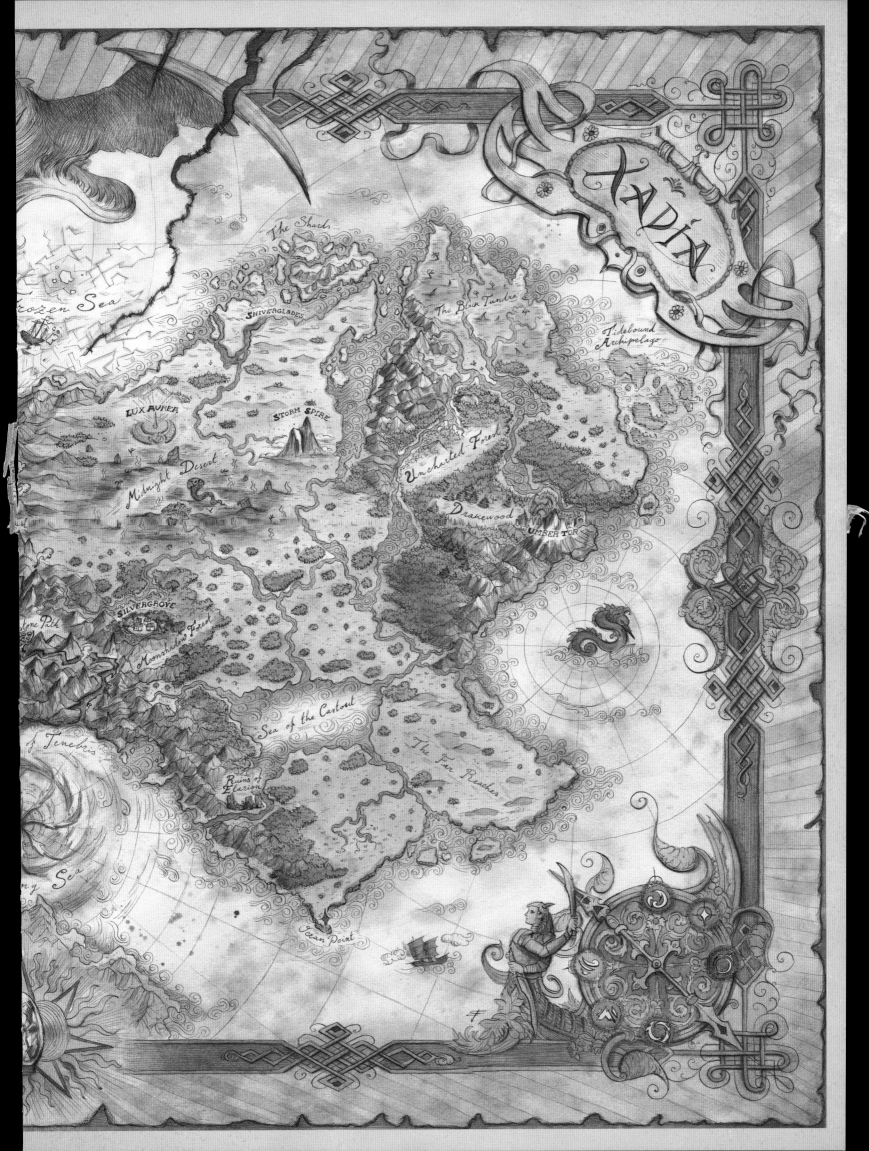